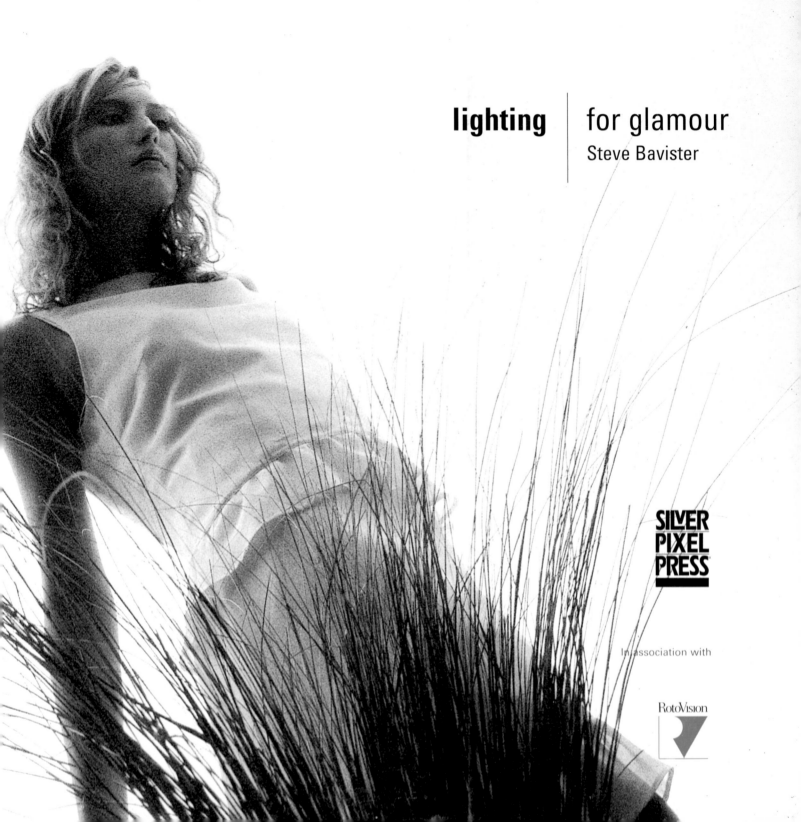

Woodbourne Library
Washington-Centerville Public Library
Centerville, Ohio

DISCARD

W9-CNG-180

lighting | for glamour
Steve Bavister

SILVER
PIXEL
PRESS

In association with

RotoVision

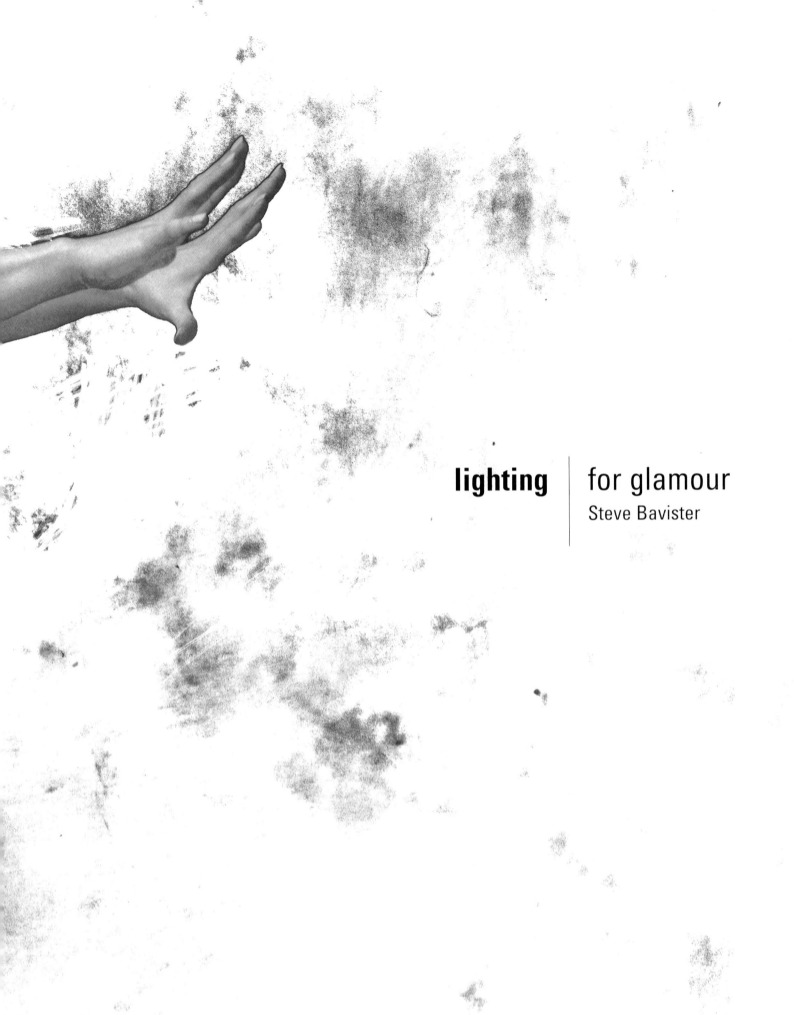

lighting | for glamour
Steve Bavister

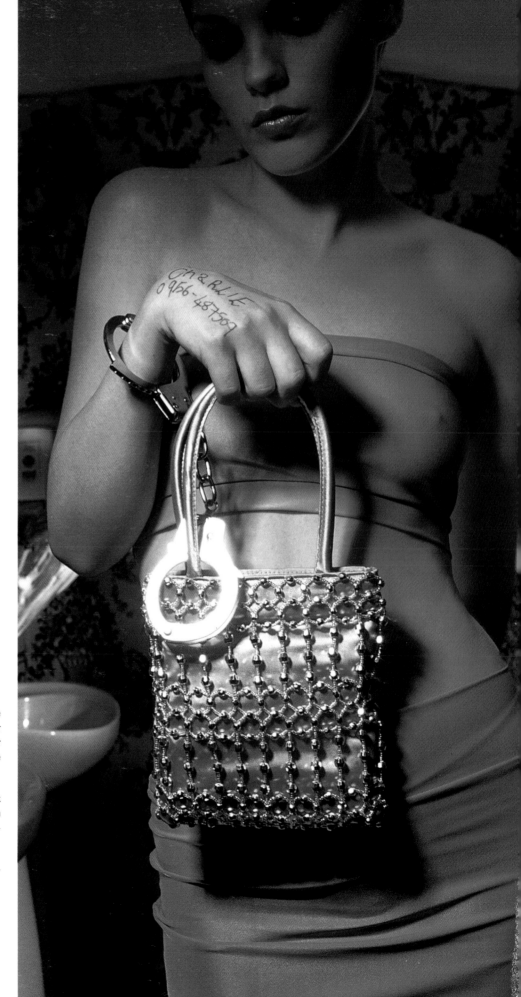

lighting for glamour

First North American Edition, 2001

Published by:
Silver Pixel Press®
A Tiffen® Company
21 Jet View Drive
Rochester, NY 14624 USA
www.silverpixelpress.com

ISBN: 1-883403-86-3

© RotoVision SA 2001

Written by Steve Bavister

Printed in Singapore

All rights reserved. No part of this book may be
reproduced, translated, stored in a retrieval system or
transmitted in any form or by any means, electronic or
otherwise, without prior written permission of the
publisher.

The photographs and diagrams used in this book
are copyrighted or otherwise protected by legislation
and cannot be reproduced without the written permis-
sion of the holder of the rights.

All trademarks and registered trademarks are recog-
nized as belonging to their respective owners.

778.92
Bavi

contents

lighting...

No matter how experienced we are as photographers there's always something new to learn – and this is never more true than when it comes to lighting. Whether you developed your skills in this area by watching master photographers at work, or from reading books and magazines, or simply through trial and error, you will almost certainly have built up a small repertoire of techniques that you come back to time and again. But endlessly recycling your set-ups can get boring and repetitive. Not only for you, but also for your clients. What's more, styles of lighting change over time, and without realising it you can suddenly find your work looking dated – and neither successful nor saleable. So given that lighting is arguably the single most important element in any photograph, it's essential to keep up with contemporary trends.

RotoVision's LIGHTING... series of books seeks to answer these needs. Each title features a selection of current, high-style images from leading exponents in that particular field who have been persuaded to share their lighting expertise with you. In most cases we have talked to the photographer at length to find out exactly where everything was positioned and why one kind of accessory was used over another. At the same time we also picked up a lot of useful suggestions and general information which has also been included. Some of the images rely purely upon daylight; in others ambient illumination is combined with flash or tungsten lighting; and some feature advanced multi-head arrangements. As a result, the LIGHTING... series provides a wonderfully rich smorgasbord of information which would be impossible for you to find collect-

ed together in any other way. Each self-contained two- or four- page section focuses on an individual image or looks at the work of a particular photographer in more depth. Three-dimensional lighting diagrams show you the lighting set-up at a glance – allowing you to replicate it for your own use – while the commentary explains in detail what was involved. Whenever possible, additional images are also included that were either taken at the same time or using the same technique, or illustrate an alternative treatment.

Who will find this book useful? Anyone looking to improve their photography, whether it be for pleasure or profit. Professionals, or those looking to make the move from amateur to professional, will find it an invaluable source of inspiration to spice up their own image-making. Each of the photographs here is designed to help fire your imagination and encourage your creativity to flow in a different and more interesting direction. Alternatively, you may be looking to solve a particular picture-taking problem. You've got a job to do and you're unsure of the best approach. Or you've run low on ideas and want to try out some new techniques. If so, simply flip through the pages until you come across an image that has the kind of feel or look you're after and then find out how it was created.

Art directors will find each title an invaluable primer on contemporary styles as well as a source for new photographic talent. Ultimately, though, LIGHTING... will appeal to anyone who enjoys looking at great pictures for their own sake, with no other motive in mind.

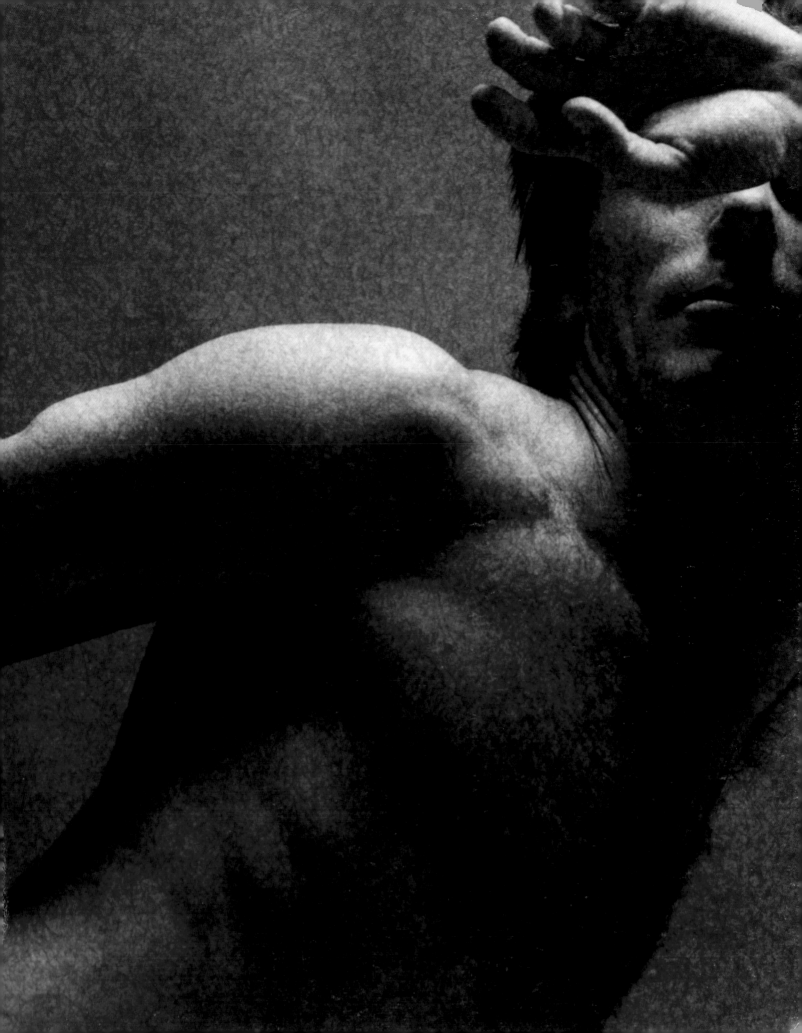

...for glamour

When you mention most areas of photography it's immediately clear to all concerned what you're talking about. In architectural photography the subject is buildings; in portraiture you take pictures of people; and in still-life work you are concerned with capturing objects on film.

Tell people you're a glamour photographer though, and you're likely to get a range of reactions – depending upon their interpretation of what that term means. The word is ambiguous; Collin's English Dictionary describes glamour as 'physical attractiveness; especially when achieved by make-up', or, 'alluring or exciting beauty or charm'. Webster's American Dictionary says 'a magic spell to cast enchantment, a seemingly mysterious and elusive fascination'. Traditionally, in the newsagents, glamour has meant nude shots and girlie magazines. This book's title 'LIGHTING for glamour' is purposefully ambiguous, and the images have been chosen for their allure, charm or eroticism. The models have been lit and photographed in such a way as to create that elusive fascination and the book describes exactly how to achieve the very varied glamorous look.

Much beauty and lifestyle photography now has a distinct glamourous element; fashion of course has always drawn upon it, and erotic portraiture is commonplace these days. In most developed countries provocative poses and sexy expressions can be seen gazing down from billboards and out of magazines every day of the week.

markets for glamour

Over the last decade the phenomenal growth of lifestyle magazines aimed at men has opened up a whole new world of opportunity at the more erotic end of the market – many feature pictures of bikini- or underwear-clad models. But getting work of this kind is far from easy, as most of the girls come from the world of TV and film, and the photography is given to known photographers rather than bought.

Glamourous images are widely used in advertising – as the cliché goes; sex sells. Although work of this kind is still commissioned, an increasing amount is now bought from stock libraries, which have become a much more powerful force in the photography business over the last few years. Where once they only offered rather safe and bland images, the leading agencies now aggressively market cutting-edge material. For anyone looking to get into glamour work, this is probably one of the best routes to follow.

Further evidence that erotic images have been embraced by the mainstream can be seen in the growth of both the 'naughty' greetings card and fine art markets. To be successful in any of these areas you have to keep up to date with current fashions. Styles change with astonishing rapidity, and images can date almost overnight, and it's not just the clothes, hair and expressions that can look old-fashioned. Whole genres of pictures – women dressed up in basque and stockings or musclebound men in garages – suddenly seem laughably passé. Knowing what's hot and what's not is the key, and the way to do that is to keep in touch with market trends by watching advertisements on television and by studying magazines.

working with models

One of the things you need to be alert to is what kind of models are being used. Are they wafer-thin or a more 'real-life' size? Do they look like the girl or guy next door, or are they all models and movie stars? Certainly they need to be attractive –

though for some kinds of nude or fetishistic work it's the body that's more important than the face. While amateur models will be happy to work for a small fee or maybe even a few prints for their portfolio, they will lack the experience to pose easily and interpret fluidly the brief the photographer gives them. However, for aspiring glamour photographers this can be the only cost-effective way of putting together their own book and starting to sell their work. Working with professional models is a different ball game entirely. Many are like actresses who can switch from one look to another in seconds – one moment pensive, the next vivacious. They will also be savvy to the tricks of the trade, such as not to wear elasticated underwear on days when they are doing nude or semi-nude work, as the marks can take a long time to fade. The fee involved in booking a professional model should be looked upon as an investment rather than a cost, as you are much more likely to be able to sell your pictures if the model is attractive and well-styled.

teamwork counts

In the early stages of a glamour career the only people likely to be present at the shoot are the photographer and the model. Unless you are particularly knowledgeable about styling it will be up to the model to do their own hair and make-up, and they may vary in their abilities.

As soon as possible, therefore, you should engage the services of a make-up artist who will have the know-how to make an already attractive model look gorgeous and a beautiful model look stunning. As well as being aware of the right amount of make-up to apply for the camera, he or she should also be able to create many different looks with just one model. Bigger shoots may also see the client or an art director present, along

with an assistant or two. If, as is often the case, some nudity is involved, then the smaller the team the better, allowing the model to feel more relaxed and at ease.

lighting matters

Lighting is of course a crucial element in making the model look their best – quite literally 'showing them in the best possible light'. Using daylight outdoors allows you the advantage of the many different moods offered by the conditions and the seasons – and this can be helped by using white reflectors and black boards to bounce and flag the light. Indoors, too, the light flooding in through windows can be used to excellent effect.

Once again though, the controlled environment of the studio means that anything is possible – and the only limiting factor is your imagination. What is important, as in other areas of photography, is that the lighting be adapted to suit the subject, rather than having a standard set-up that's used for everything. The many different approaches explained in this book will provide inspiration should you find yourself getting in a rut.

In terms of equipment, it's most often a medium-format camera with a standard or short telephoto lens that is used for glamour work. 35mm is also popular for the speed and ease of working it offers – but a 5 x 4 inch is rarely used because it is slower and more laborious. As ever, it is the skill of the photographer in bringing together all these elements to produce the finished image that is crucial.

understanding light

The raw material of the photography profession.

Every art or business has its raw material. To create a pot requires clay. For a statue you must have stone. And to produce a painting you need some kind of paint.

But what about photography – what's our raw material? The answer of course is light. You can have all the cameras, lenses, accessories and film in the world, but without light you won't get very far.

In the same way that other artists have to fashion their raw material, so photographers have to learn to work with light if they're to be successful. Indeed, as many will know, the very word 'photography' derives from Greek and means 'painting with light' – still an excellent way of describing what a photographer does.

The most astonishing thing about light is its sheer diversity – sometimes harsh, sometimes soft; sometimes neutral, sometimes orange, sometimes blue; sometimes plentiful and sometimes in short supply.

Given that light is the single most important element in any photograph, it's astonishing how few photographers pay any real attention to it. Many – including professionals – can be so eager to press the shutter release and get the shot in

the bag that they don't pay light the attention it deserves. However, for successful photography, an understanding of light and the ability to use it creatively are absolutely essential.

The best way of developing and deepening that understanding is to pay close attention to the many moods of daylight. You might find yourself noticing how beautiful the light is on the shady side of a building, or coming in through a small window, or dappled by the foliage of a tree. Use that awareness and knowledge when creating your own lighting set-ups.

quality versus quantity

Taking pictures is easier when there's lots of light. You're free to choose whatever combination of shutter speed and aperture you like without having to worry about camera-shake or subject movement – and you can always reduce it with a neutral density filter if there's too much. But don't confuse quantity with quality.

The blinding light you find outdoors at noon on a sunny day or bursting out of a bare studio head may be intense, but it's far from ideal for most kinds of photography.

More evocative results are generally achieved when the light is modified in some way – with overall levels of light being often much lower. With daylight this modification might be by means of time of day, early morning and late evening being more atmospheric, or by weather conditions, with clouds or even rain or fog producing very different effects. Some of the most dramatic lighting occurs when opposing forces come together – such as a shaft of sunlight breaking through heavy cloud after a storm.

In the studio, as well as the number of lights used and their position, it's the accessories you fit which will determine the overall quality of the light (see pp16–18).

soft and hard

For some situations and subjects you will want light that is hard and contrasty, with strong, distinct shadows and crisp, sharp highlights. When it's sunny outdoors the shadows are darker and shorter around noon and softer and longer when it's earlier or later in the day. Contrasty lighting can result in strong, vivid images with rich, saturated tones if colour film has been used.

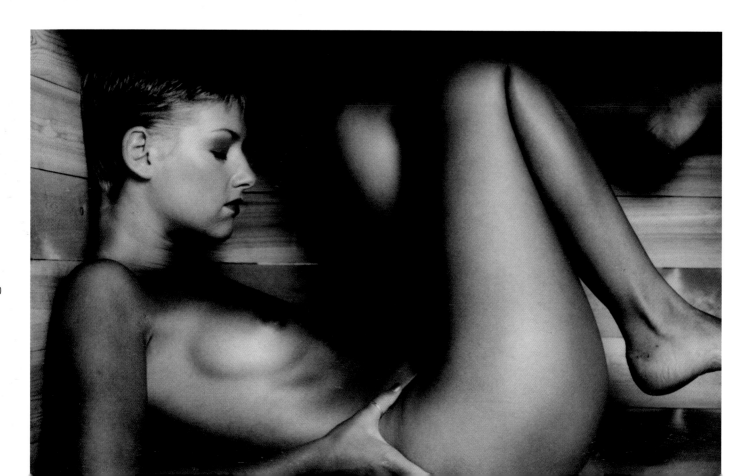

However, the long tonal range you get in such conditions can be difficult to capture on film, especially when using transparency materials – you may have to allow either the highlights to burn out slightly or the shadows to block up. Care must be taken when doing so that no important detail is lost or that the image doesn't then look either too washed out or too heavy. If so, some reduction in contrast can often be achieved by using reflectors.

This kind of contrasty treatment is not always appropriate or suitable and for many subjects and situations a light with a more limited tonal range that gives softer results may work better. Where you want to show the maximum amount of detail, or create a mood of lightness and airiness, with the minimum of shadows, the soft lighting of an overcast day or a large softbox is unbeatable.

Here the principal risk is that the picture will be too flat to hold the viewer's interest – though imaginative design and composition should avoid that problem.

In the studio, you have full control over the contrast, which you will choose on the basis of what is most appropriate.

lighting direction

In every picture you take you are using light to reveal something about the subject – the texture, form, shape, weight, colour or even translucency. That's where to a large degree the direction of the lighting comes in. Looking at what you are going to photograph, and thinking about what you want to convey about it, will give you some idea about the best lighting direction to employ.

colour temperature

We generally think of light as being neutral or white, but in fact it can vary considerably in colour – you need only think about the orange of a sunrise or the blue in the sky just before night sets in. The colour of light is measured in Kelvins (K), and the range of possible light colours makes up the Kelvin scale. Standard daylight-balanced film is designed for use in noon sunlight, which typically has a temperature of 5500K – the same as electronic flash. However, if you work with daylight film in light of a lower colour temperature you'll get a warm, orange colour, while if you work with it in light of a higher temperature, you'll get a cool, blue tonality. Such casts are generally regarded as wrong, but if used intentionally they can give a shot more character than the blandness of a clean white light – as many excellent shots in this book testify most eloquently.

measuring light

All you ever wanted to know about using a meter but were afraid to ask.

in-camera meters

Over recent years the accuracy of in-camera meters has advanced enormously, and many autofocus models now boast computerised multi-pattern systems whose processing power would have filled the average lounge in the 1960s. By taking separate readings from several parts of the subject and analysing them against data drawn from hundreds of different photographic situations, they deliver a far higher percentage of successful pictures than ever before.

However, the principal problem with any kind of built-in meter remains the fact that it measures the light reflected back from the subject – so no matter how sophisticated it may be, it's prone to problems in tricky lighting situations, such as severe backlighting or strong sidelighting.

An additional complication is that integral meters are stupid – in the sense that they don't know what you're trying to do creatively. So while you might prefer to give a little more exposure to make sure the shadows have plenty of detail when working with black & white negative film, or to reduce exposure by a fraction to boost saturation when shooting colour slides, your camera's meter will come up with a 'correct' reading that produces bland results.

Of course, not all in-camera meters are that sophisticated. Many photographers still use old and serviceable models with simple centre-weighted systems that are easily misled in all sorts of situations.

For all these reasons, any self-respecting professional photographer or serious amateur should invest in a separate, hand-held lightmeter, which will give them full control over the exposure process – and 100 percent accuracy.

incident light meters

Hand-held meters provide you with the opportunity to do something your integral meter never could – which is take an 'incident' reading of the light falling onto the subject. With a white 'invercone' dome fitted over the sensor, all the light illuminating the scene is integrated, avoiding any difficulties caused by bright or dark areas in the picture.

Using an incident meter couldn't be easier. You simply point it toward the camera and press a button to take a reading. Most modern types are now digital, and you just read the aperture or shutter speed off an LCD panel, sliding a switch to scroll through the various combinations available. With older dial types you read the setting from a scale.

When using filters, you can either take the reading first and then adjust the exposure by the filter factor if you know it, or hold the filter over the sensor when making a measurement.

To those who've grown to rely on automated in-camera systems, this may sound a long-winded way of going about things. But in fact once you've used a separate meter a few times you'll find it doesn't take much longer. What does it matter if it takes a few seconds more to get a good result?

Most of the time the exposure calculated by an incident meter can be relied upon, but there are a couple of situations where you might need to make some slight adjustment:

1. When the main subject is either much darker or lighter than normal. Here, to get good reproduction, you may need to increase exposure by 1/2 to 1 stop with dark subjects and decrease exposure by 1/2 to 1 stop with light subjects.

2. When contrast levels are extremely high and beyond the film's ability to accommodate them. Here, it's often necessary to give 1/2 or even 1 stop extra exposure to prevent the shadows blocking up.

spot meters (a)

Those seeking unparalleled control over exposure should consider buying a spot meter, which allows you to take a reading from just one percent of the picture area. Many photographers involved in all kinds of picture-taking swear by theirs and would be completely lost without it.

Spot meters are different from incident meters in that they have a viewfinder which you look through when measuring exposure. At the centre is a small circle, which indicates the area from which the reading is made. Of course considerable care must be taken when choosing this area.

If you plan to measure the exposure from just one area, you need to make sure it's equivalent in tone to the 18 percent middle grey the meter expects. Grass is usually about right, as is dark stonework on a building. To be sure, it's a good idea to carry around a Kodak Grey Card, designed specifically to give average reflectance.

Another alternative is to take a 'duplex' reading – measuring the lightest and darkest parts of the scene and then taking an average. Most spot meters offer a facility which does this automatically.

In some pictures it's the correct rendering of the light or dark tones that's important, and some spot meters feature clever 'Highlight' and 'Shadow' buttons that ensure they come out correctly.

(a)

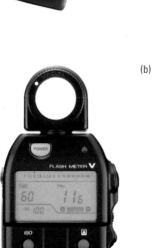

(b)

(c)

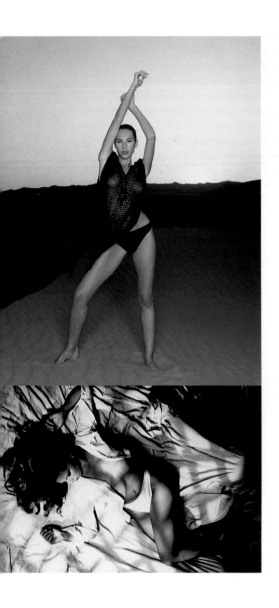

reciprocity law failure

The ISO ratings that manufacturers give their film assume that they have the same sensitivity whatever the aperture or shutter speed combination – that the exposure will be the same at 1/60sec and f/2 as at 1/4sec and f/8 as at 4 seconds and f/32. This is called the Reciprocity Law – but it's not always true.

If the shutter is longer than about 1 second, or shorter than around 1/4000sec, the law can break down and cause underexposure. The way to correct this is obviously to give an increase to compensate, but the problem is that films vary enormously in terms of their reciprocity characteristics, so you may need to experiment with your favourite emulsion if you do a lot of long exposure work.

As a starting point, increase exposure by 0.5 stops if the shutter speed is 1/4sec, by 1 stop if it's 16 seconds, and by 2–3 stops if it's one minute – although many manufacturers warn against using such long speeds because of the danger of significant colour shifts.

exposure latitude

If film manufacturers have anything to say on the matter, one day soon you won't need to make exposure adjustments – no matter how much the camera's meter is misled. By steadily increasing the exposure latitude of films – that is the degree to which they can be under- or overexposed and still give good results – they plan to make it all but impossible to get a bad result.

It is claimed that modern print films have a latitude of 5 stops – 3 stops over and 2 stops under. Certainly on the overexposure front the claims are justified. Pictures given 3 stops more than required are generally indistinguishable from those that received the right amount of light.

Underexposure can be more of a problem. Give 1 stop less than is required and the prints are generally still OK, but underexpose by 2 stops and you often get significantly inferior results.

With slides, though, it's a different story. The latitude is a lot less – rarely more than 1 stop – and with some films, such as Fujichrome Velvia, as little as 1/2 stop with critical subjects. This means careful exposure compensation is crucial when shooting trannies.

flash meters (b)

Many of the more expensive hand-held meters, both incident and spot, have a facility for measuring electronic flash as well. For those who don't feel the need for an ambient meter, separate, reasonably-priced, flash-only meters are available.

The benefit of having a meter that can measure flash is obvious. In the studio it allows you to make changes to the position and power of lights and then quickly check the exposure required. When using a portable electronic gun, you can calculate the amount of flash required to give a balanced fill-in effect.

Incident flash meters are used in exactly the same way as when taking an ambient reading. The meter is placed in front of the subject, facing the camera, and the flash fired. This can usually be done from the meter itself, by connecting it to the synchronisation cable and pressing a button.

The flash facility on spot meters is most helpful for making sure that the important part of the picture is correctly exposed. When shooting a portrait, for instance, a close-up reading can be taken of the subject's face.

Another widely available feature allows you to compare flash and ambient readings – this is ideal for balancing flash with ambient light or mixing flash with tungsten.

Some of the more advanced flash meters can also total multiple flashes – useful if you need to fire a head several times to get a small aperture for maximum depth of field.

colour temperature meters (c)

Colour temperature meters are specialist pieces of equipment that are not essential, but most photographers would benefit from one. These measure not the amount of light, but its colour.

The standard measure for the colour of light is Kelvins (K). Daylight film is balanced for use at 5500K, although the actual colour of daylight varies considerably. On an overcast day it can be higher, 6000–7000K, producing a blue cast, or 4000K in late afternoon, giving an orange tinge.

A simple press of a button on a colour meter can confirm the exact colour temperature and tell you what light balancing filter(s) would be required to correct it.

It also works with tungsten lighting, and the most difficult type of light to work with, fluorescent; indicating the necessary colour correction filter(s) needed to produce a neutral print.

You may not need a colour meter if you work mainly with colour negative film, but if you use transparency film where colour accuracy is essential, it can be a worthwhile investment.

13

using light

If light is your raw material, how do you fashion it to produce the results you want?

working with daylight

One option for certain kinds of work is to run your studio on daylight – and some professionals do just that. Consider the advantages: the light you get is completely natural, unlike flash you can see exactly what you're getting, and it costs nothing to buy or run.

When working outdoors light can be controlled by means of large white and black boards which can be built around the subject to produce the effect required.

Indoors, you might want to choose a room with north-facing windows. Because no sun ever enters, the light remains constant throughout the day. It may be a little cool for colour work – giving your shots a bluish cast. If so, simply fit a pale orange colour correction filter over the lens to warm things up – an 81A or 81B should do fine.

Rooms facing in other directions will see changes of light colour, intensity and contrast throughout the day. When the sun shines in you'll get plenty of warm-toned light that will cast distinct shadows. With no sun, light levels will be lower, shadows softer, and colour temperature more neutral.

The size of the windows in the room also determines how harsh or diffuse the light will be. Having a room with at least one big window, such as a patio door, will make available a soft and even light. The effective size of the window can easily be reduced by means of curtains or black card, for a sharper, more focused light. In the same vein, light from small windows can be softened with net curtains or tracing paper. The ideal room would also feature a skylight, adding a soft downwards light.

Whatever subject you're shooting, you'll need a number of reflectors to help you make the most of your daylight studio – allowing you to bounce the light around and fill in shadow areas to control contrast.

using studio lights

Daylight studios have many merits as the pictures in this book taken using ambient light demonstrate. There are, however, obvious disadvantages: you can't use them when it's dark, you can't turn the power up when you need more light, and you don't have anywhere near the same degree of control you get when using studio heads.

Being able to place lights exactly where you want them, reduce or increase their output at will, and modify the quality of the illumination according to your needs means the only limitation is your imagination. Any visualised lighting set-up is possible (although you might need to hire a few extra lights when you start to get more ambitious).

how many lights do you need?

Some photographers seem to operate on the basis of 'the more lights the better', using every light at their disposal for every shot. In fact there's a lot to be said for simplicity – there's only one sun, after all – and some of the best photographs are taken using just one perfectly positioned head. By using different modifying accessories you can alter the quality of its output according to your photographic needs. Before going onto more advanced set-ups, it's a good idea to learn to make the most of just a single light source – trying out backlit and sidelit techniques as well as the more usual frontal and 45 degree approaches. If you want to soften the light further and give the effect of having a second light of lower power, a simple white reflector is all you need.

Of course, having a second head does give you many more options – as well as using it for fill-in you can place it alongside the main light, put it over the top of the subject, or wherever works well.

Having two lights means you can also control the ratio between them, reducing or increasing their relative power to control the contrast in the picture. For many subjects a lighting ratio of 1:4 – i.e. one light having 1/4 of the power of the other – is ideal, but there are no hard-and-fast rules and experimentation often yields exciting and original results.

In practice, many photographers will need to have at least three or four heads in their armoury – and unless advanced set-ups or enormous fire power are required, that should be sufficient for most situations.

However, it is worth reiterating that it is all too easy to overlight a subject, with unnatural and distracting shadows going in every direction. Before you introduce another light try asking yourself what exactly it adds to the image – and if it adds nothing, don't use it.

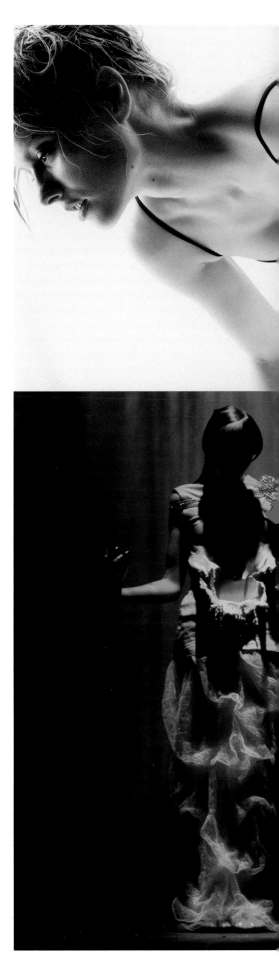

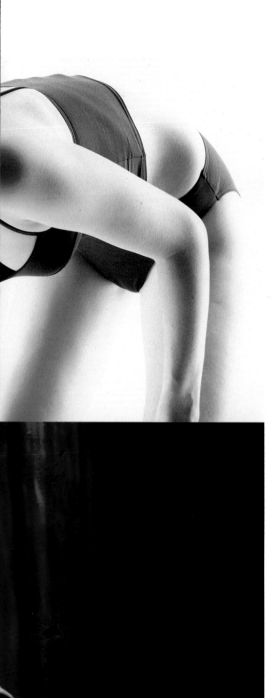

when and how to use reflectors

Reflectors are simply flat sheets of reflective material designed to bounce light back onto the subject. The aim is to control the contrast within a scene by lightening, or 'filling-in', the shadow areas. Ready-to-buy reflectors come in all shapes and sizes, but many professionals prefer to improvise.

Large sheets of Formica, card or polystyrene are commonly used, any of which can be cut down to size as necessary. Folding circular types, using a clever 'twist and collapse' design, are easier to store and move around, and typically available in 30cm, 50cm, 1m or 1.2m diameter sizes. There are also 'professional' panels measuring around 6 x 4ft. Plain white reflectors are ideal when you want simple fill lighting, while silver versions give a crisp, clear light and gold is ideal when you want to add some warmth.

Most of the time the reflector needs to be as close as possible to the subject without actually appearing in the picture.

flash or tungsten?

The main choice when buying studio heads is tungsten or flash – and there are advantages and disadvantages to both.

Tungsten units tend to be cheaper and have the advantage of running continuously, allowing you to see exactly how the light will fall in the finished picture. However, the light has a strong orange content, typically around 3400K, requiring the use of tungsten film or a blue correction filter used either over lens or light for a neutral result. Tungsten lights can also generate enormous heat, making them unsuitable for certain subjects.

Flash heads are more commonly used because they are much cooler to run, produce a white light balanced to standard film stocks, and have a greater light output.

Many studios have both types, and a decision about which to use is based on the requirements of the job in hand.

which accessories when?

Every bit as important as the lights themselves are the accessories that are fitted to them. Very few pictures are taken with just the bare head, as the light simply goes everywhere – which is not normally what's wanted at all. To make the light more directional you can fit a dish reflector, which narrows the beam and allows you to restrict it to certain parts of your subject.

A more versatile option is provided by 'barn doors', which have four adjustable black flaps that can be opened out to accurately control the spill of the light. If you want just a narrow beam of light, try fitting a snoot – a conical black accessory which tapers to a small circular opening.

Other useful accessories include spots and fresnels, which you can use to focus the light, and scrims and diffusers to reduce the harshness.

If you want softer illumination, the light from a dish reflector can be bounced off a large white board, or more conveniently, especially for location work, fired into a special umbrella.

If that's not soft enough for you, invest in a softbox – a large white accessory that mimics window light and is perfect for a wide range of subjects. The bigger the softbox, the more diffuse the light.

Acetate
Clear plastic-like sheet often colour tinted and fitted over lights for a colour cast

Ambient light
Naturally occurring light

Available light
See Ambient light

Back-projection
System in which a transparency is projected onto a translucent screen to create a backdrop

Barn doors (a)
Set of four flaps that fit over the front of a light and can be adjusted to control the spill of the light

Boom
Long arm fitted with a counterweight which allows heads to be positioned above the subject

Brolly (b)
See Umbrella

CC filters
Colour correction filters used for correcting any imbalance between films and light sources

Continuous lighting
Sources that provide steady illumination, in contrast to flash which only fires briefly

Diffuser
Any kind of accessory which softens the output from a light

Effects light
Light used to illuminate a particular part of the subject

Fill light
Light or reflector designed to reduce shadows

Fish fryer
Extremely large softbox

Flash head
Studio lighting unit which emits a brief and powerful burst of daylight-balanced light

16 ## glossary of lighting terms

Common and less well-known terms
explained.

(c)

Flag
Sheet of black card used to prevent light falling on parts of the scene or entering the lens and causing flare

Fluorescent light
Continuous light source which often produces a green cast with daylight-balanced film – though neutral tubes are also available

Fresnel (c)
Lens fitted to the front of tungsten lighting units which allows them to be focused

Giraffe
Alternative name for a boom

Gobo (d)
Sheet of black card with areas cut out, designed to cast shadows when fitted over a light

HMI
Continuous light source running cooler than tungsten but balanced to daylight and suitable for use with digital cameras

(d)

Honeycomb (e)
Grid that fits over a lighting head producing illumination that is harsher and more directional

Incident reading
Exposure reading of the light falling onto the subject

Joule
Measure of the output of flash units, equivalent to one watt-second

Kelvin
Scale used for measuring the colour of light. Daylight and electronic flash is balanced to 5500K

(e)

Key light
The main light source

Kill spill
Large flat board designed to prevent light spillage

Lightbrush (f)
Sophisticated flash lighting unit fitted with a fibre-optic tube that allows 'painting with light'

Light tent
Special lighting set-up designed to avoid reflections on shiny subjects

Mirror
Cheap but invaluable accessory that allows light to be reflected accurately to create specific highlights

(f)

Mixed lighting
Combination of different coloured light sources, such as flash, tungsten or fluorescent

Modelling light
Tungsten lamp on a flash head which gives an indication of where the illumination will fall

Monobloc
Self-contained flash head that plugs directly into the mains (unlike flash units which run from a power pack)

Multiple flash
Firing a flash head several times to give the amount of light required

Perspex
Acrylic sheeting used to soften light and as a background

Ratio
Difference in the amount of light produced by different sources in a set-up

Reflector
1) Metal shade round a light source to control and direct it **(g)**
2) White or silvered surface used to bounce light around

Ringflash
Circular flash tube which fits around the lens and produces a characteristic shadowless lighting

Scrim
Any kind of material placed in front of a light to reduce its intensity

Slave
Light-sensitive cell which synchronises the firing of two or more flash units

Snoot (h)
Black cone which tapers to concentrate the light into a circular beam

Softbox (i)
Popular lighting accessory producing extremely soft light. Various sizes and shapes are available – the larger they are, the more diffuse the light

Spill
Light not falling on the subject

Spot
A directional light source

Spot meter
Meter capable of reading from a small area of the subject – typically 1–3°

Stand
Support for lighting equipment (and also cameras)

Swimming pool
Large softbox giving extremely soft lighting (see also Fish fryer)

Tungsten
Continuous light source

18

Umbrella (b)
Inexpensive, versatile and portable lighting accessory. Available in white (soft), silver (harsher light), gold (for warming) and blue (for tungsten sources). The larger the umbrella the softer the light

practicalities

How to gain the most from this book.

The best tools are those which can be used in many different ways, which is why this book is designed to be as versatile as possible. Thanks to its modular format, you can interact with it in whichever way suits your needs at any particular time. Most of the material is organised into self-contained double-page spreads based around one or more images – though there are also some four-page features that look at the work of a particular photographer in more depth.

In each case there are at least two diagrams which show the lighting used – based on information supplied by the photographer. If you want to produce a shot that's similar, all you have to do is copy the arrangement. Naturally the diagrams should only be taken as a guide, as it is impossible to accurately represent the enormous variety of heads, dishes, softboxes, reflectors and so on that are available while using a limited range of diagrams, nor is it possible to fully indicate lighting ratios and other such specifics. The scale, too, has sometimes had, to be expanded or compressed to fit within the space available. In practice, however, differences should be small, and will anyhow allow you to add your own personal stamp to the arrangement you're seeking to replicate. In addition you'll find technical details about the use of camera, film, exposure, lens etc. along with any useful hints and tips. The spreads themselves are organised into chapters, each devoted to a specific lighting situation – starting with daylight and increasing in complexity, from one light to multiple-head set-ups.

icon key

Icon	Label
⊛	Photographer
⊙	Client
◑	Possible uses
⊚	Camera
◔	Lens
▣	Film
⊙	Exposure
○	Type of light
○	Model
⊕	Stylist
⊛	Assistant
○	Location
⊛	Set
▯	Make-up

understanding the lighting diagrams

three-dimensional diagrams

medium format camera

35mm camera

standard head

standard head with barn doors

spot

spot with honeycomb

spot with snoot

softbox

diffuser

strip light

reflector

backdrop

plan view diagrams

medium format camera 35mm camera

standard head standard head with barn doors

spot

spot with honeycomb

spot with snoot softbox

diffuser strip light

reflector backdrop

19

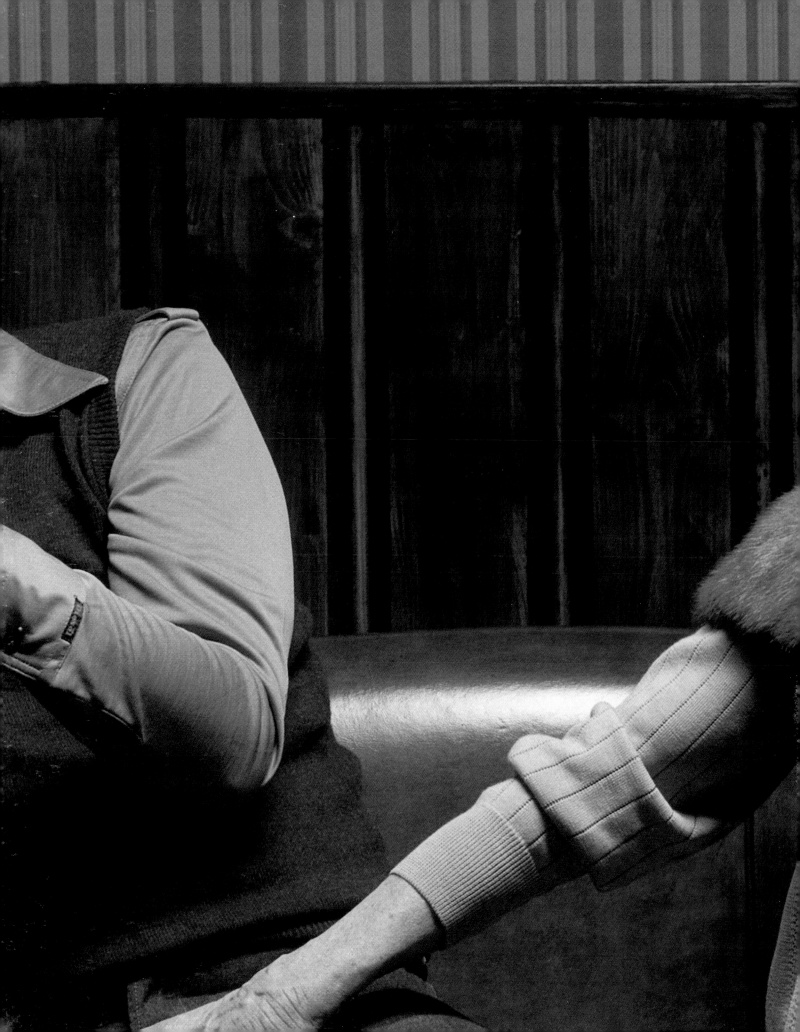

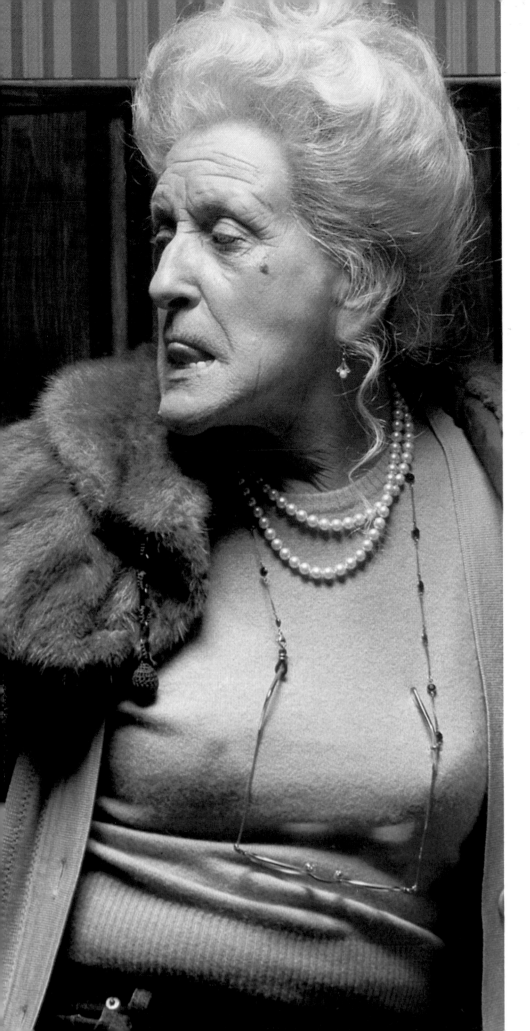

ambient & daylight

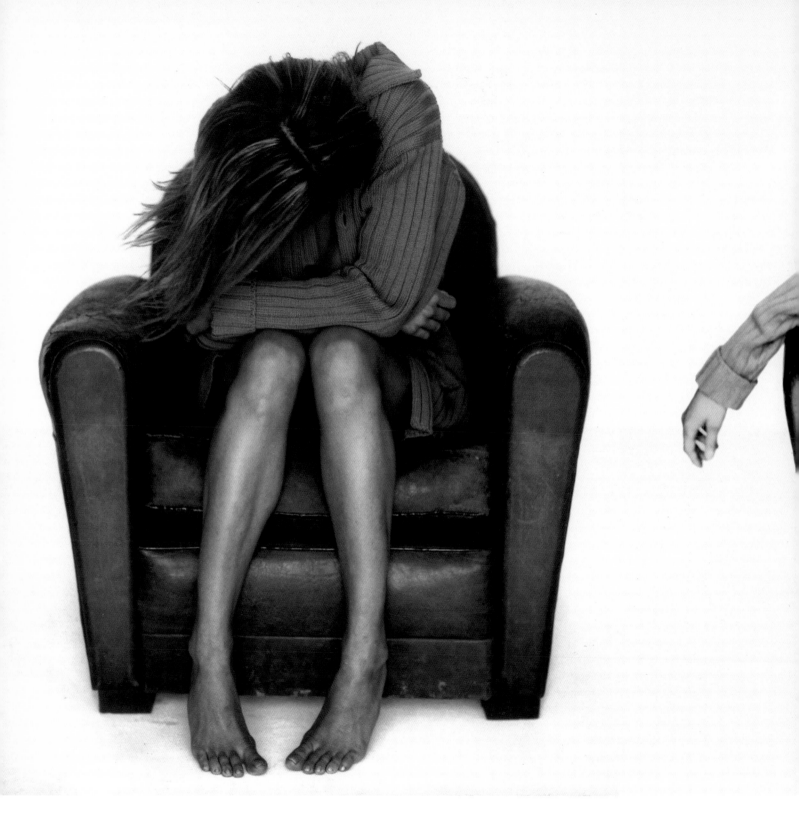

nadine

Unconventional posing adds an eroticism that lifts this daylight image out of the mundane.

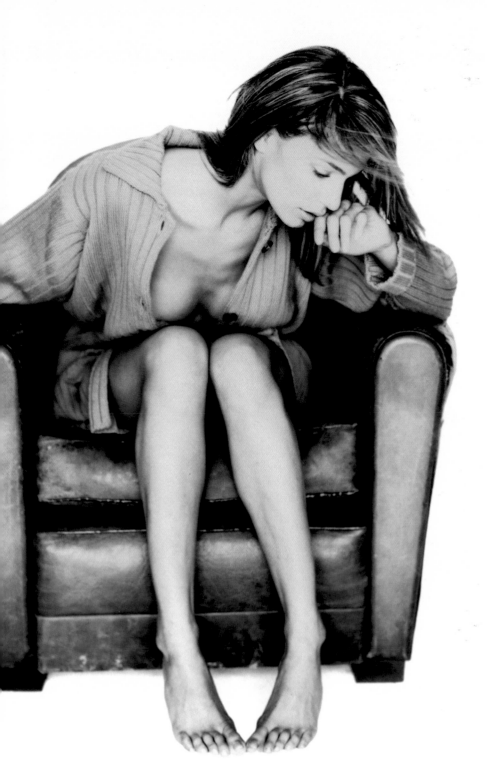

 Frank Wartenberg

Vogue magazine advertisement

Editorial

6 x 7cm

110mm

Agfa Scala 200X

Not known

Daylight

Nadine

Uta Sorst

Bert Spangemacher

Ruth Vahle

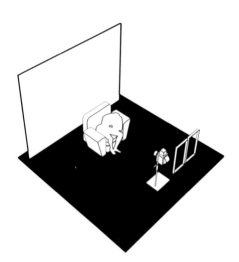

plan view

Although commissioned to show the clothes of the client for an advertisement in Vogue magazine, the photographer also wanted to add a touch of eroticism. This he has achieved primarily through the unconventional posing. The lighting, though, is as simple as it is effective – daylight indoors flooding through windows behind the camera. Screens were fitted in front of the windows to soften the illumination, while the naturally contrasty film emulsion helps give the image a lift.

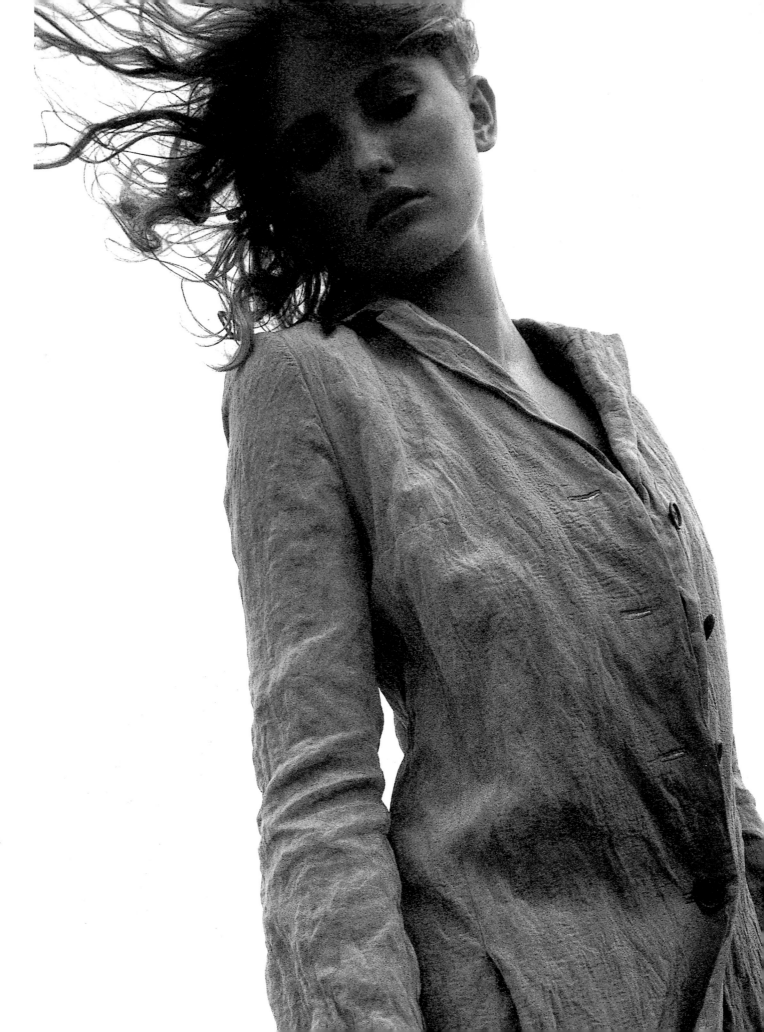

Because there were so many potentially distracting elements at ground level – cars, trees, people etc. – the model was raised up on a purpose-built platform 1.5m high, which made it easy to use the sky as a plain backdrop. Had the intention been to light the face fully, a reflector could have been used. However, since the emphasis was on the clothes, the complexion was allowed to fall a stop or two darker. The model's hair was naturally blowing in the wind – no machine was necessary.

While strong, direct sunlight is wonderful for landscape and travel photography, it can be too harsh for beauty and fashion photography. Far better, under such conditions, to find a shaded area where the light is not so intense and harsh. That's what the photographer did here, shooting with his back to a wall away from sunlight, and using the natural softness of the light – combined with a grainy 35mm film stock – to produce a wonderfully atmospheric image.

🚶	Morten Bjarnhof
🌊	House of Sand
🌐	Catalogue/advertising/in-store display
📷	35mm
📷	50mm
▶	Kodak T400CN
⏱	1/125sec at f/2
💡	Shadow side of wall
🗺	Majorca
👤	Louise Simony

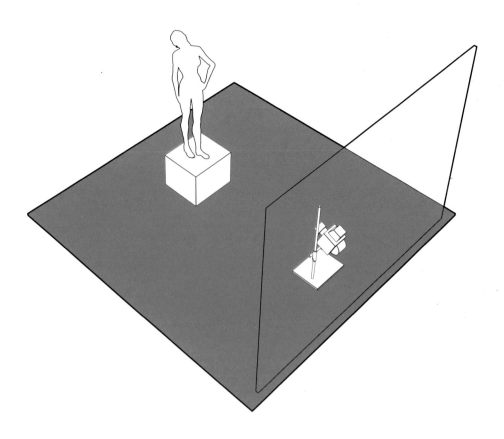

plan view

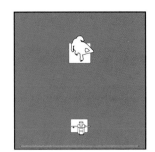

girl with hair blowing

On a sunny day, the shadow side of a building provides wonderfully soft light.

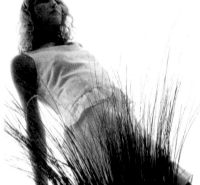

Taken at exactly the same location, with the model still on the raised platform, this image sees her turning her face towards the light for a different feel. A 35mm lens and a lower angle were used to give the sense of the girl leaning backwards. Although it looks natural, the grass was a prop, cut from nearby and held in front to create a sense of depth.

25

girl with globe

Stormy light at the end of the day is combined with blue-gelled fill-in.

Stormy skies behind and a deep blue cast in front – lighting doesn't get any moodier than this. Taken just before the sun went down, this image combines gelled fill-in from a flash head with the naturally atmospheric ambient conditions. Several different green and blue gels were fitted over a flash head on the left-hand side, which was fired into an umbrella. To enhance the mood, the degree of fill-in was set to be around a stop less than would have normally been allowed for a full exposure.

Why is the girl holding the globe? Does it have some deep mystical significance? Sadly, no. In fact the top of the Alexandra McQueen bikini had been lost, and because they didn't want to shoot topless the girl needed to hold something to cover up her breasts – and the globe was the only vaguely suitable object they could find before the light went completely.

Ⓐ Iko Ouro-Preto
Ⓐ Jalouse
Ⓐ Editorial
Ⓐ 6 x 7cm
Ⓐ 80mm
Ⓐ Kodak Ektachrome EPP
Ⓐ 1/30sec at f/8
Ⓐ Evening light with fill-in
Ⓐ Cape Town, South Africa

plan view

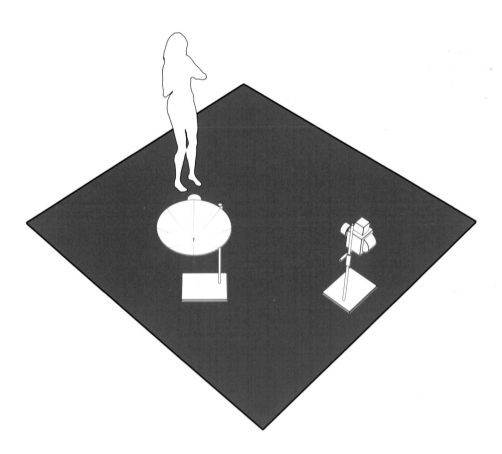

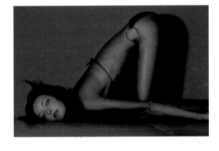

27

This was taken shortly afterwards, but using a wall around a swimming pool as the backdrop rather than the sky. To get the ideal shooting position the photographer had to paddle in the water, and the model had to stay in that uncomfortable position for 15 minutes while Polaroids were checked.

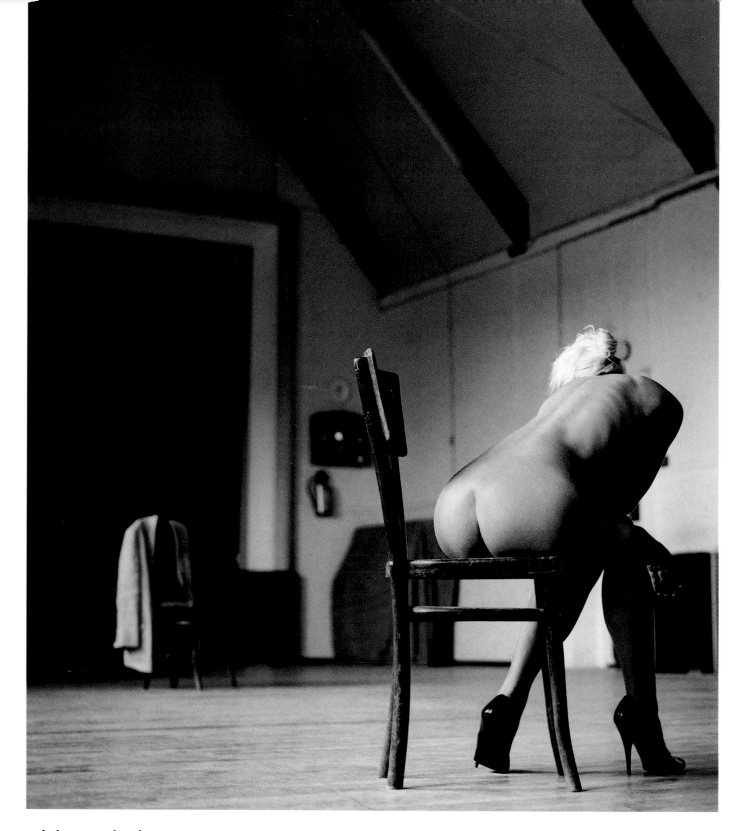

girl on chair

A strong feeling of reality is created by shooting in an existing location, using naturally occurring lighting and creating casual-looking poses.

'This was taken on location at a local village hall rather than in my studio – allowing me to give the picture a sense of "real-life". I used the available light from windows which ran the entire length of the room and these gave a kind of "wrap-around" illumination. Because the windows faced north, and the shoot took place mid-afternoon, the light was soft and diffuse. There was no need to add any reflectors, because curtains on the other side of the room bounced back the light.'

Nigel Holmes
Personal project
6 x 6cm
80mm
Ilford XP2 (rated at ISO100)
Not recorded
Ambient indoors
Louise Hodges

plan view

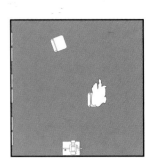

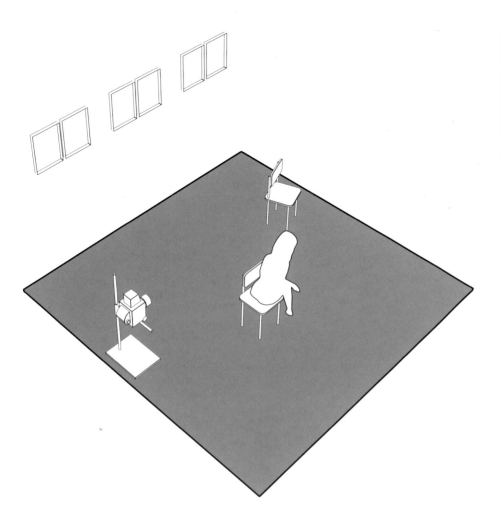

on posing

'To create more interest, and tell a kind of "story", I placed my jacket on a chair in the background. I started by taking some pictures with the model facing me, but then when she faced the other way I knew I had the shot I wanted.'

practical tips

* Use windows facing north and you get a soft light because no direct sunlight enters

29

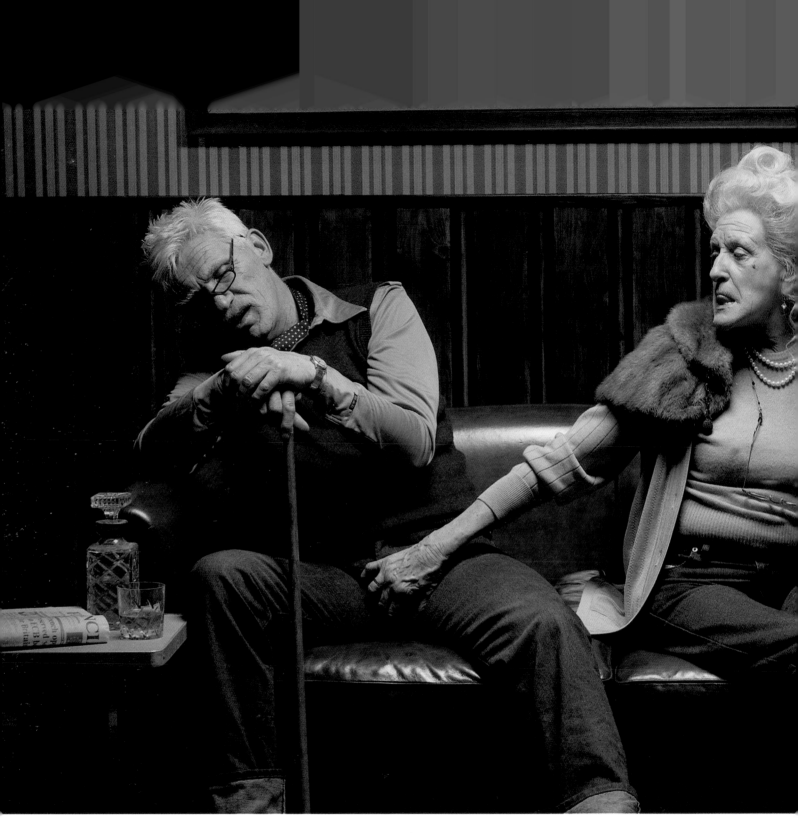

couple

Intentionally drab lighting provides the subtle edge to the type of sexy glamour that the Diesel clothing label promotes.

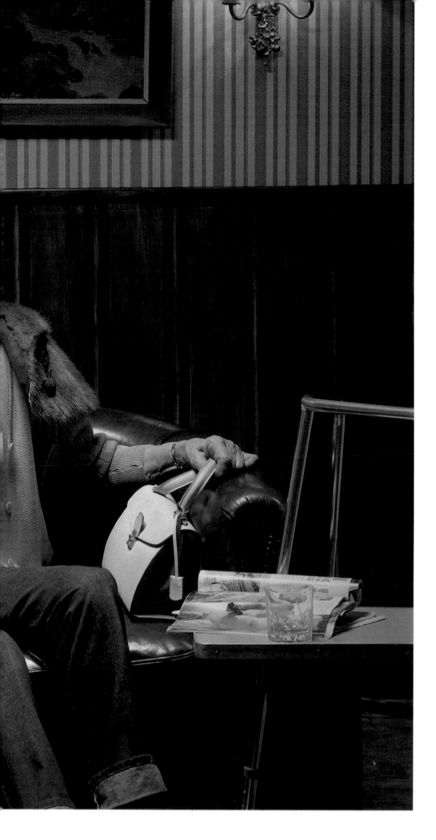

 Erwin Olaf
Diesel
Advertisement
6 x 6cm
150mm
Fujicolor 100
Not known
One softbox plus reflector

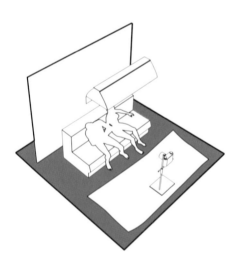

This set was built in Erwin's studio and lit to resemble an old people's home. He wanted to create a gloomy, realistic atmosphere, so the illumination comes from a large softbox over the top of the models and slightly to the front of them. To darken the background further, a 30cm strip of lace was hung from the front edge of the softbox. The effect is similar to using barn doors, but with a much softer edge. Rather than use individual reflectors, Erwin laid out a large sheet of white cloth just out of shot at the front of the picture. The original image, featuring rich, vivid colours, was scanned into the computer and the saturation reduced by 50 percent.

plan view

motel fetish

Making use of existing lighting and employing lamps as spotlights embodies an individual approach to lighting.

Chas Ray Krider
Personal project
6 x 7cm
80mm
Kodak RPN
1/2sec at f/5.6
Room lighting and modelling light
Bridget

'I decided I didn't want to shoot models in the studio', says Krider, 'I wanted to put them in an environment everyone was familiar with. I was also concerned to have realistic backdrops, so existing rooms were the perfect setting that everyone could relate to.'

'What appealed to me about motels is that everyone has been to one. In America they're often used for clandestine rendezvous, and I drop a lot of clues in my photos to show there are two people in the room, not just one – such as two cocktail glasses. I also build sets in my studio that look like motels. I buy carpets, drapes, chairs and so on to create the effect. However, locations give me things I can't reproduce easily in the studio, such as bathrooms and doorways.'

'I've been working on this particular look for five years now, and have shot around fifty different sequences. I have a small stable of models I work with, and I try to re-invent them whenever I work with them. "Motel Fetish" is the working title I gave to the project, and it seems to have stuck, but I don't really know where the fetish element comes in – though over time the images have certainly become more sexually dangerous. I started collecting period lingerie about 15 years ago and I'm putting it into use in these pictures. Most of the clothing you see comes from my prop department, although models usually provide their own shoes.'

'My pictures have a very "retro" look, but I'm not trying to recreate the past. There are hints that the pictures weren't taken years ago, such as the inclusion of a CD player or a television screen tuned to a recognisable programme. What I'm trying to do is drag what I like about the past into the present.'

'Most of the time I just use the ambient light in the room – though of course I move lamps around for the best effect, and often I'll tip a lamp up and use it like a spot. I tried using flash, but just couldn't get that believable, ambient, wrap-around light. Sometimes I use the modelling light from a large softbox to provide fill-in. I tend to have it set and positioned so that it doesn't throw its own shadow. Occasionally I also use a TV as an extra light source, to illuminate some of the dark areas of the picture. Basically it's an "amateur" aesthetic I'm working with. I ask myself, what would some guy do who was in a room with a model, had the wrong film in the camera, and didn't have any additional lighting. There's a remarkable degree of constancy about the lighting in motels, and around 75 percent of my "Motel Fetish" pictures were taken at 1/2sec at f/5.6.'

using daylight film in tungsten conditions

Most of the pictures taken in this series were shot on daylight-balanced negative film, with the orange cast produced by the tungsten lighting pulled back to neutral at the printing stage – leaving just enough warmth left in to create a sense of atmosphere.

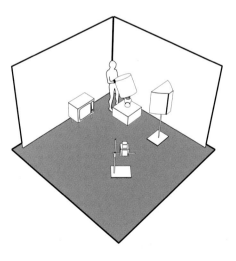

girl leaning against wall holding lamp

'The light for this shot is coming almost entirely from the lamp, which I asked the model to tip to give the effect you see. To soften the shadows, I also used the modelling lights of a large softbox for overall illumination.'

plan view

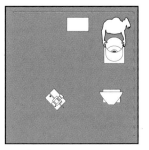

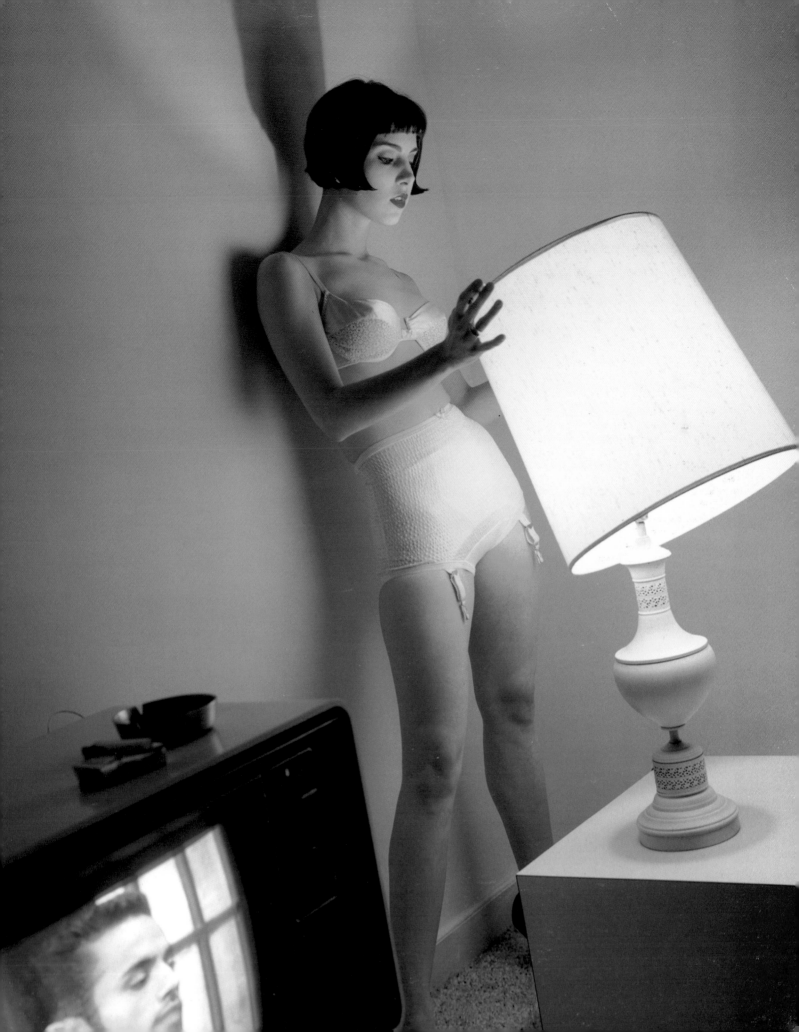

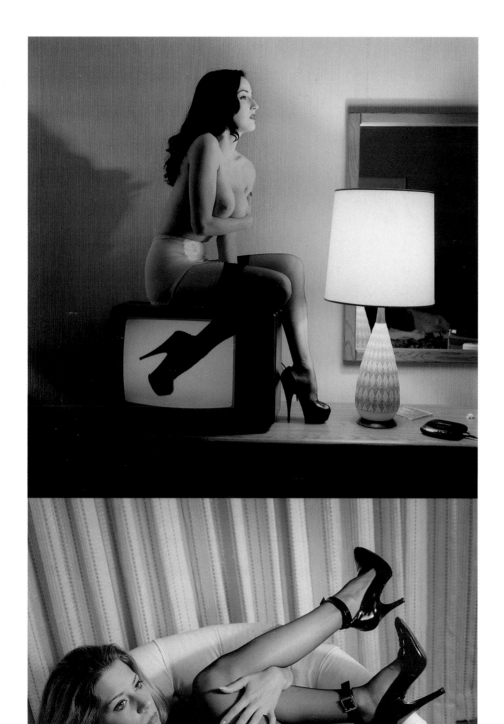

Chas Ray Krider
Personal project
6 x 6cm
80mm
Kodak RPN
1/2sec at f/5.6
Room lighting and modelling light
Dita

Chas Ray Krider
Personal project
6 x 6cm
80mm
Kodak RPN
1/2sec at f/5.6
Room lighting and modelling light
Amber Rose

34

girl sitting on television

'I waited a long time to meet the right person with the right shoe for this shot! I'd taken it several times before with different models, but this was the only time it has really worked. It looks as though the only light source is the lamp, but in fact there was also a 13-inch reflector which was illuminating her face and throwing the shadow on the wall. The television was tuned out, to add a contrasting colour and create the silhouette of the stiletto shoe.'

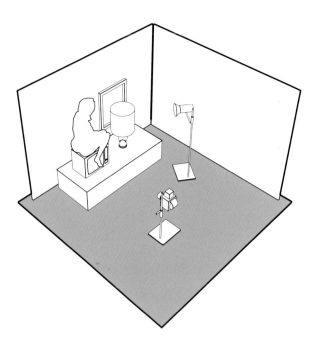

plan view

girl sitting in chair

'The main illumination for this shot comes from a tilted lamp to the right to the camera, which I've used as a spot to flood the model with light. On the opposite side there's a large softbox around 3m away, whose modelling lights provide a fill so the shadows are not too strong. In addition, there's a light with barn doors lighting the curtains at the back.'

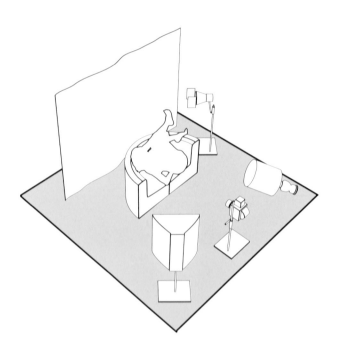

plan view

35

Verona is a German TV star, and it was Frank's first session with her. 'I wanted to show her in a different way', he says, 'and I think I did. While there's a lot to be said for sophisticated lighting set-ups, sometimes they're simply not necessary – and daylight does it best. That's what was used here, and to good effect. With direct sunlight behind the photographer, and the model in front of a studio backdrop, it is the style and composition of the image that you notice.

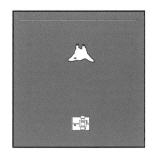

- Frank Wartenberg
- Gala magazine
- Editorial
- 35mm
- 105mm
- Agfa Scala 200X
- Not known
- Daylight
- The beach
- Verona
- Ruter Valile
- Bert Spangemacher

plan view

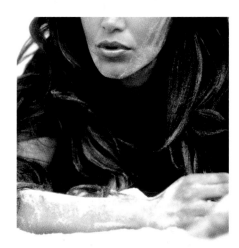

verona

Simple unadulterated daylight coupled with a tantalizing close-up composition creates an air of quiet mystery.

As this picture from the same series shows, the location was a beach, which acted as a natural reflector, bouncing light up to soften the shadows.

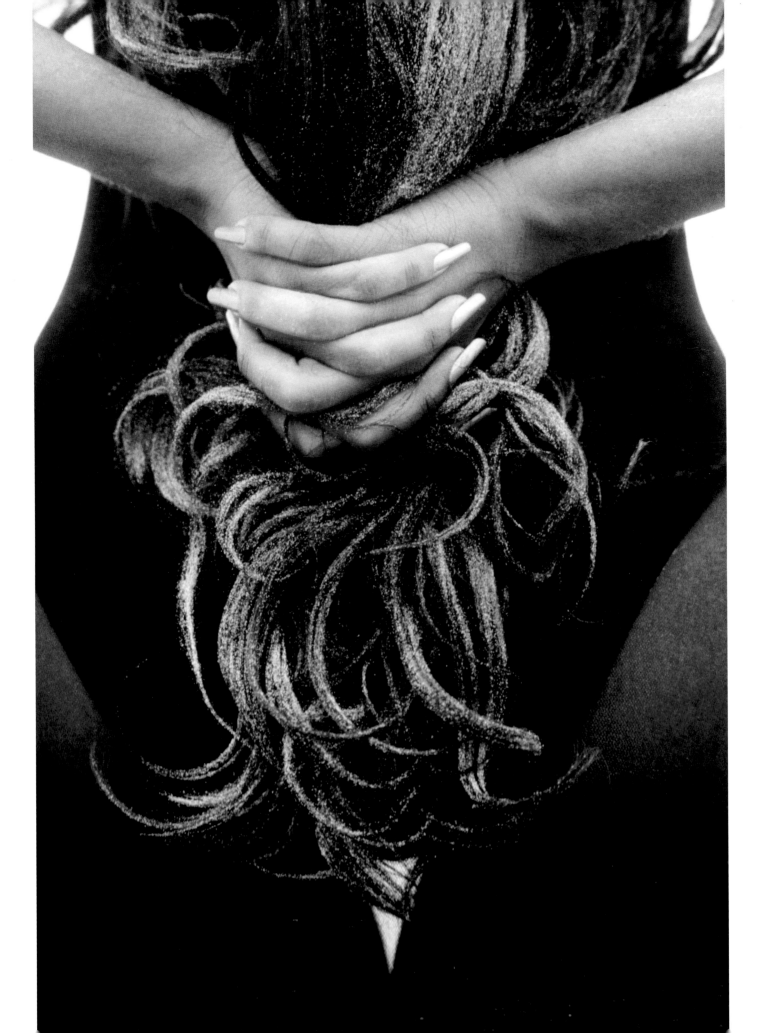

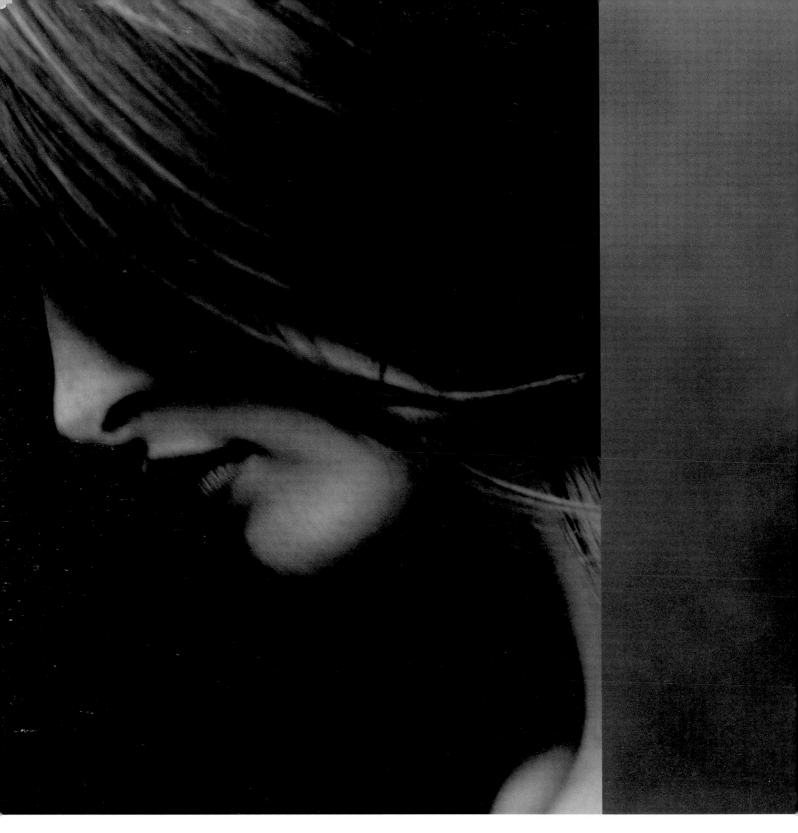

girl in maze

The qualities of daylight depend upon the location in which you shoot.

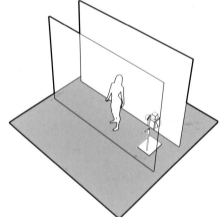

- Morten Bjarnhof
- Inwear
- Brochure
- 6 x 7cm
- 105mm
- Kodak T400CN
- 1/60sec at f/2.8
- Daylight
- Barcelona, Spain
- Matilda
- Kristian Weiss

Daylight has many qualities, depending upon time of day and location, which can be exploited by a talented photographer. Here it looks at first sight as if the picture might have been taken in the studio, the catchlight in the eyes suggesting an overhead light in a classic beauty set-up. But in fact it was taken on location, inside a maze in Barcelona. Because the route through the maze is only 1.5m wide, and the hedging is 3m high, the lighting is almost entirely from the front and above. Combine this with overcast weather and you have perfect conditions for a wonderful portrait – shot at maximum aperture because of the low light levels.

plan view

'This picture is lit entirely with daylight – there's no auxiliary lighting and no reflectors were used,' describes Trenchard; 'the model is halfway inside a huge old water tank, and the only light is from the direction she is facing. Because of the time of day being around 6pm, the light is diffuse with a warm hue, and is coming from the right of the camera. This results in a soft shadow and a large catchlight in the eyes.'

⊛ Peter Trenchard
◉ Personal project
▣ 6 x 6cm
◍ 80mm
▤ Kodak Pro Gold 100HC
⏲ 1/60sec at f/4
◍ Available light

plan view

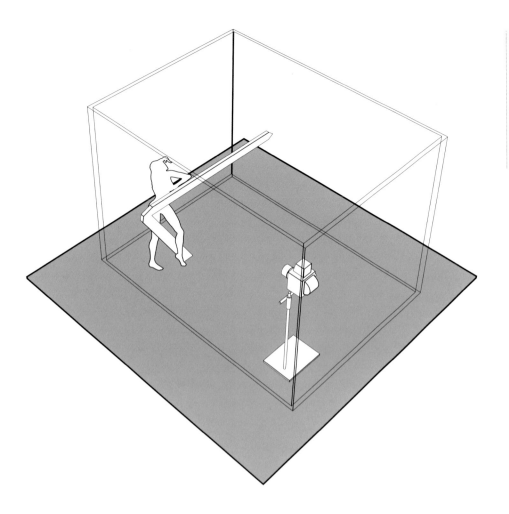

relaxed girl

Late afternoon sun provides soft and glowing illumination.

why no reflectors?

I didn't use any reflectors with this shot because I think they would have killed it. I didn't want to make the shirt any brighter because it would have distracted attention from the face.

'We wanted a casual, natural feel to the pictures,' Holmes says, 'so I began by asking the model to hold a cup as if she was lounging around doing nothing – but it looked a little false. We came up with the idea of her filing her nails, which seemed more real.'

'I deliberately left all the "clutter" in the background, because its interest enhances, rather than detracts, from the subject.'

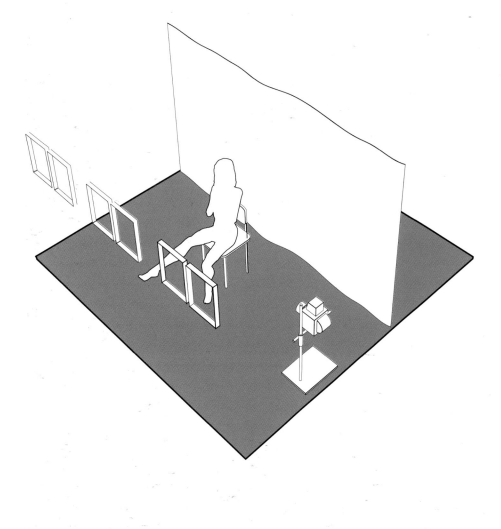

practical tips

* When using available illumination in situations such as this, light levels will be low and a tripod is essential to avoid camera-shake
* Keep your eyes out for real locations that can be called upon as and when they are required for particular jobs

plan view

model filing her nails

Using available light in a real location can make it easy to create authentic-looking images that offer a counterpoint to obviously set-up studio images.

Nigel Holmes
Personal project
Bronica SQ-A
80mm
Ilford XP2 (rated at ISO100)
Not recorded
Ambient indoors
Louise Hodges

43

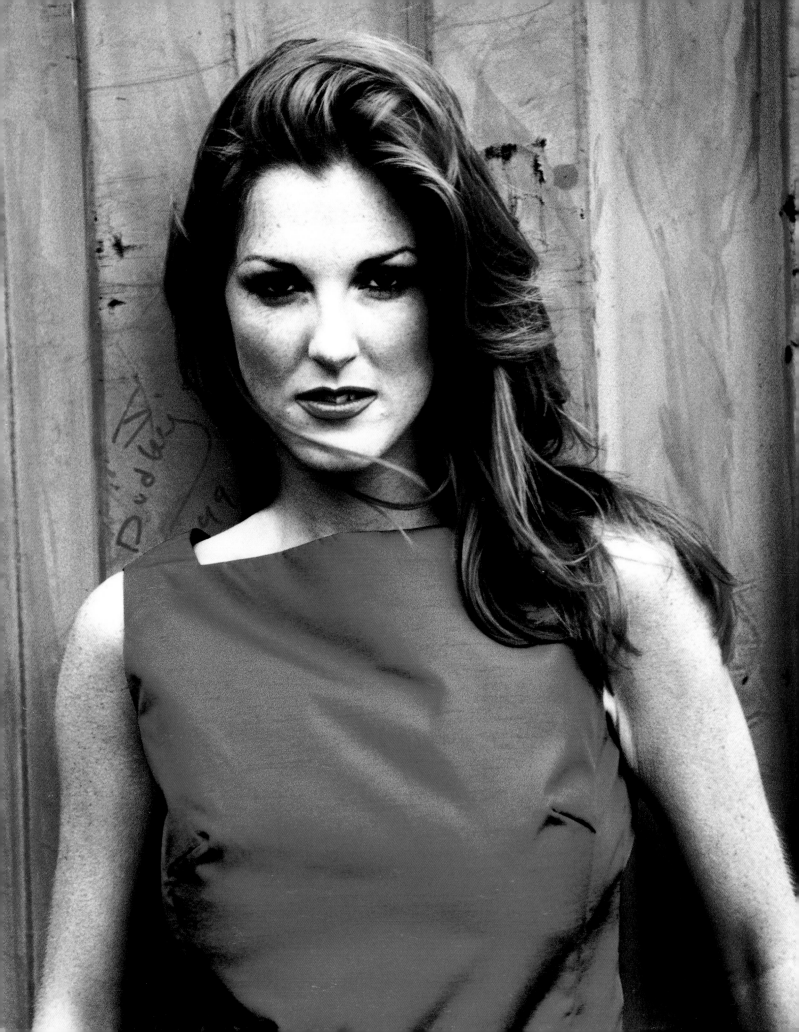

'Having taken a series of shots in the studio for use on the model's index card, I decided, as I often do, to include some pictures taken on location.' Stone wanted a gritty, contemporary feel to the images, and so chose a bold, industrial setting, saying, 'I wanted the model to come across as vampish and sexy but without the clothes being too overt, so I asked her to wear the green dress. The diffuse lighting of an overcast day was perfect, with soft shadows and a limited tonal range.'

'Contrasty light is unflattering in general for portraits, and is especially unsuitable when cross-processing, which increases contrast further. I knew that when the transparency film had been cross-processed in C41 chemicals the colours would be even more vivid. Sometimes I use reflectors or a little fill-in flash when working outdoors, but on this occasion I didn't judge it to be necessary.'

- (👤) Keeley Stone
- (➰) Catwalk
- (◉) Model index card
- (📷) Nikon F-801
- (◎) 28–200mm zoom (at 200mm)
- (▣) Ektachrome E100VS
- (◷) 1/250sec at f/8
- (💡) Available light outdoors
- (👤) Zoe Everett

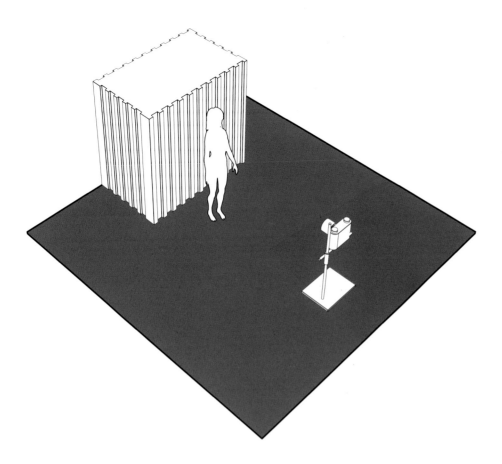

plan view

cross-processed model

When putting together a varied portfolio of pictures for a model, it's worth including a series taken outdoors using daylight.

practical tips

45

* Using an 81B warm-up filter gives the shot a golden appearance
* If the sun is shining, you can always find less contrasty illumination in the shadow of a building or under the cover of trees
* Reflectors or fill-in flash can be used to brighten subjects in heavily overcast conditions

'Sand is more into creating an image than showing the clothes – which is very nice for the photographer. My aim was to create an ambience, a mood, an atmosphere', says Bjarnhof.

While this arresting image owes much of its appeal to the attractive models and the tight composition, the lighting was also an important factor in its success. It was taken on a beach in Portugal very late in the day, just before the sun slipped below the horizon. The photographer was standing with the sea immediately behind him, and the couple are looking out towards it. The light in this kind of situation is very flattering: the weak sun creates a catchlight in the eyes without the models having to squint, and the large area of water acts like a huge natural reflector, softening the shadows. Because the existing background was confused and potentially distracting, a white board was erected behind the subjects. To make sure all of each face was in focus, an aperture of f/16 was used.

- Morten Bjarnhof
- House of Sand
- Catalogue/advertising/in-store display
- 6 x 7cm
- 165mm + extension tube
- Kodak T400CN
- 1/125sec at f/16
- Shadow side of wall
- Dean Kaufman and Helle Naested
- Louise Simony
- Portugal

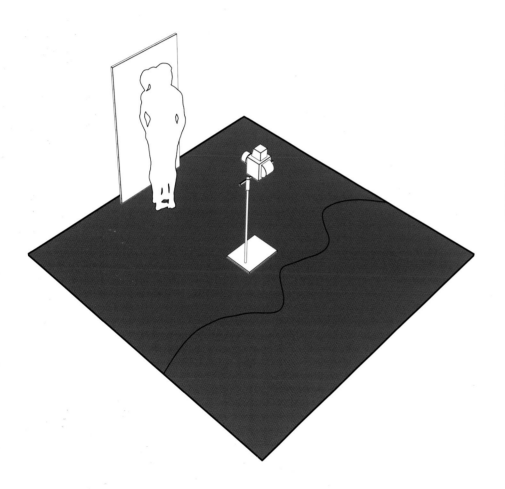

plan view

close couple

Using natural reflectors such as the sea is a great way of softening the light.

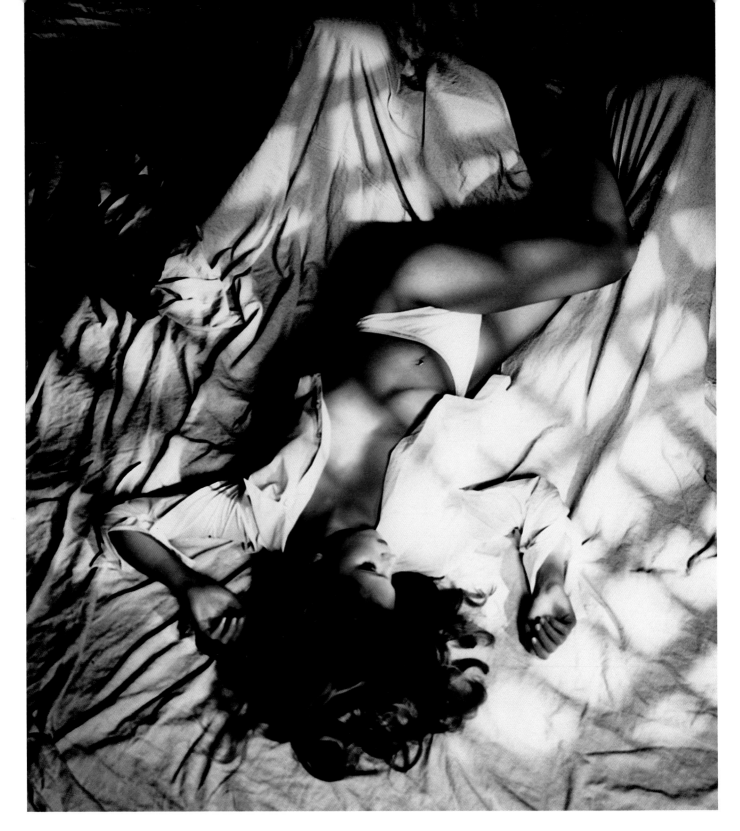

girl on bed

Creating a dreamy window light effect using a criss-cross grid.

'With this shot I'm trying to recreate a window light effect,' says Trenchard, 'a dreamy and slightly erotic moment with the girl maybe thinking about the night before. The model is lying on the floor, on a white backcloth, with her feet up on an armchair, and I'm photographing from a ladder looking down on her.'

'The window light effect is created by a criss-cross grid fitted over a mono spot around 4m away on the right-hand side. In addition, there's a spotlight illuminating the face, coming in from above right at the same angle as the head.'

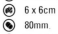

Peter Trenchard
Personal project
6 x 6cm
80mm
Kodak EPN 100
1/250sec at f/5.6
Electronic flash

plan view

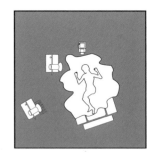

cross-processing technique

'When cross-processing it's important not to let too much flesh fall into shadow, because it can really clog up and lose detail. You're better to overexpose than underexpose, that's why I used a spot to light the face.'

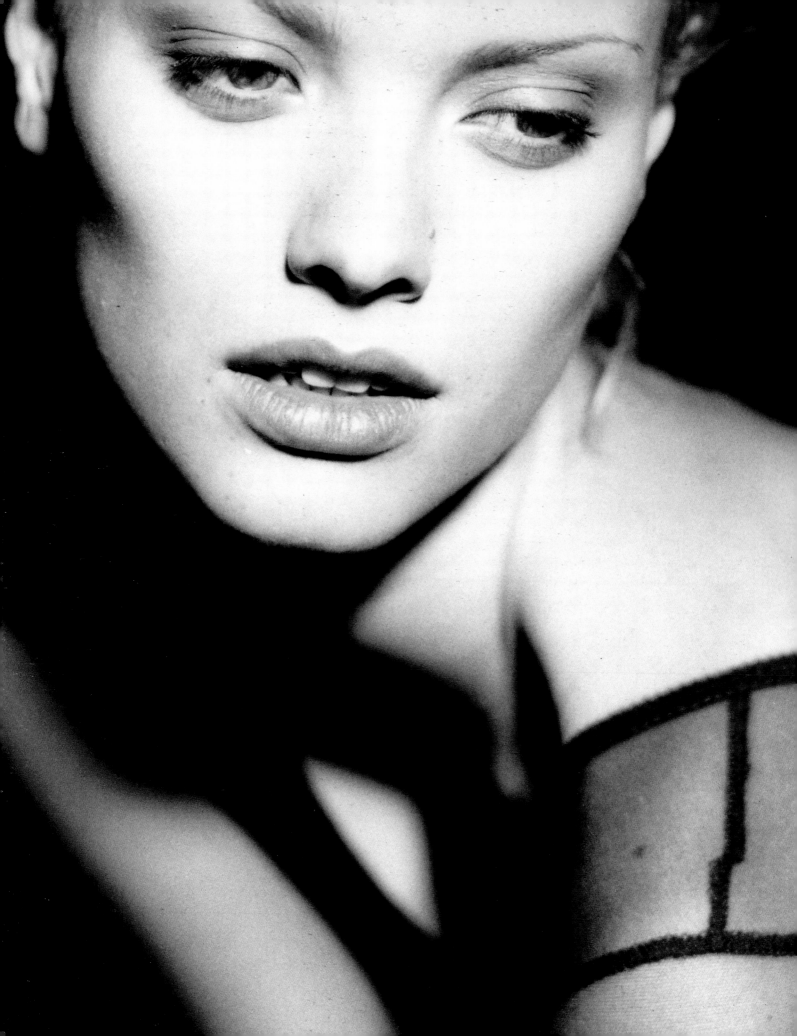

one light wonders

long hair

When images are to be manipulated digitally, it's important to light the main subject as well as possible.

'This picture was shot in two parts,' describes Spranklen. 'The model was photographed first with her hair tied back just to get the profile, and then again laying down so her hair fell down. The hair was then stripped in and enhanced in the computer.'

'The main shot was the profile, and for that I used a softbox off to the left-hand side and slightly high. As leather tends to soak up quite a lot of light I placed two large silver reflectors on the right hand side at 120 degrees to each other to bounce a lot back in. The background was just a block colour specified by the art director which was stripped in at the digital stage.'

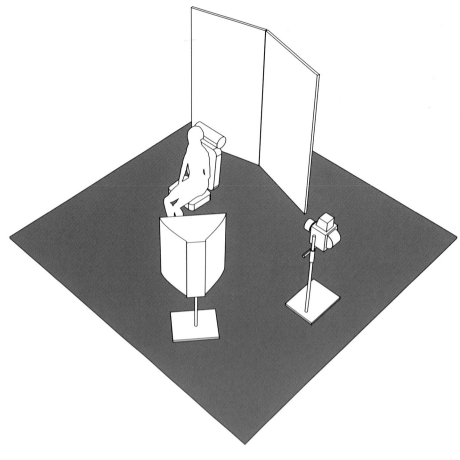

(A) Brian Spranklen
(~) BASF
(◉) Poster
(▦) 6 x 4.5cm
(◉) 150mm
(▣) Kodak Ektachrome E100S
(○) 1/60sec at f/11
(○) One main light
(◉) Vanessa Long, Nemesis
(◉) Alison Chesterton

plan view

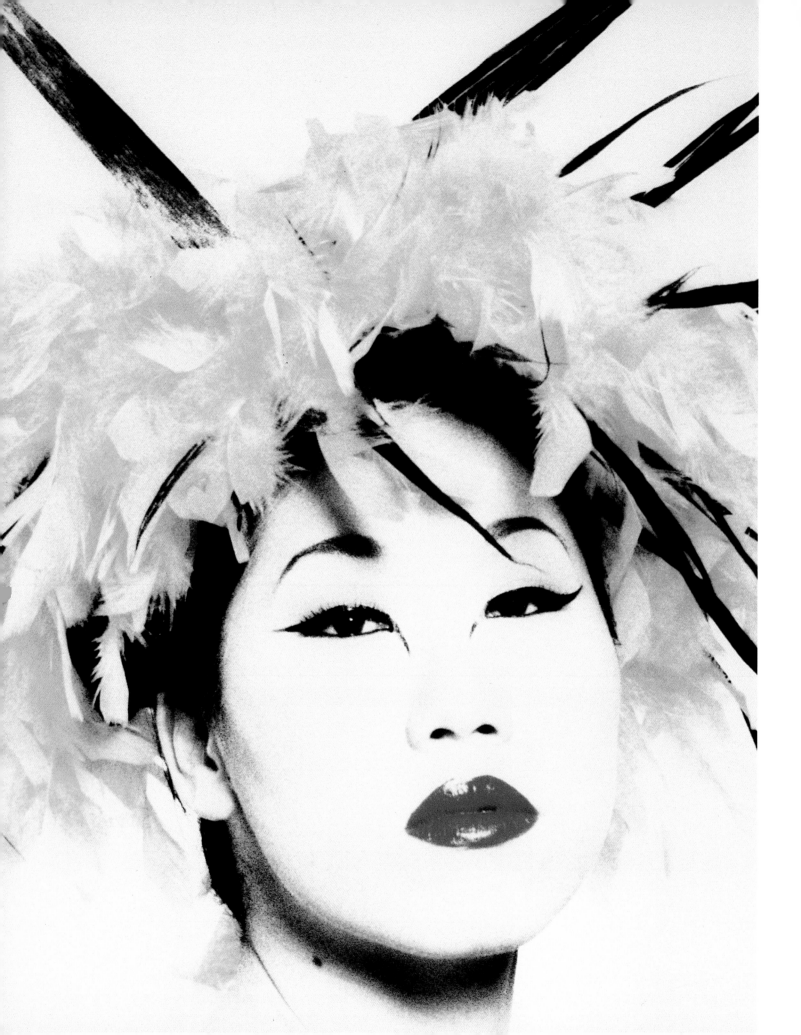

'The stark, clean quality of this image comes from using a single, heavily-softened light source close to the camera and about 0.5m above it. The make-up used, including having the hair pulled through the yellow hair band, enhances the effect; and the tungsten-balanced slide film was cross-processed to distort the colours and tones.'

- Nigel Tribbeck
- London College of Fashion
- Promotional shot
- 35mm
- 85mm
- Fujichrome 64T (cross-processed)
- 1/60sec at f/5.6
- Electronic flash
- Yukiko Shigeyama
- Christie Lee

plan view

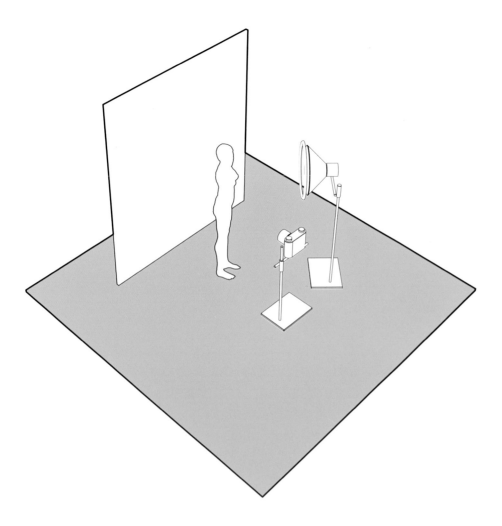

high-key image

A single light source from the front gives clean, simple lighting.

practical tips

* When cross-processing film you will normally need to up-rate it. An ISO 64 film, such as that used here, should generally be shot at ISO 125 or 200 – though you should bracket initially until you're more experienced in this kind of work

'Although this looks like a location shot it was taken in my studio.' Starkwell comments, 'The dramatic lighting comes from just one theatre-style spotlight about 3m from the subject. I knew the lighting had to be hard because the look is provocative and the model's dress is black rubber.'

🚶 Simon Starkwell
🎯 Personal promotion
📷 35mm
⬤ 80–200mm
▣ Ilford FP4
🕐 1/125sec at f/11
💡 One theatre-style spot
👩 Jenny Rata
🧑 Judy Keaton

plan view

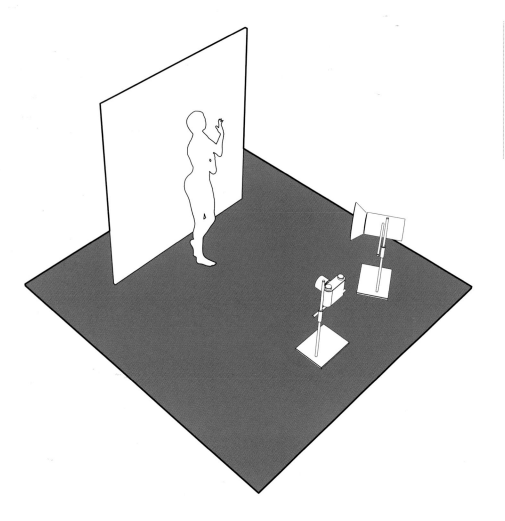

smoking model

Using a theatre-style spotlight produces an effect like a film still.

creating a convincing backdrop

'All these posters were specially made and pasted onto boards to create the backdrop. All say the same thing. I didn't want all the words to show, so you'd have to guess what some of them were. I wanted a bit of mystery.'

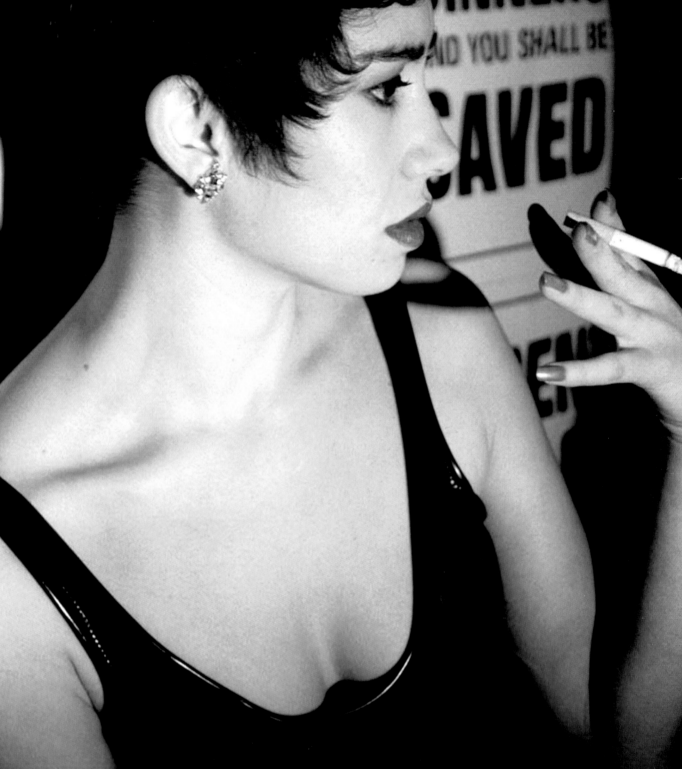

'The lighting for this shot is really simple,' explains O'Byrne. 'There's just a single softbox to the left of the camera and angled down at 45 degrees, plus an 8 x 4ft reflector over on the right-hand side, just slightly filling in the shadow areas. Later I noticed that the model bore some resemblance to a bull and decided to add the horns and sky background digitally to create an image of Taurus.'

Ⓐ Vinnie O'Byrne
Ⓔ Personal promotion
Ⓕ 6 x 4.5cm
Ⓖ 150mm
Ⓗ Kodak Plus-X
Ⓘ 1/60sec at f/8
Ⓙ Softbox and reflector

plan view

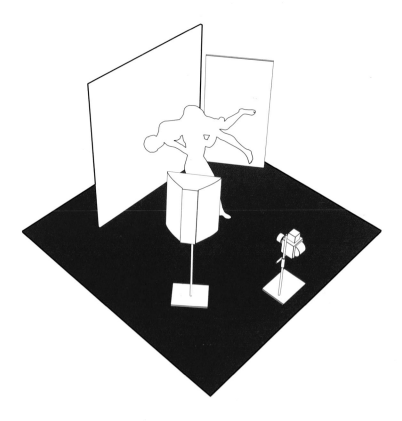

taurus

Simple 45 degree lighting provides the basis for a stylish digital image.

practical tips

* Replacing the background digitally is easier if it's of a uniform tonality, and replacing a dark colour is most straightforward.

Lighting of this kind will forever be associated with Hollywood in the 1930s and '40s, although it's just as effective today as it was then. The secret, if you can call it that, is to use a spotlight with barn doors to limit the lighting to the subject and avoid background spill. Traditionally, hard-edged tungsten lighting was used for this kind of work, but flash works just as well, providing you don't soften it too much.

practical tips

* A black background ensures that the model stands out well
* Overexposing by around 1–2 stops helps burn out any imperfection in the model's complexion

* Frank Wartenberg
* Personal promotion
* 35mm
* 105mm
* Fuji Velvia
* Not known
* Electronic flash
* Franziska K.
* Uta Sorst
* Bert Spangemacher
* Karin Gade

plan view

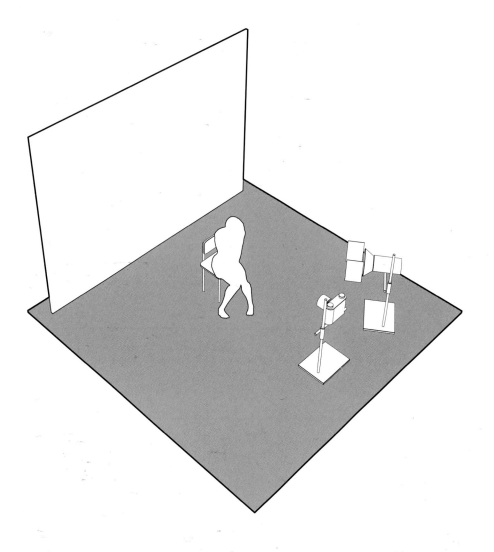

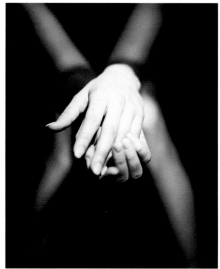

Another image from the same shoot – pictures don't always have to include the face.

franziska k

One spotlight is all you need for dramatic 'Hollywood' lighting such as this.

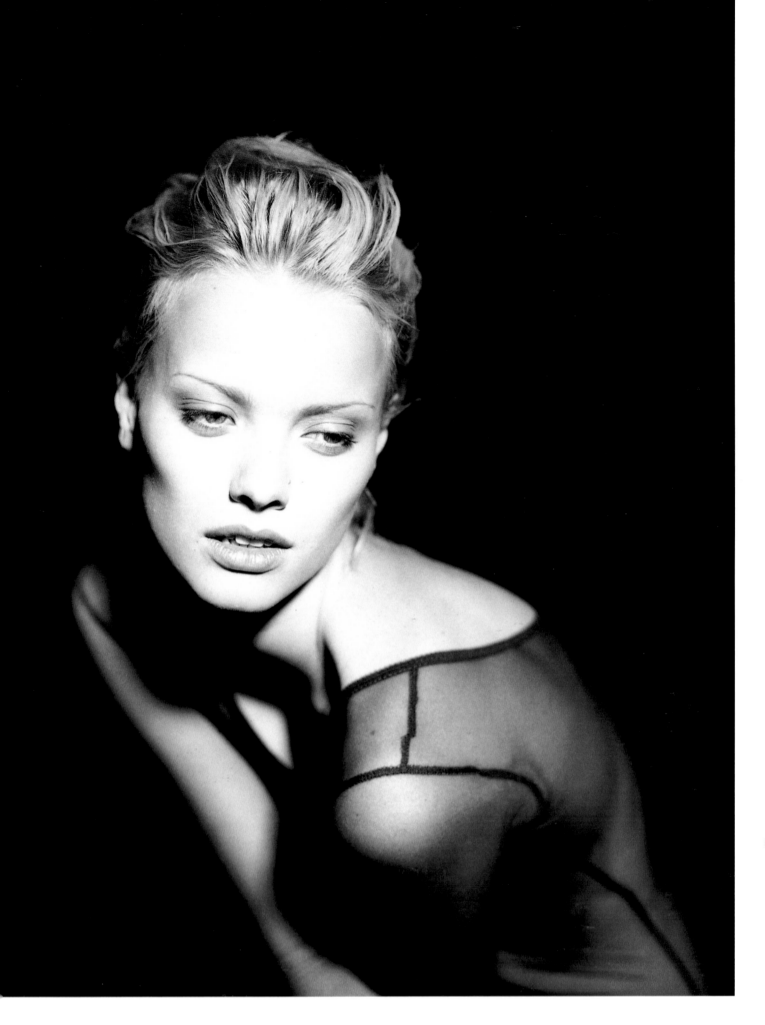

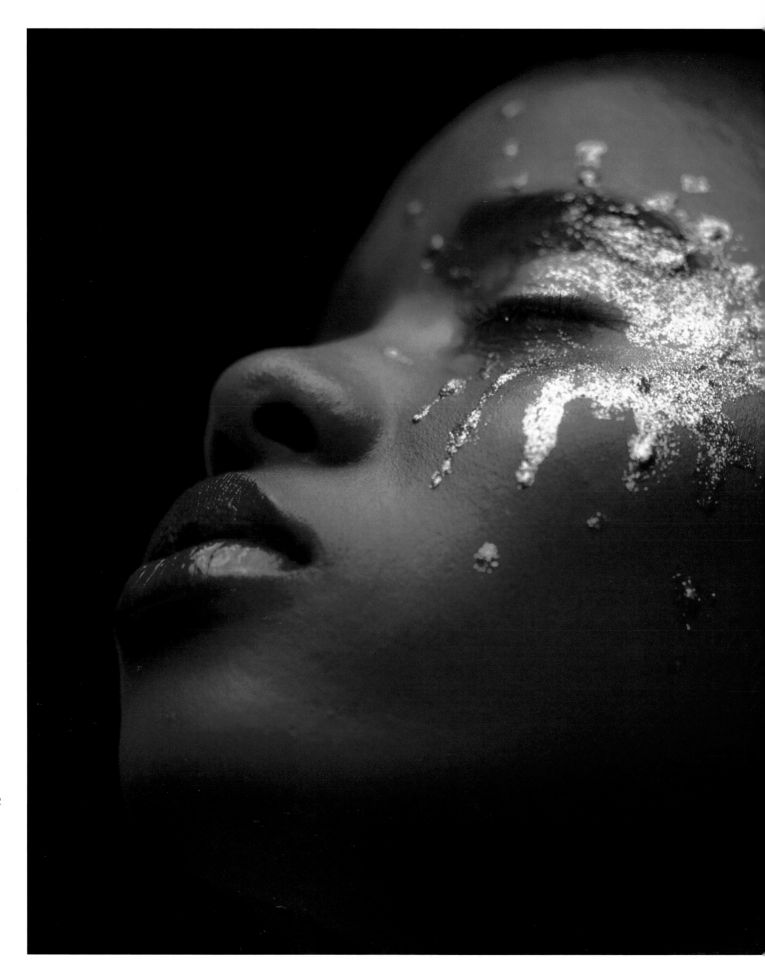

Although the lighting in this shot is very simple (only one light was used), the precision required for the placement of each element demonstrates a high level of skill. The model is holding a white reflector beneath her chin, and this is bouncing fill light under her chin and onto her cheeks. The flash head has a blue gel fitted and is positioned directly over her face. This light reflects in the artfully applied silver make-up which suggests a spontaneous splash of liquid that highlights the eye and cheekbone. The camera is medium format, so as to capture the level of detail required for the impactful close crop. Finally, the black cloth background is left unlit to prevent any distraction.

- Frank Wartenberg
- Foto magazine cover shot
- Editorial
- 6 x 7cm
- 110mm
- Kodak EDR 64 ASP
- 1/60sec at f/16
- Electronic flash
- Titiana
- Gesa Mähler
- Georg Bechstädt
- Studio
- Anja Pagel

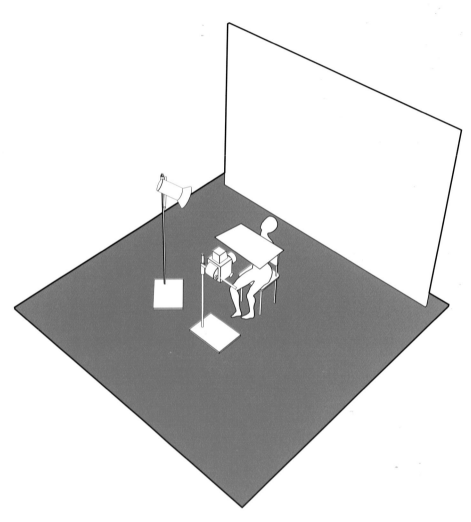

upturned face

The deceptively simple lighting of this shot belies the skill of all involved in its production.

plan view

63

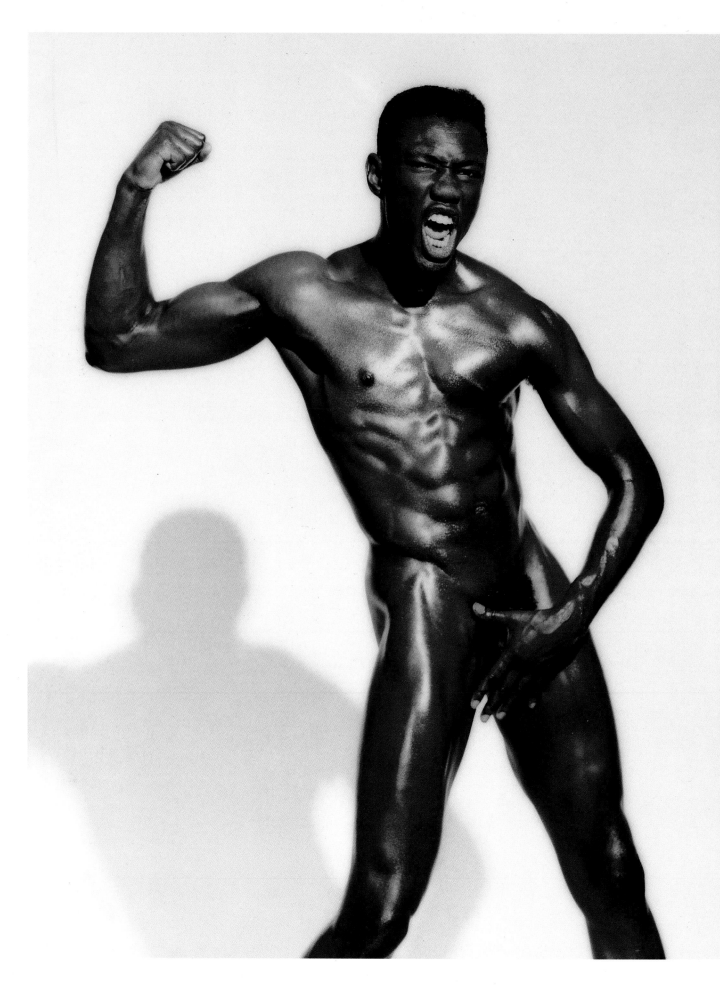

'I wanted to accentuate this guy's athleticism', Yerbury explains, 'and so I used just one light placed at 45 degrees to the right, this was a 1000 watt spotlight about 2.5m away. As well as casting a distinct shadow, the harsh directness of the lighting throws the muscular physique into sharp relief, and complements the aggressive pose. After printing it on Kodak Ektalure paper I selenium-toned it, which gives the rich, warm colouring.'

Trevor Yerbury
Personal project
Hasselblad
150mm
Kodak T-Max 100
1/60sec at f/5.6
Tungsten spotlight

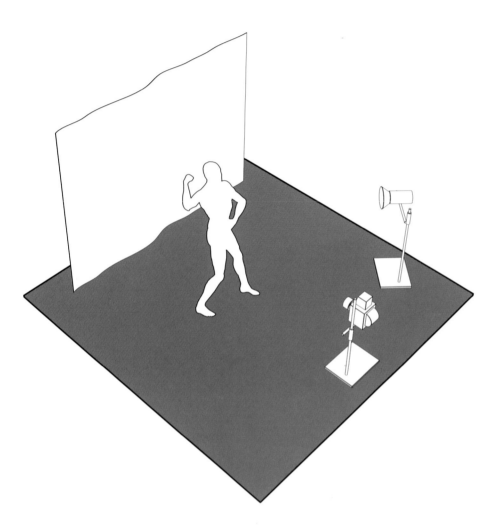

plan view

dramatic lighting

Sometimes one light is all you need, especially if you are after a dramatic image.

Spranklen began by photographing the model and the hand-painted backdrop together, but to give as many options as possible the two were also shot separately – in the end the two individual images were stripped together to give the final composition.

Spranklen comments, 'the model is lit with just one light, a Bron "Fluter", a kind of spotlight which gives a harder illumination. We wanted just one directional light, but rather than a standard beauty approach we also wanted distinct shadows. As it was flash, we put a half tungsten gel over it to warm it up. The background was photographed with even illumination, scanned in and then had the colour and saturation boosted, finally blur zoom was added.'

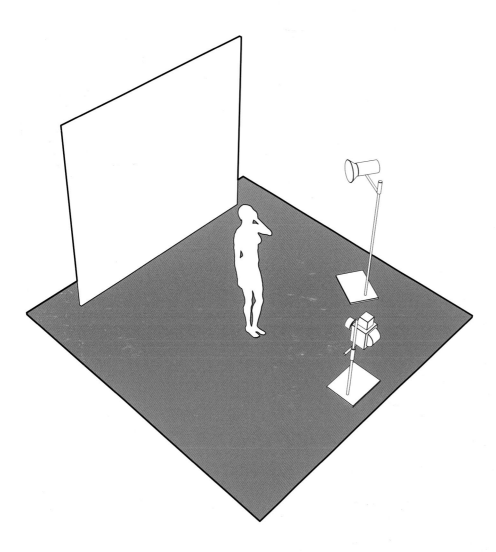

zoom girl

Photographing the model and backdrop separately gives increased creative versatility.

Brian Spranklen

BASF

Poster

6 x 4.5cm

150mm

Kodak Ektachrome E100SW

1/60sec at f/8

Electronic flash

Vicky Wiltshire, Nemesis

Alison Chesterton

plan view

'This girl was originally photographed in a square box, with her hand on the corner of the box, and the camera directly above her. The image was then combined with the rock and the water swirl in the computer. The lighting for the model comes from a larger softbox to the left and slightly above her, so as well as hitting her face it's sweeping across her back and catching her bottom as well. There are also two reflectors, one either side of her body.'

🚶	Vinnie O'Byrne
🎯	Personal work
📷	6 x 7cm
🔘	105mm
🎞	Kodak Plus-X
⏱	1/60sec at f/8
💡	Electronic flash

practical tips

* People say softboxes are flattering, but they are cruel in the fact that they pick up every flaw. Hard lights tend to burn out imperfections and are often better for photographing beauty.

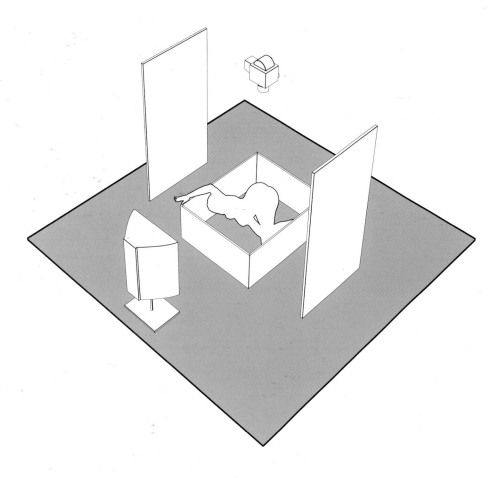

eurus

When you're putting together a digital composition, the elements need careful lighting first.

plan view

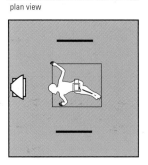

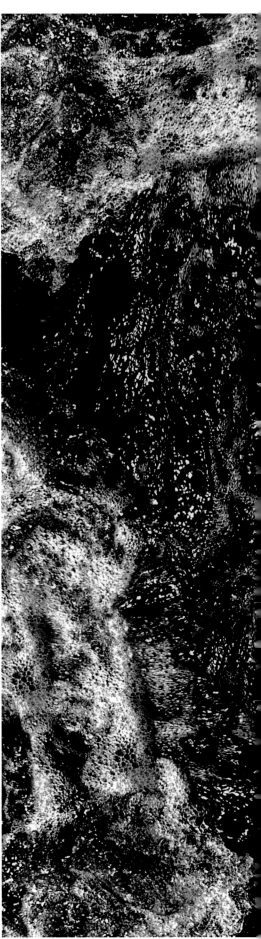

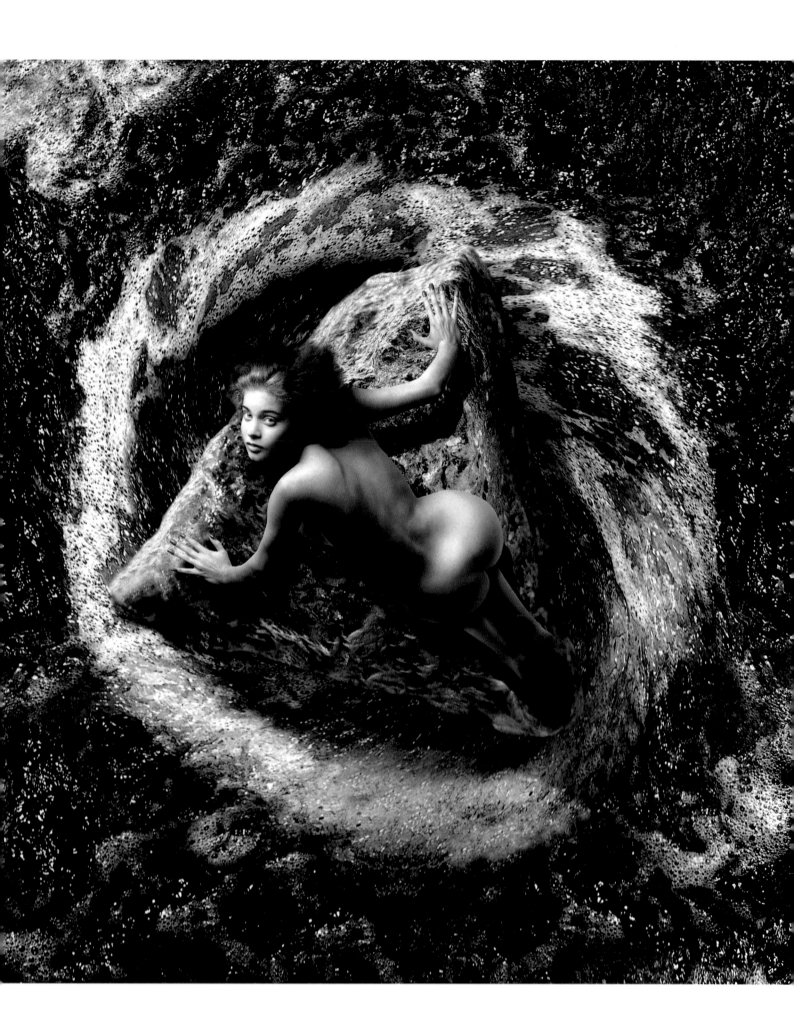

Tribbeck comments, 'a lot of my pictures are taken with just one light, fitted with a big dish reflector. For variation I place different things across the front of the dish, such as bits of cloth and filters. I find the result a little similar to a ringflash but more versatile and controllable.'

'For this profile shot I didn't want any strong shadows, so the light is to my right and just above me, less than 1m from the model. I often use a standard 50mm lens, and tend to go in close with it – so I'm only about 0.5m from the model as well. The slide film I used was cross-processed in C-41 chemistry, and the resulting negative given heavy filtration to produce the final image.'

- Nigel Tribbeck
- London College of Fashion prospectus
- Editorial
- Canon F1
- 50mm
- Agfa RSX 100 (cross-processed)
- 1/60sec at f/5.6
- Electronic flash
- Becky Rule

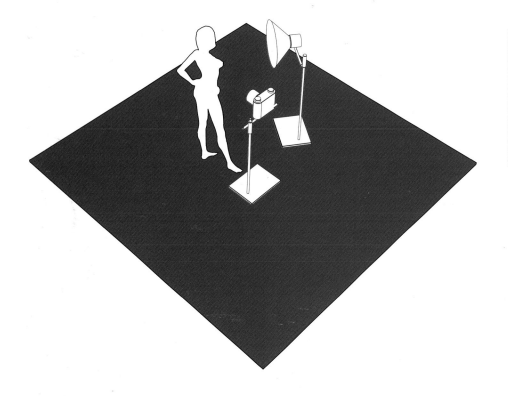

plan view

pink bob

Just one light close to the model gives a soft and shadowless result.

practical tips

* Going in close with a standard lens and shooting with a large aperture limits depth of-field. This controls where the zone of sharpness falls and concentrates attention on just part of the subject

passive resistance

Just one overhead softbox supplemented by reflector boards provides even illumination.

(人) Vinnie O'Byrne
(◉) Personal work
(▥) 6 x 4.5cm
(◕) 150mm
(▣) Kodak Plus-X
(○) 1/60sec at f/8
(◔) Softbox and reflectors

'I was working with the two models, playing around with shapes, and this image just evolved,' says O'Byrne. 'The girl that's grabbing isn't really grabbing, and the girl that pushing away isn't really pushing away – hence the title "Passive Resistance". The lighting comes from a softbox above and slightly in front, giving even illumination. There are white boards to the front and side to fill-in the shadows.'

chemical emulsion lift

'Once I'd made a black & white print I employed a chemical emulsion lift, which blisters the dark areas so they float above the image in the dish. You can put your fingers in and rub it around to help it along – if you look carefully at this image you can see the marks made by my thumb. The chemical bleaches the image and creates a kind of negative effect, but if you then put the print into a toner it brings the image back up. For this shot a blue toner was used.'

plan view

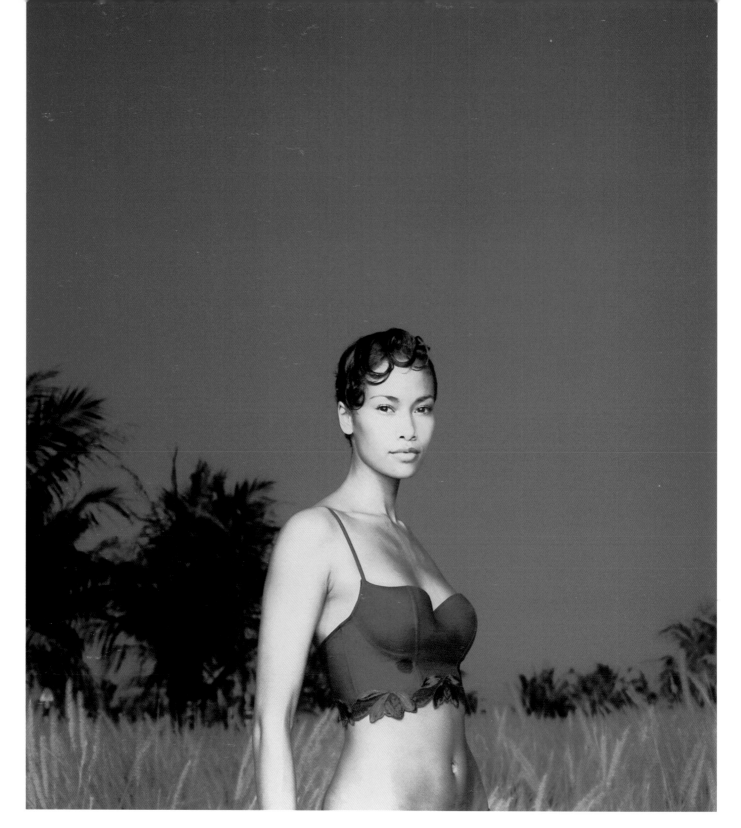

blue bikini

Two softboxes supplement daylight for a stunning image.

This shot looks as if it might have been taken at night, but that's just an illusion. In fact, it was taken on a sunny day, contre-jour, but by lighting the model with flash and reducing the exposure this beautiful twilight effect has been achieved. The two softboxes are side by side over the camera, illuminating the model evenly.

practical tips

* Even in the middle of the day it's possible to produce a night-time effect by the way you balance the flash and ambient exposure

(symbol) Frank Wartenberg
(symbol) Otto magazine
(symbol) PR
(symbol) 6 x 7cm
(symbol) 90mm
(symbol) Kodak 100VS
(symbol) Not known
(symbol) Flash/daylight

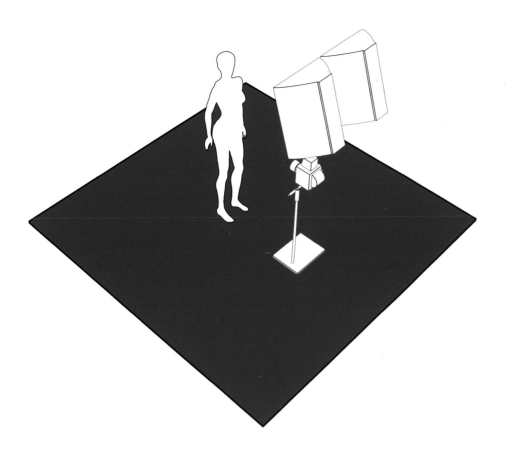

plan view

girl in a box (over)

Lighting simplicity is the key to this stylish shot.

'Generally I like to keep things simple in the studio', Trenchard explains, 'and this shot is lit by just one square softbox over to the right-hand side about 2.5m from the subject. The box has been raised slightly off the ground and the light is slightly above the level of the box. As a result, the light wraps around the model, producing shadows that are distinct but not too heavy.'

(symbol) Peter Trenchard
(symbol) Model portfolio for dancer
(symbol) Hasselblad
(symbol) 80mm
(symbol) Kodak T-Max 100
(symbol) 1/250 seconds at f/8
(symbol) One softbox

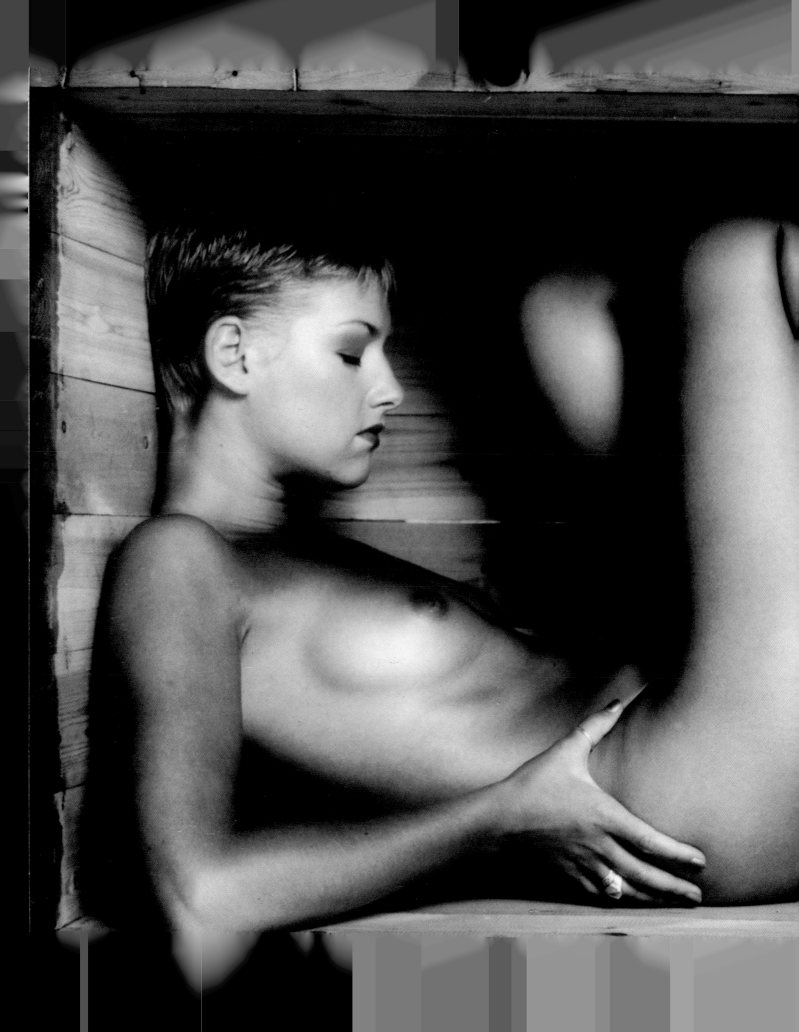

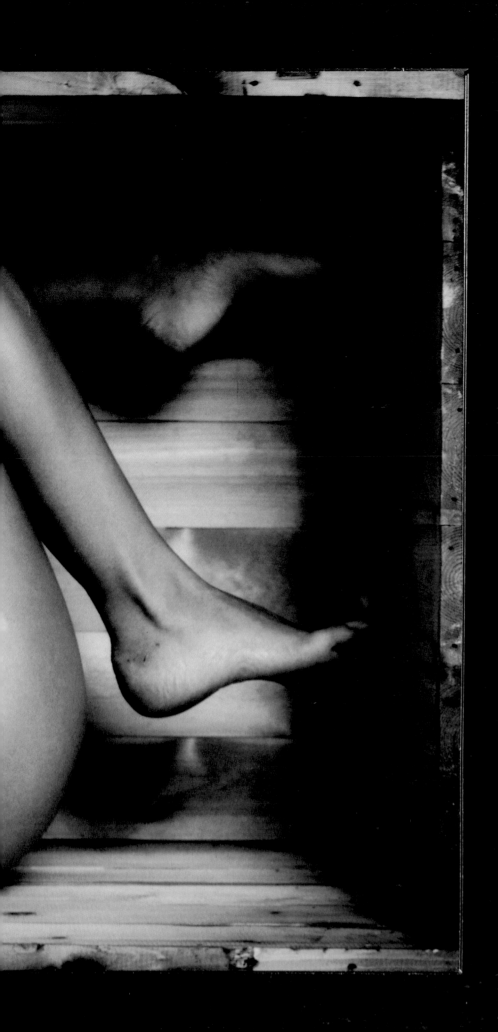

practical tips

* When trying out experimental techniques such as using infrared or cross-processing, it's a good idea to bracket your exposures, i.e. taking a series of images at exposures above and below what you believe to be correct
* When using infrared film, you either need to refocus using the infrared scale on the lens or set a small aperture with increased depth of focus

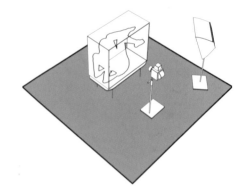

plan view

dynamic duos

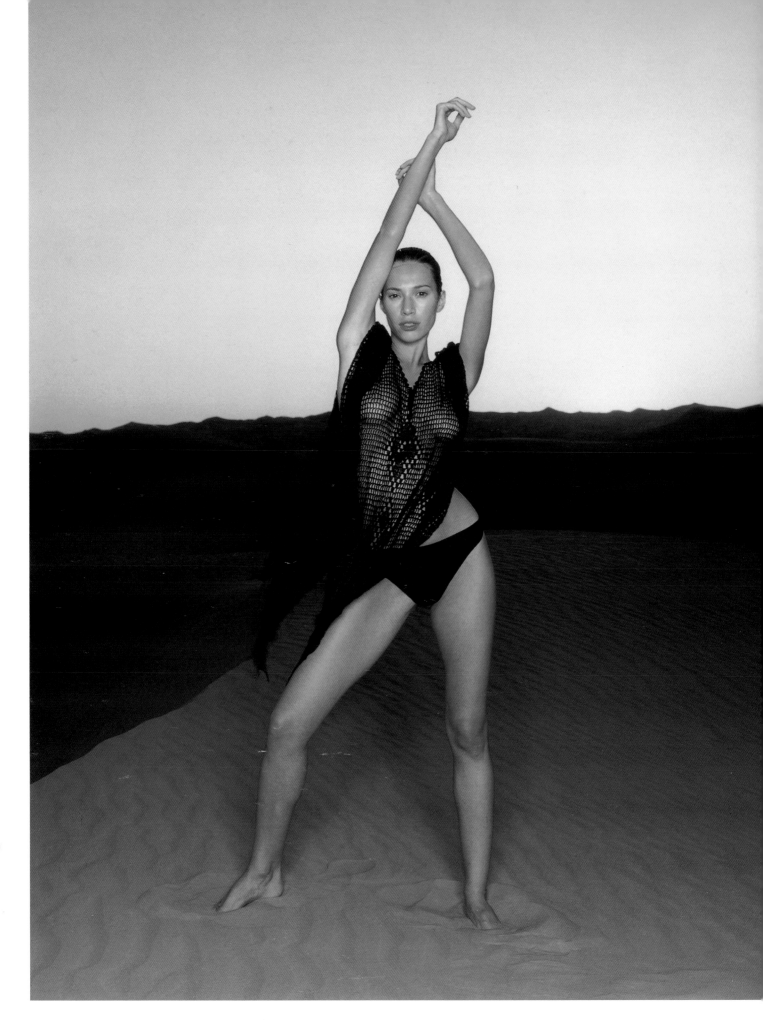

The delicate colours of the twilight sky after the sun has set over the desert provide a fabulous backdrop for this striking image – with the pose wonderfully connecting the upper and lower parts of the image. For balanced fill and even illumination on the model, two flash heads fitted with softboxes were placed side by side above the camera.

- Frank Wartenberg
- Personal promotion
- 6 x 7cm
- 110mm
- Fuji Velvia
- Not known
- Flash/daylight
- Ivona, Model Werk
- Uta Sorst
- Malte Bartjen and Georg Bechstädt
- Desert in Dubai
- Edwin Kaufmann

plan view

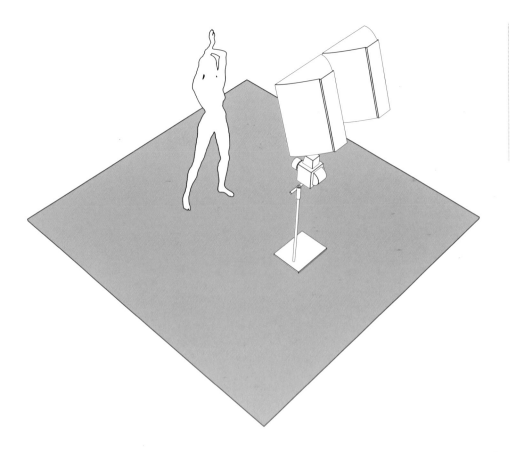

desert light

Two softboxes provide flash fill-in against a setting sun.

practical tips

* Photographers are generally advised not to place the horizon across the middle of the picture, as the result is often static, but here it works well because the model cuts across the two areas

82 dance

Tall neon light provides simple but dramatic lighting.

Simple lighting doesn't have to be dull – as this impactful image clearly demonstrates. The light in question is a neon strip to the left placed as close to the model as possible without being seen by the camera. The result is burnt out highlights and deep shadows, which gives a wonderful feeling of shape and form. The effect was enhanced by the cross-processing of the film. A second light on the shiny red background offers a welcome horizontal band of brightness.

- ☿ Frank Wartenberg
- ☺ Max magazine
- ◉ Editorial
- ▦ 35mm
- ◐ 105mm
- ▣ Kodak EPR (cross-processed)
- ◷ Not known
- ◉ Mixed lighting
- ◉ Daniela Nourega
- ◡ Uta Sorst
- (⚐+) Malte Bartjen
- ⬚ Betty Amrhein

plan view

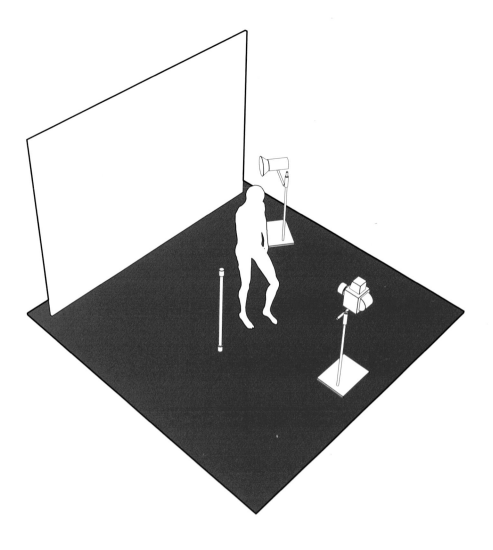

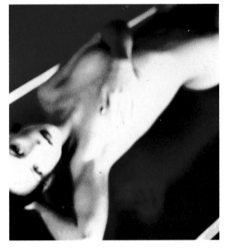

practical tips

* While sharpness can sometimes be important, the overall mood often contributes more to the success or failure of an image

* Asking the model to dance creates a controlled degree of blur which adds to the atmosphere and prevents the image looking too static and controlled

Taken during the same session, this picture features the model on a Plexiglas table top, with the main lighting coming from an HMI source to the right supplemented by the neon strip further round to the right.

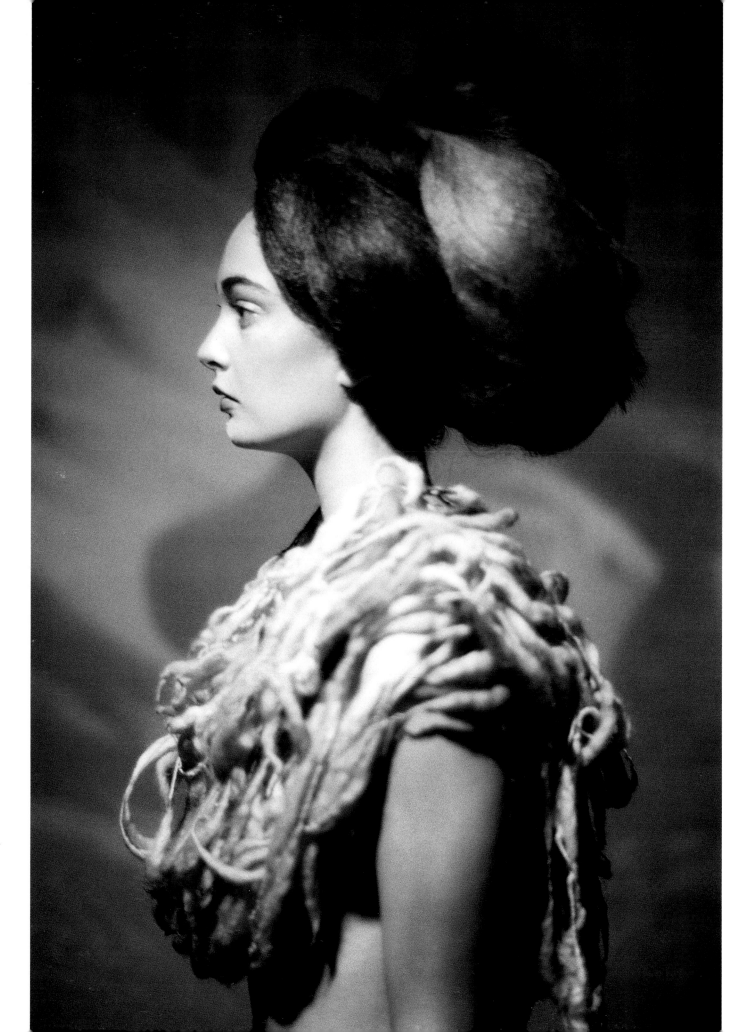

Two softboxes facing each other provide the illumination for the model – with one set to half the power of the other to stop it looking too even and bland. Both are slightly higher than the model, throwing shadows downwards. The background is just a plain white paper roll lit by one light, but to add interest Tribbeck placed branches in front of the light. He uses all sorts of things in this way, to make the background more appealing.

on reflectors

'I don't use many reflectors in my work,' comments Tribbeck, 'I prefer to bring in another light to control the ratios accurately.'

- Nigel Tribbeck
- Agfa
- Test shot
- 35mm
- 50mm
- Agfa Scala 200X
- 1/60sec at f/8
- Electronic flash
- Youn Ju Nam

plan view

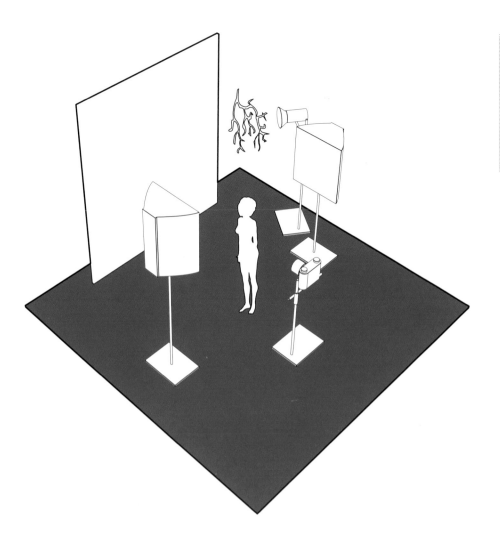

big hair

Two softboxes provide the lighting structure for this timeless portrait.

film focus

Agfa Scala 200X is the only black & white slide film commercially available – though it is possible to produce transparencies from any monochrome film with appropriate processing.

The model is illuminated by just one light, which was positioned a little above the model's head, angled to point directly down at her. A diffusion filter gives it a wider spread and softens it slightly. A second light positioned behind the model and to the right gives some gradation across the grey background.

The 'soot and whitewash' effect comes largely from using a naturally contrasty film – and overexposing it by 1 stop to bleach out the skin tone, reduce the shadow from the nose, and give the eyes and lips more emphasis.

- Nigel Tribbeck
- Wella
- PR
- 6 x 6cm
- 120mm macro
- Agfa Ortho 25
- f/4 at 1/60sec
- Electronic flash
- Melissa Galliger
- Christie Lee

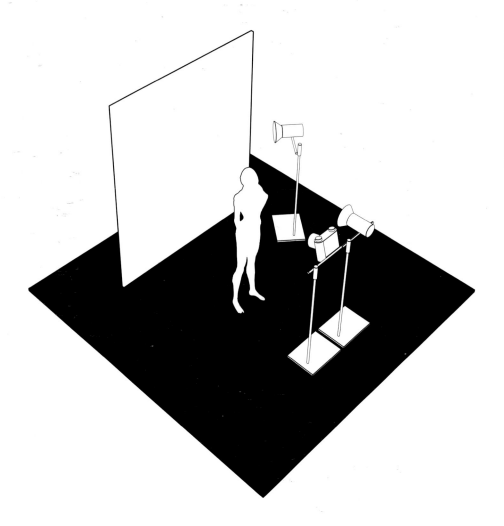

plan view

white face

Just one subject light produces directional illumination suitable for use with a contrasty film.

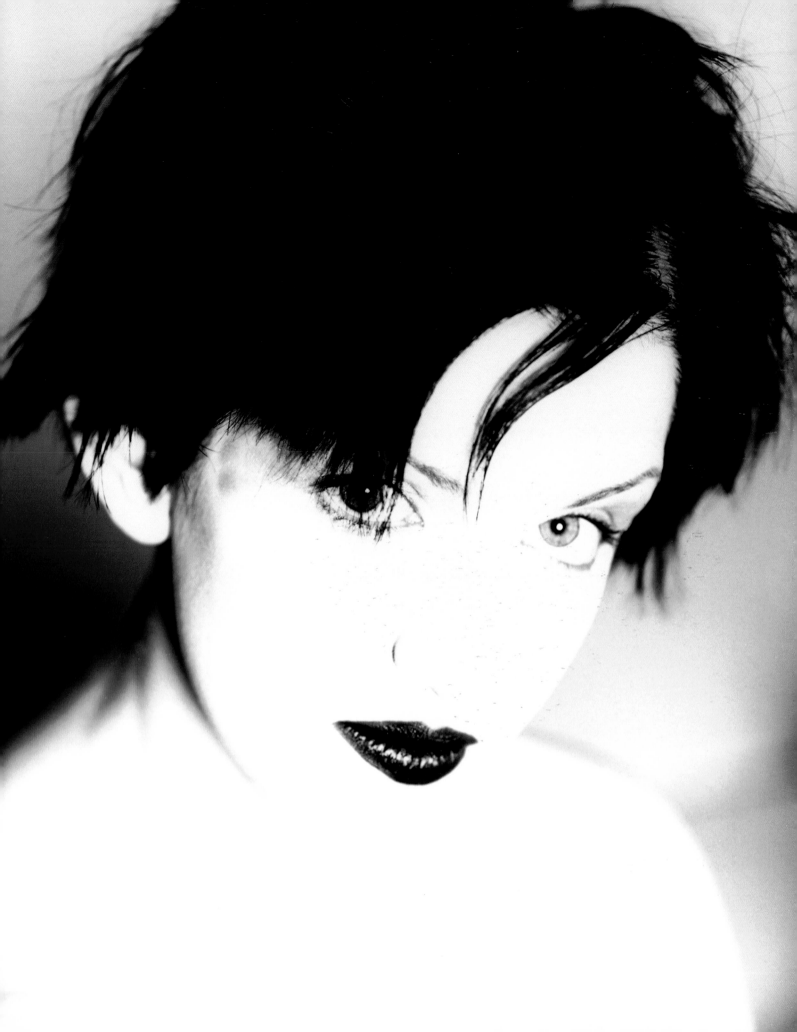

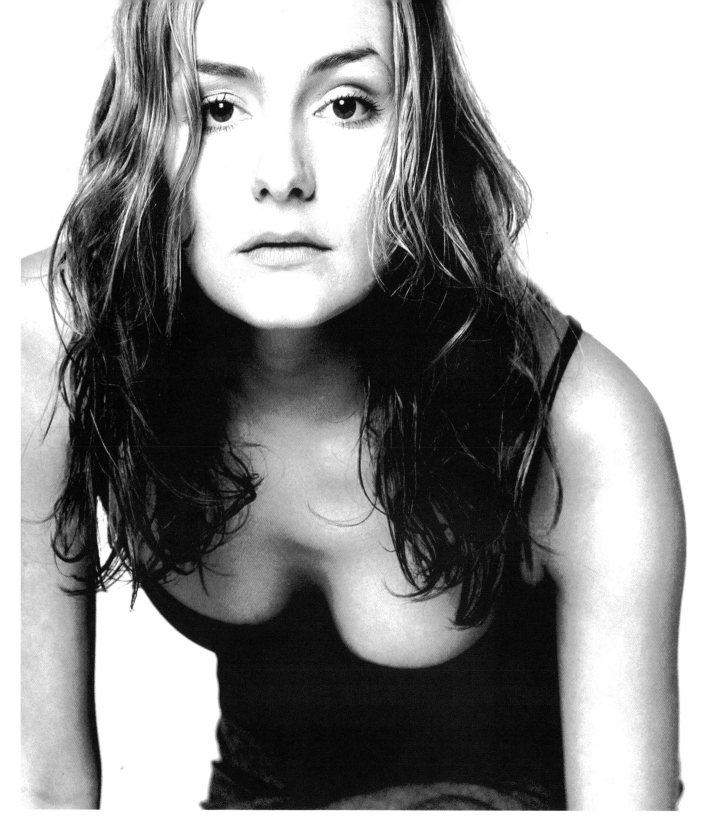

desaturated model

Standard beauty lighting provides a strong basis for digital enhancement.

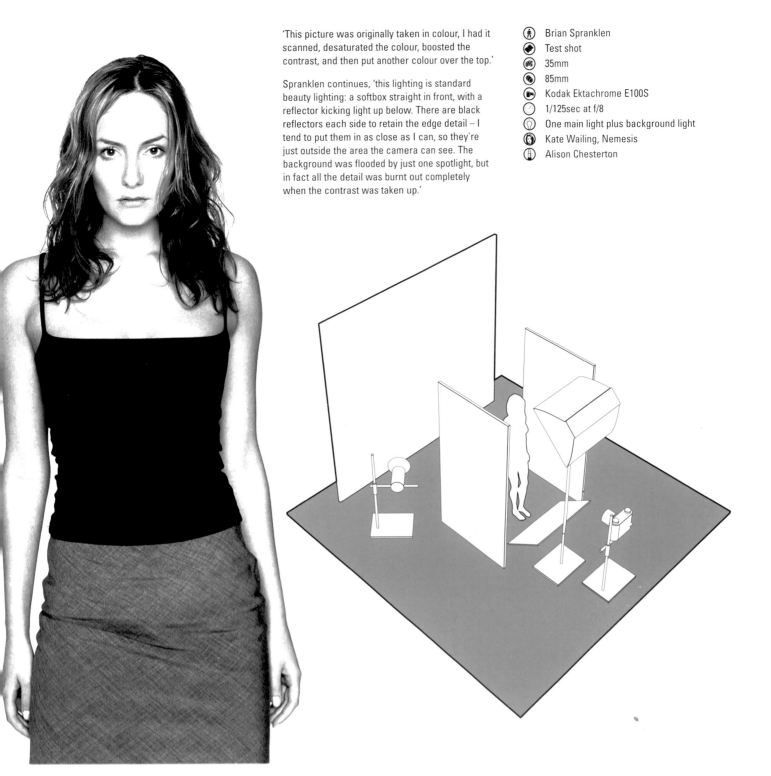

'This picture was originally taken in colour, I had it scanned, desaturated the colour, boosted the contrast, and then put another colour over the top.'

Spranklen continues, 'this lighting is standard beauty lighting: a softbox straight in front, with a reflector kicking light up below. There are black reflectors each side to retain the edge detail – I tend to put them in as close as I can, so they're just outside the area the camera can see. The background was flooded by just one spotlight, but in fact all the detail was burnt out completely when the contrast was taken up.'

⊕	Brian Spranklen
◉	Test shot
🎞	35mm
◎	85mm
⊕	Kodak Ektachrome E100S
⏱	1/125sec at f/8
☉	One main light plus background light
⊙	Kate Wailing, Nemesis
⊡	Alison Chesterton

black reflectors

Although they sound like a contradiction in terms, black 'reflectors' are essential tools in fashion photography, allowing light to be sucked out of certain areas, and helping to define the shape of a model against a white background.

plan view

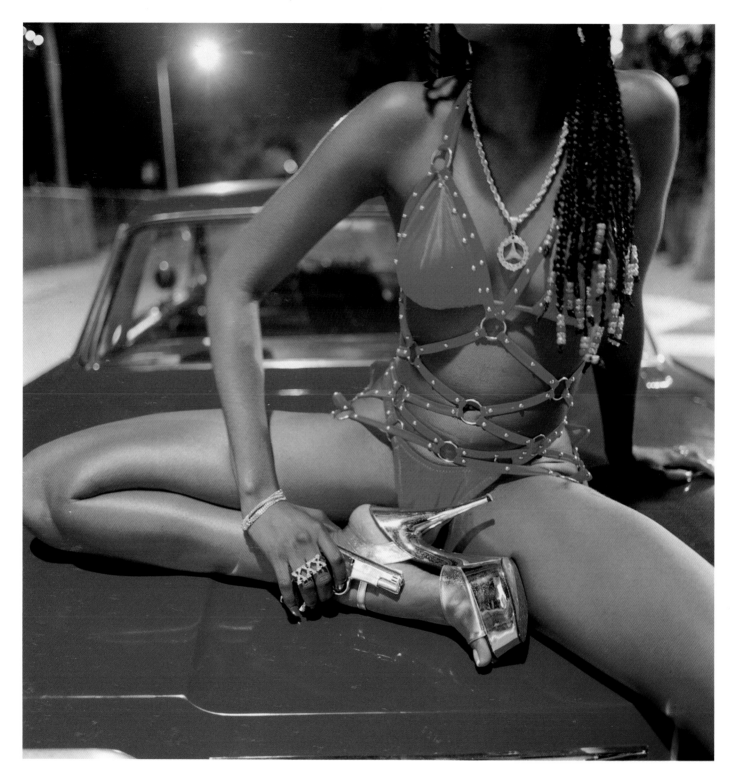

miami girl

The best way to use flash when supplementing ambient lighting is to enhance what's already there.

Many pictures that combine ambient lighting with flash look false because of additional lighting being different from what was there originally. Often the flash is too powerful or sometimes it comes from the wrong direction.

In these images of Miami, Jamil GS has got it just right. The model has been lit sufficiently to stand out, but not so heavily that the effect looks overdone. The direction of lighting is the same as the street lighting already there, and the result is therefore authentic and convincing. Two mains units were used, one either side of the girl, with the lighting ratio balanced towards the head on the right. Thus, this close up looks entirely natural.

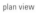

- Jamil GS
- Virgin records
- Promotional
- Hasselblad
- 60mm
- Kodak VHC
- Not known
- Flash/ambient
- Michelle
- Jason Farrah

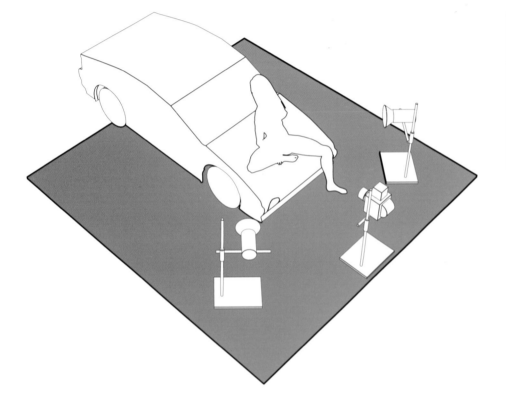

plan view

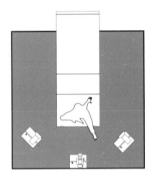

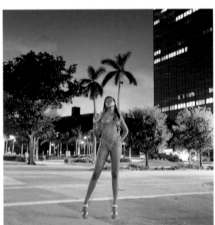

A long exposure was needed in order to record the background fully, including the lights on the glass-fronted building. This has resulted in the slight blurring of the palm trees and the model's feet.

91

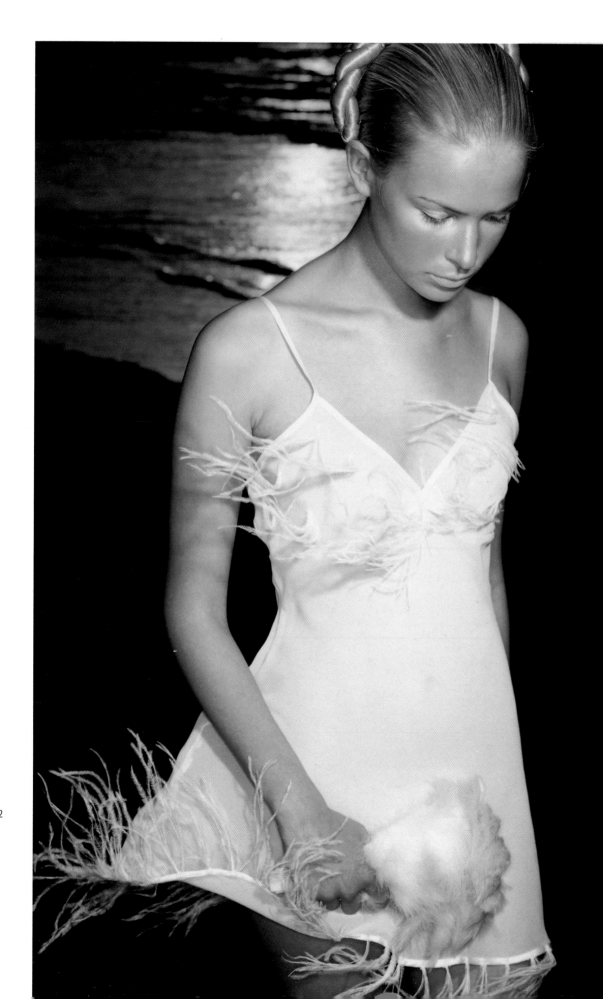

At first sight this looks like it may have been a studio shot, using back projection to provide the sunset and a wind machine for the movement in the dress. In fact it was shot on location at the end of the day, using two flash heads to illuminate the model.

The main light is a ringflash around the lens of the camera, this produces the characteristic shadows all around the body. The second light is a spot to the right which highlights the face and upper body, as well as giving the shadows from the fringe on the dress. Exposure was balanced, with a long shutter speed required to register the low light levels of the setting sun.

- Frank Wartenberg
- Foto magazine
- Editorial
- 6 x 7cm
- 90mm
- Kodak 100VS
- Not known
- Electronic flash
- Maria Nessen
- Uta Sorst
- Malte Bartjen and Georg Bechstädt
- Edwin Kaufmann

plan view

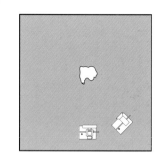

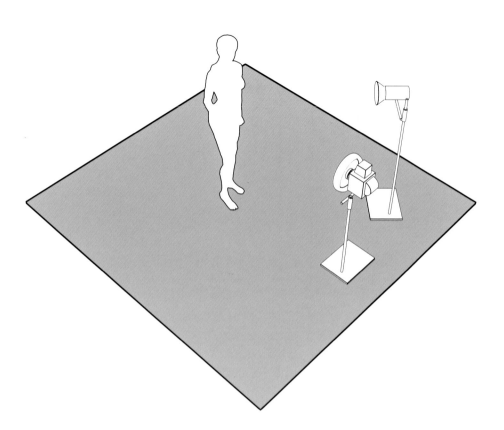

feathers in the wind

Two flash heads help produce studio-quality images on location.

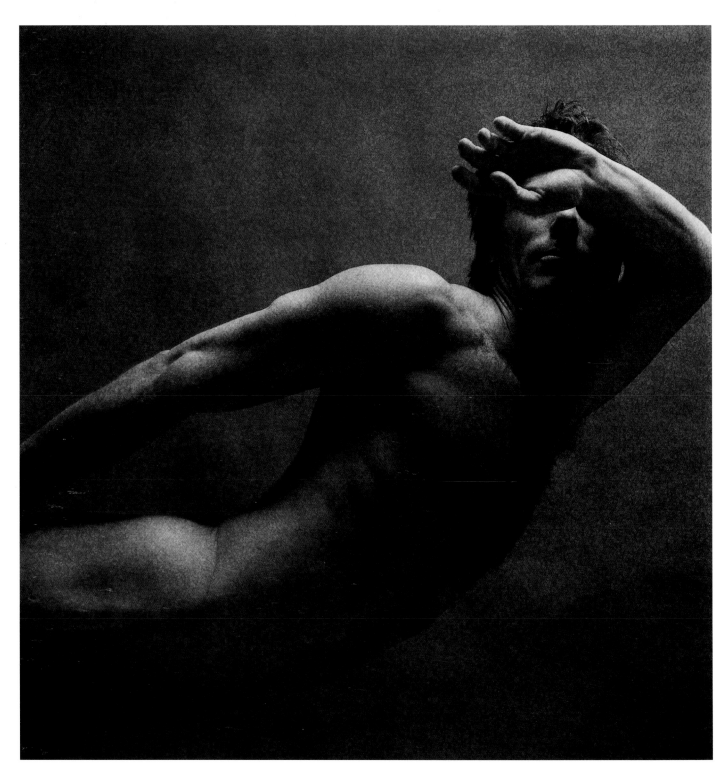

blue nude

Dramatic sidelighting makes the most of a sculpted body.

'This picture was taken as part of a series for a guy who is a personal trainer, and after we'd taken the shots he wanted he was happy to let me try out some of my ideas', says Yerbury. 'I wanted him to look as though he was going through water, so he's leaning back with his hand up to his head and his leg stretched out horizontally.'

'I used two lights, which are side by side on the right-hand side. There's a large softbox giving overall illumination, and a variable spotlight which is lighting just the face. There was another large softbox acting as a reflector on the opposite side, but it was not actually switched on. The lights are positioned about 0.5m above the model and pointing down.'

🚶 Faye Yerbury
☺ Rob Laurie
◉ Promotional
▣ 6 x 6cm
◉ 120mm
▣ Kodak T400 CN
🕐 1/60sec at f/8
💡 Electronic flash
👤 Rob Laurie

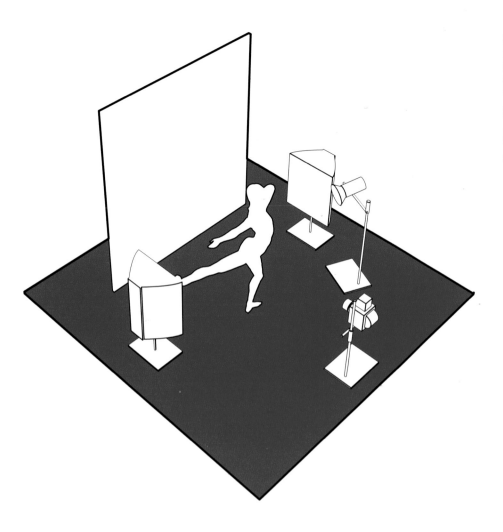

plan view

practical tips

* The textured effect comes from combining a piece of tissue along with the negative when making the print
* If you have two softboxes, one can be used as a reflector

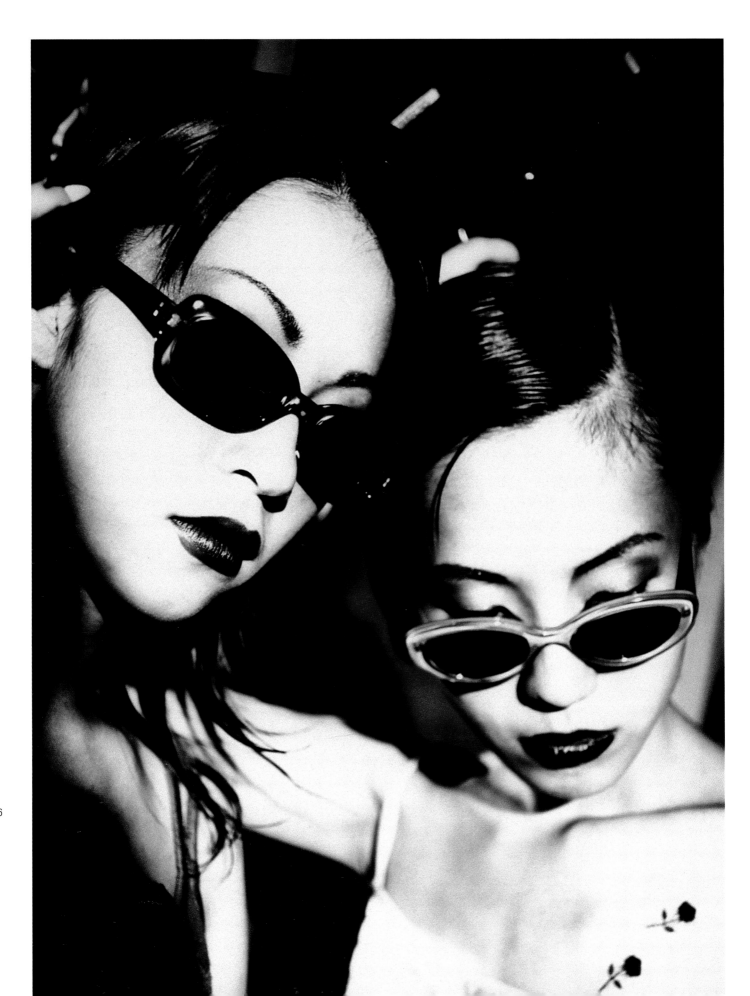

'This shot is part of a series I did in which the two girls are supposed to be hardened gangster women who are wild and reckless – and the treatment is intended to enhance that', explains Tribbeck.

'The lighting comes from just two snoots, one on the two girls and one on the background. Using a snoot limits where the light falls in a more controlled way than a softbox, where the light goes everywhere. The light on the girls was just to my right and about 2m off the ground.'

'The extreme contrast comes from using Agfa Ortho film, which I process in Ilford ID11, a fine-grain developer which maintains greater tonality than you get if you use lith developer. For a more "reportage" style, I went in close with a wide-angle lens, which gives greater drama to the perspective than working at a distance with a standard or telephoto lens.'

plan view

- Nigel Tribbeck
- London College of Fashion prospectus
- Editorial
- 6 x 6cm
- 50mm
- Agfa Ortho
- 1/60sec at f/5.6
- Electronic flash
- Lily Lai and Karen Choy
- Vicky Lee

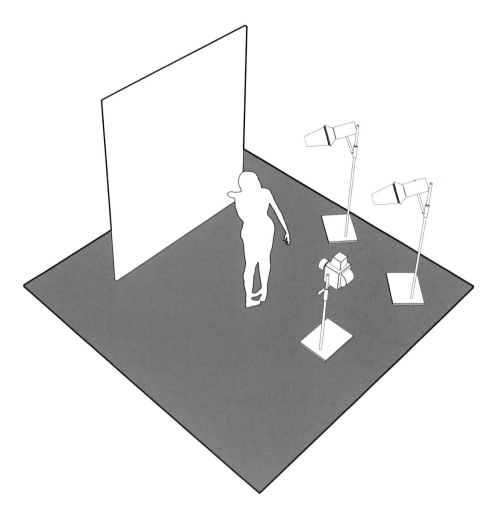

gangster girls

Fitting snoots over lights allows you to limit and control the lighting for dramatic effects.

practical tips

97

* Simple props such as sunglasses can transform the feel of a shot
* Dramatic lighting is always eye-catching, especially in the context of a high-contrast treatment

David Muscroft was looking for soft lighting, so he used just two electronic flash heads here. 'There's a 2 x 3m softbox to the left and a fresnel to the right – both around 2m from the model,' he explains. 'I like the way the light seems to "wrap" around the body, accentuating the curves. There was no light on the background, which is simply an off-white wall in the studio.'

practical tips

* Cropping in tightly on the body creates strong impact
* Using pronounced grain effects adds further interest

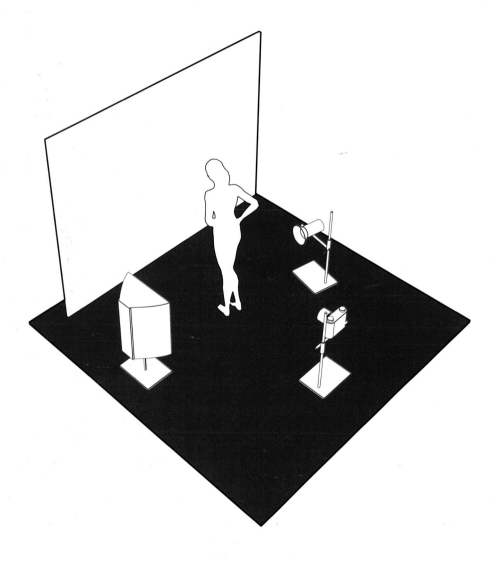

posing considerations

'I find it's best to just let poses happen and not to have a pre-set plan. I encourage the model to try out different things, and when things look right I capture them on film. For this shot I asked the model to put her hands behind her back and adjust them until the composition came together.'

plan view

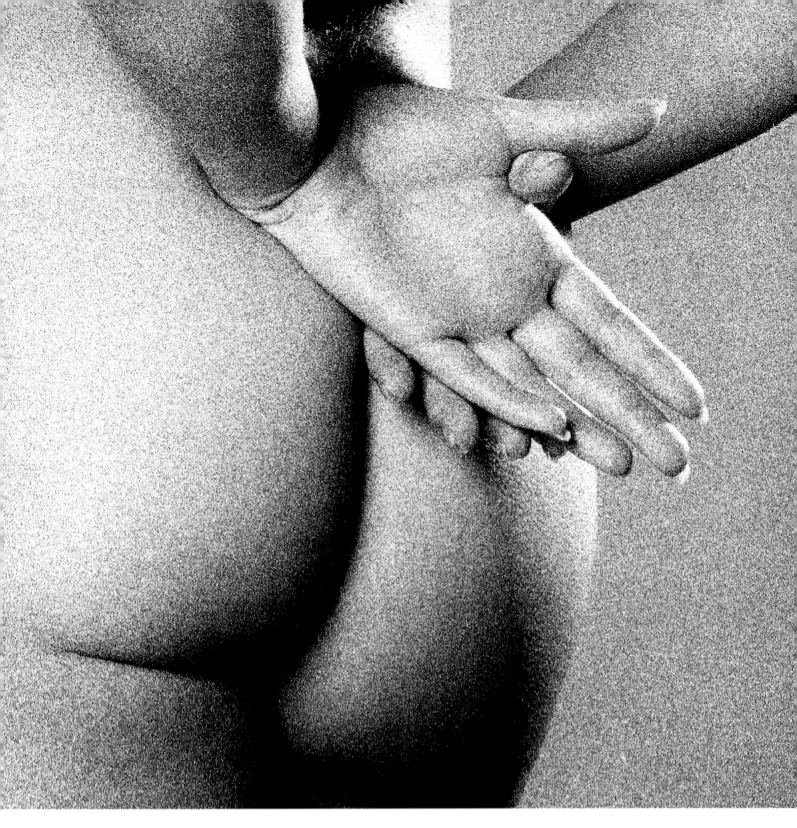

bottom

Using just two lights produces a soft and flattering composition that reveals the curves of the body.

Dave Muscroft

Stock

Various

35mm

80–200mm zoom

Kodak T-Max 3200

1/250sec at f/32

Electronic flash

Sarah Heeley

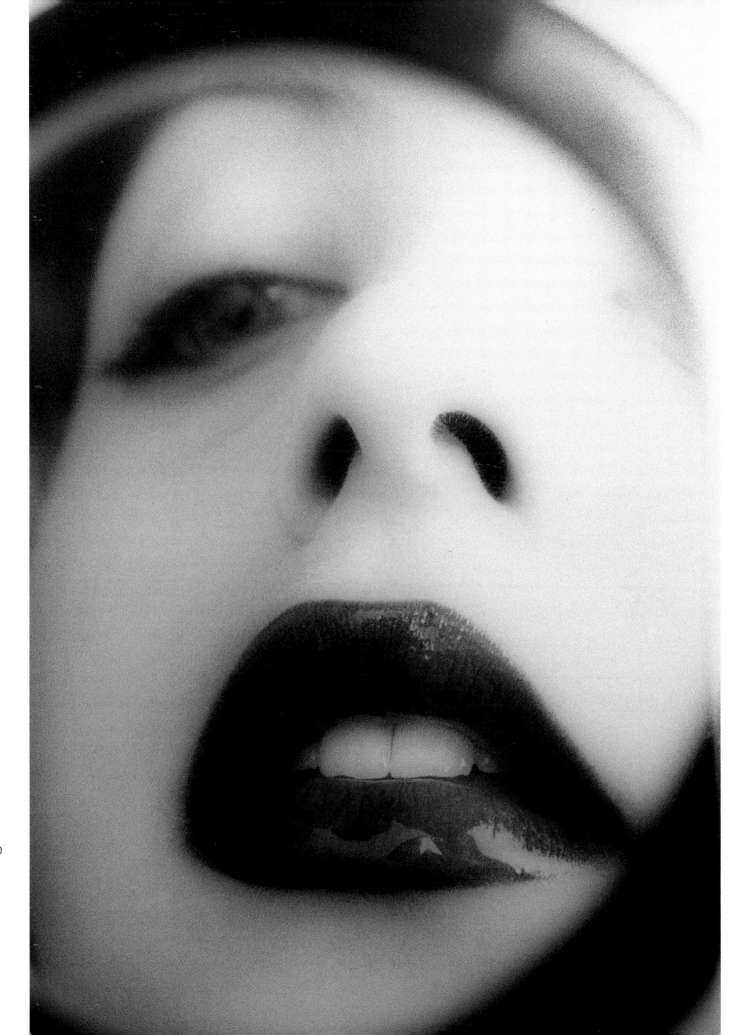

'This picture was taken for a cosmetics company.' Tribbeck explains further: 'the image you see is the model's reflection in a vanity mirror, her lipstick is highlighted by reflective lip-gloss. The main challenge was to light the face fully, which I did with two softboxes, one slightly further away than the other, which created a small, soft shadow on the face.

- ⊛ Nigel Tribbeck
- ⊛ Cosmetics à la Carte
- ⊛ Promotion
- ⊛ 35mm
- ⊛ 28mm + fish-eye converter
- ⊛ Agfa RSX 100
- ⊛ 1/60sec at f/8
- ⊛ Electronic flash
- ⊛ Ann Levy

plan view

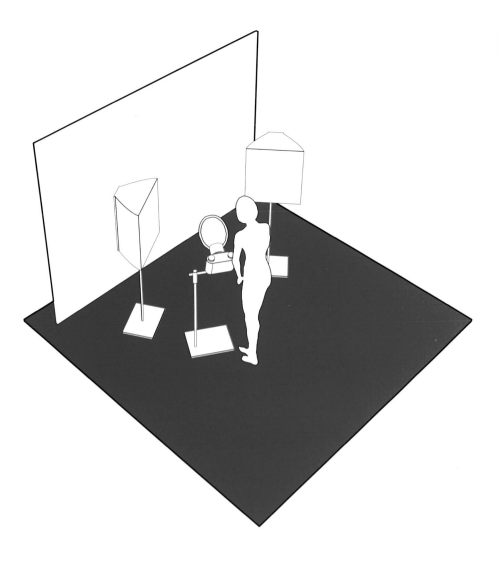

lips in the mirror

Two softboxes, reflections from a mirror and lip-gloss create a mesmerizing image.

equipment focus

'For this shot I used a cheap fish-eye converter, which gives a distortion at the edges that I really like. It's fitted to a 28mm wide-angle lens and I've gone in close to fill the frame with the subject. In fact, I was only a couple of inches away from the mirror.'

As you can see from the shadows, the dramatic lighting for this shot is coming from above. In fact, the 5000 watt tungsten head that's lighting the girl is 4m up on a mezzanine floor that allows it to be pointed directly down. With no compensating blue filter or gel used, the orange colouring of the light makes it look as if the dress, made of chain mail, is on fire – and the surreal feeling is further enhanced by the huge, dark shadow under the face. Not surprisingly, the photographer checked what it looked like with lights filling in this shadow, but the effect was much more mainstream and a lot less powerful. The light on the background, about 1m behind the model, was also a 5000 watt tungsten light (turned down), directed once again to the mezzanine floor.

ⓧ Iko Ouro-Preto
◉ Ministry magazine
◎ Editorial
▣ 6 x 7cm
◉ 80mm
◐ Kodak Ektachrome EPP
◷ 2 seconds at f/8
◉ Two tungsten lights

plan view

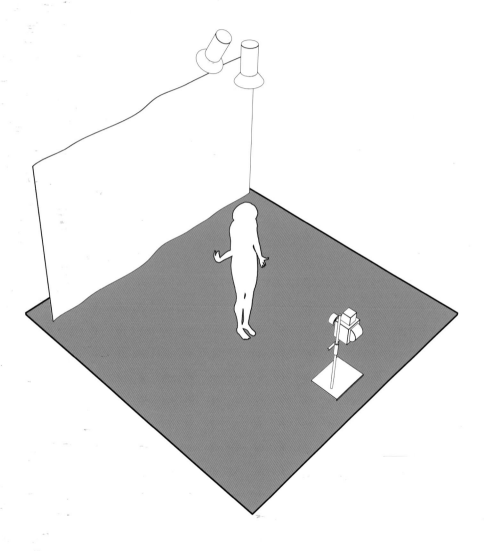

burning girl

Direct overhead lighting creates deep and rather surreal shadows.

practical tips

* Using a tungsten light without compensation results in a strong orange light which can work with some subjects but can sometimes look like a mistake if handled improperly
* High positions for lights are generally unflattering because of the shadows they throw under the eyes, nose and chin – but all rules are made to be broken

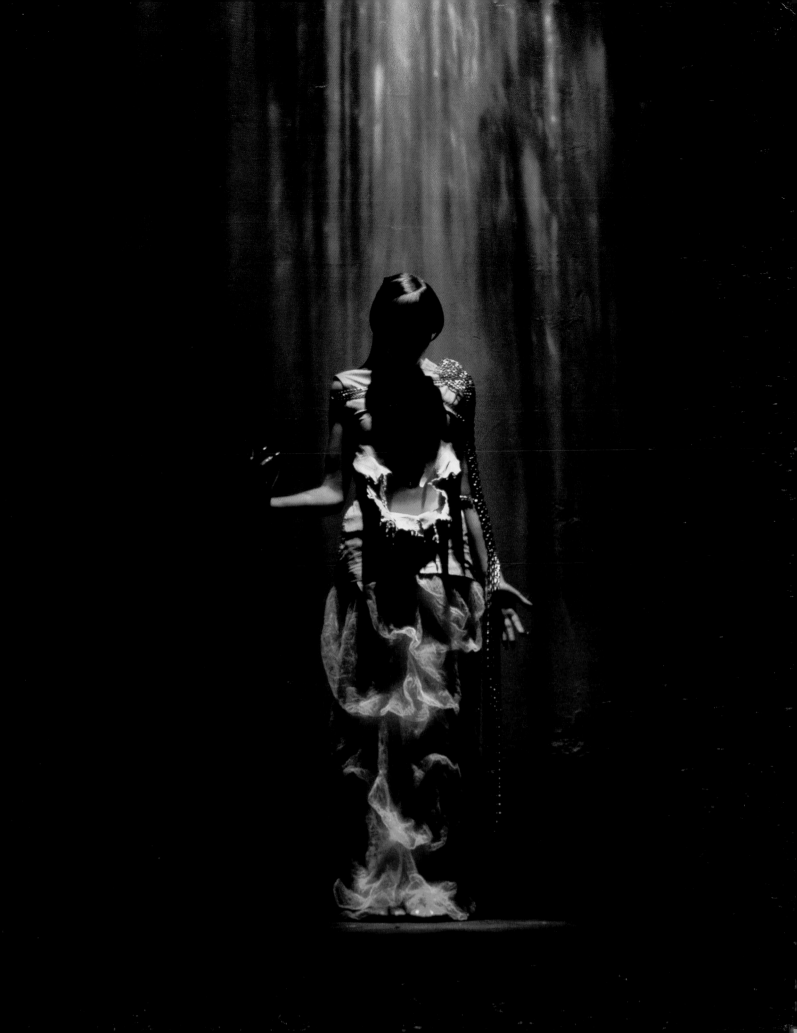

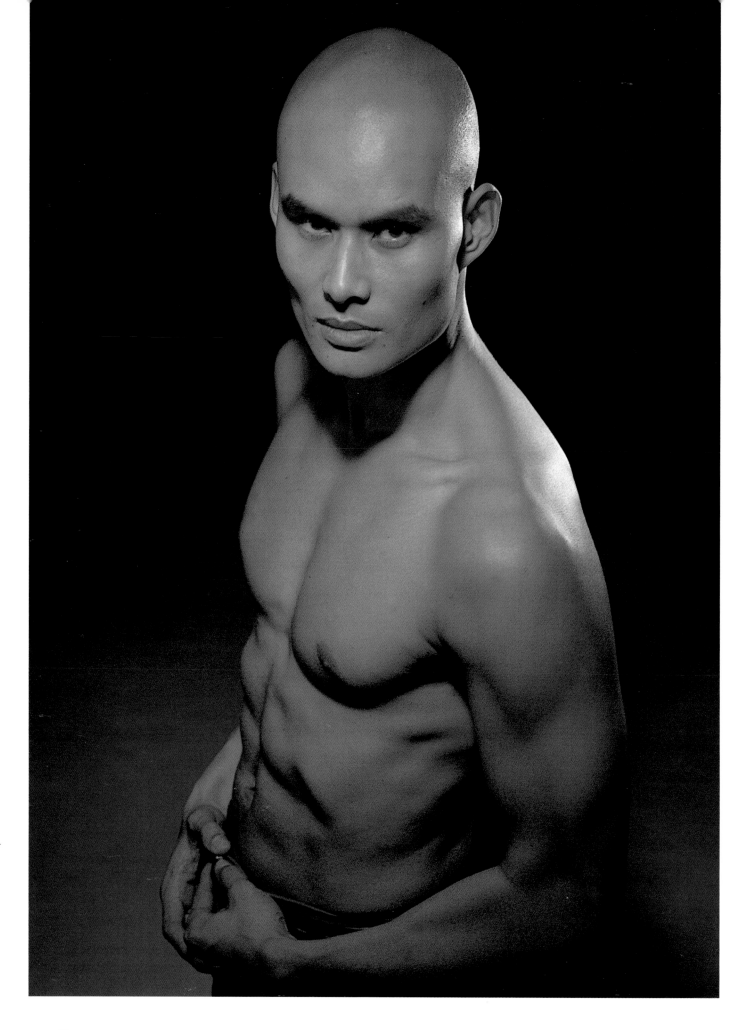

When shooting a portfolio for an actor, dancer or performer you need to supply a range of shots, capturing different moods and feelings. Here, having taken a sequence using standard lighting set-ups, Gray added gels to his lights to create a more interesting effect.

The main light is a softbox, almost directly above the model's head and angled down. Fitted over it is a blue gel. To the right, facing back towards the camera and rim-lighting the subject, is a honeycombed light that's also fitted with a salmon warm-up gel.

- Jon Gray
- Portfolio/Stock
- 35mm
- 35–105mm zoom
- Fujichrome 100 RDP
- 1/60 at f/11
- One softbox and honeycomb

plan view

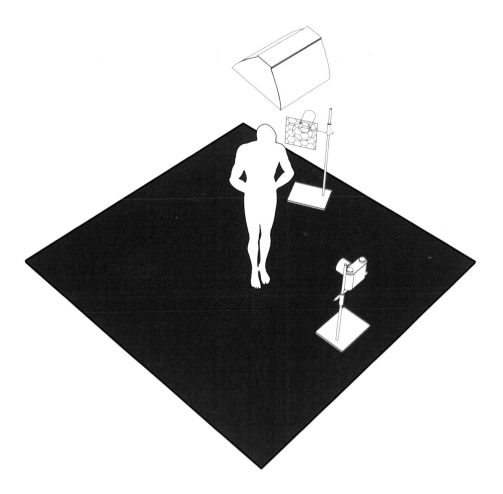

the martial arts expert

Fitting lights with contrasting gels can create a strong and mysterious feeling.

105

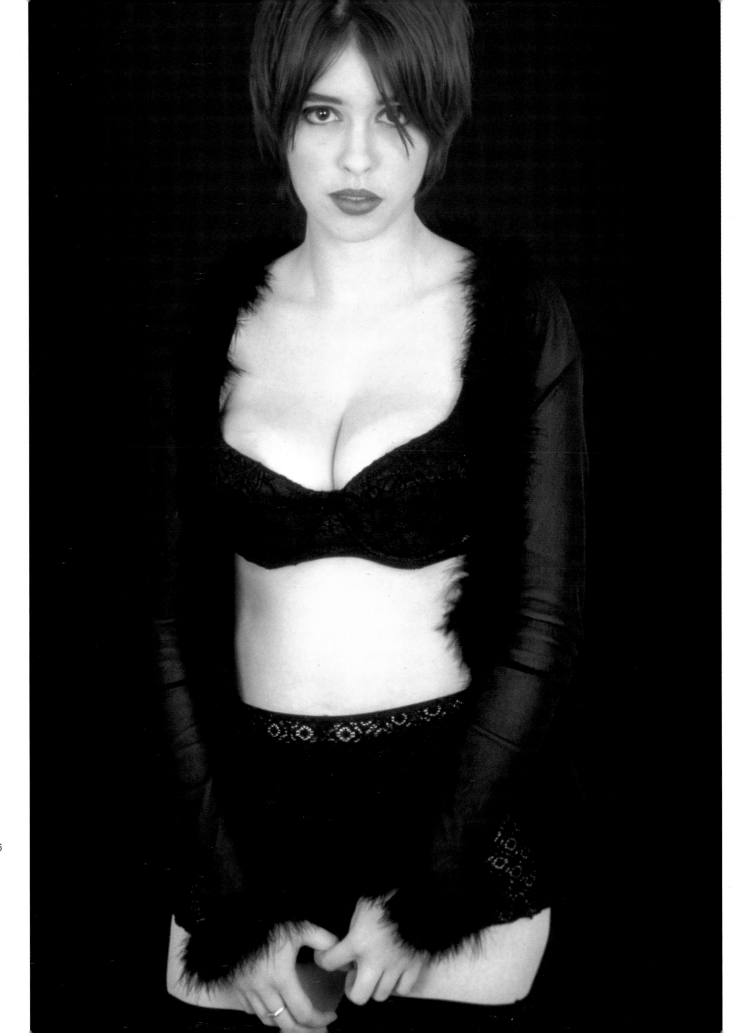

'I was looking to create an image that was modern but with a 1930s feel, for the cover of a book of erotic short stories', says Starkwell. 'I decided to go with flat lighting for maximum detail. I used two softboxes at 45 degrees to the subject to keep the amount of shadows to the minimum. The use of a plain black paper background roll also avoids shadows behind the subject.'

- (A) Simon Starkwell
- Collective publishing company
- Book cover
- 35mm
- 80–200mm
- Kodak Elite 100
- 1/125sec at f/11
- Two softboxes
- Marie Cummings

plan view

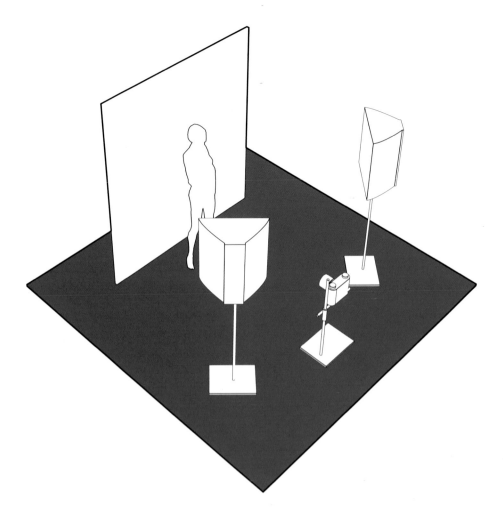

red hair and fur

45 degree lighting and a black paper background give a flat, soft image.

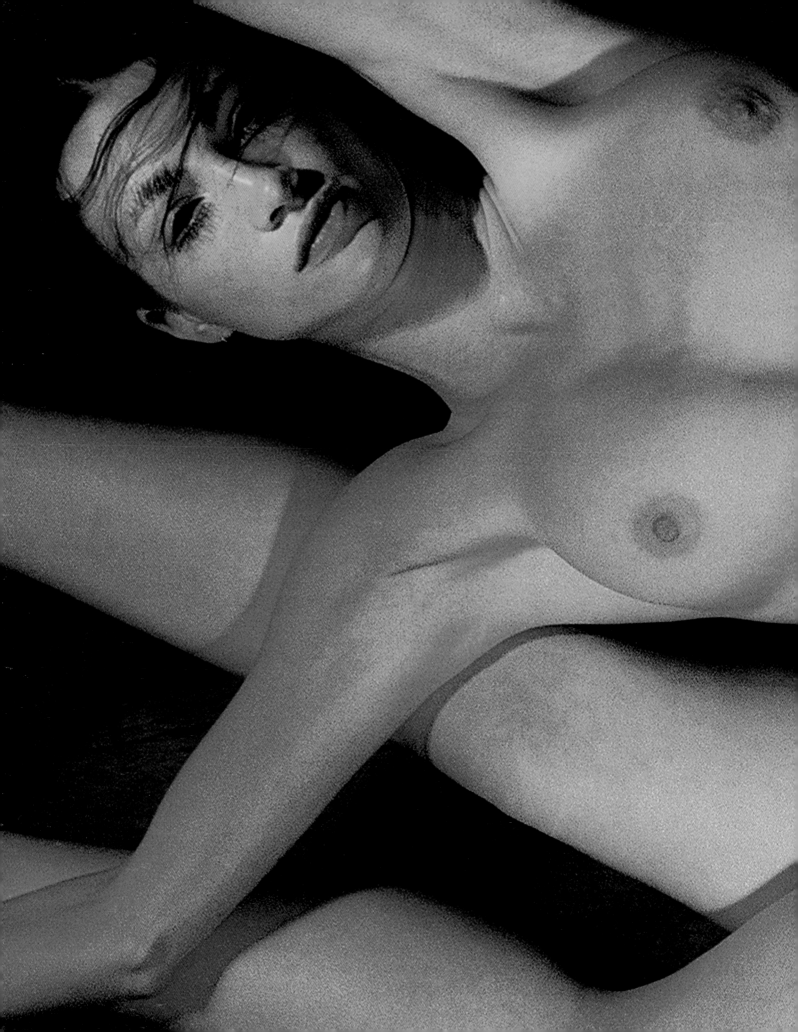

triple crown

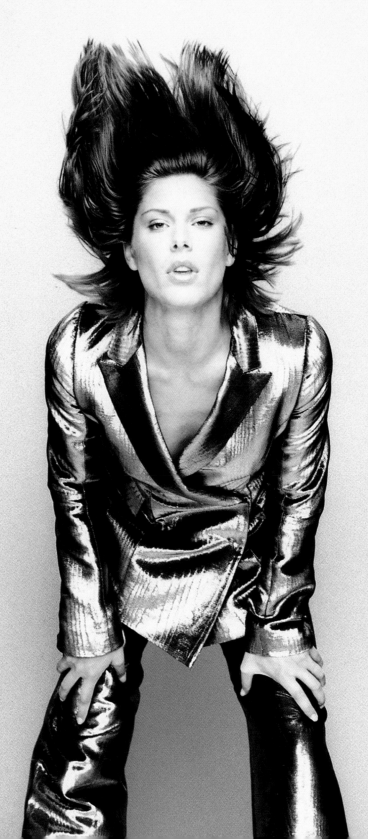

A bank of three softboxes provide the illumination for this shot – a large one over the top of the camera and two smaller ones either side. Ranging the units in this way produces flat, even lighting with soft, attractive shadows. To define and strengthen the outline of the model, two black boards were positioned on either side just out of shot.

Frank Wartenberg
Fur Sie magazine
Editorial
6 x 7cm
140mm
Kodak EPR
Not known
Three softboxes
Daniela Nogueira
Simone Freihöfer
Malte Bartjen

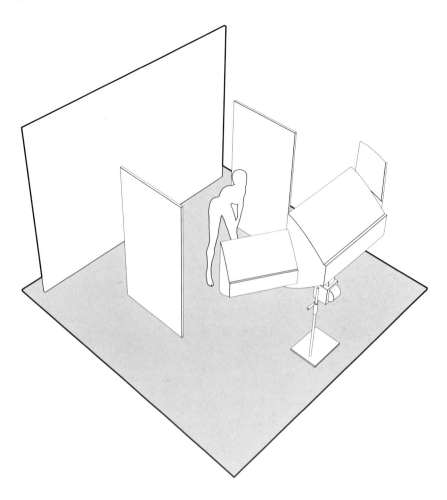

blue wall

Three softboxes produce clean and crisp fashion lighting, contrasting with the sense of movement to create this dynamic pair of images.

plan view

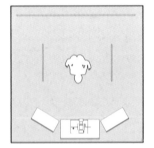

jan on chair

Dramatic lighting suits this very posed portrait. A mirror has been used to reflect light onto the face; resulting in a softer illumination of the subject's expression than if a direct spotlight had been used, but a stronger one than if reflectors had been the choice.

'I was fed up with shadowless lighting, and wanted to produce an image with more black & white tonality. I used no reflectors, just a mirror close to the camera to soften the face', says Olaf.

This was part of a series of pictures taken for a weekly magazine in which men were shown wearing women's underwear and vice versa. As the shadows reveal, the main light – fitted with an umbrella – was high and to the left. Two additional spots illuminated the background.

Erwin Olaf
Niewe Revu
Editorial
6x6cm
150mm
Kodak Plus-X Pan
Not known
Three flash heads

plan view

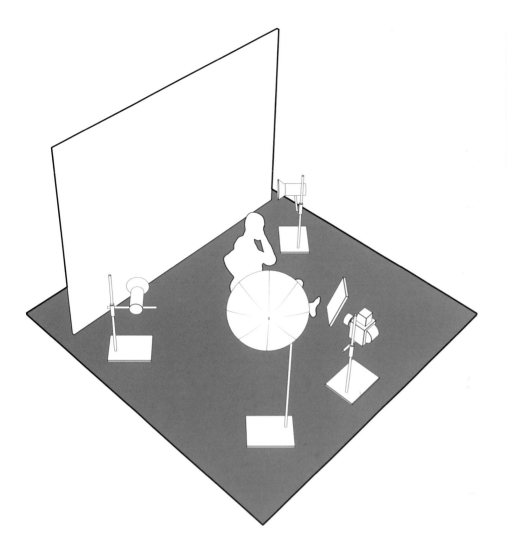

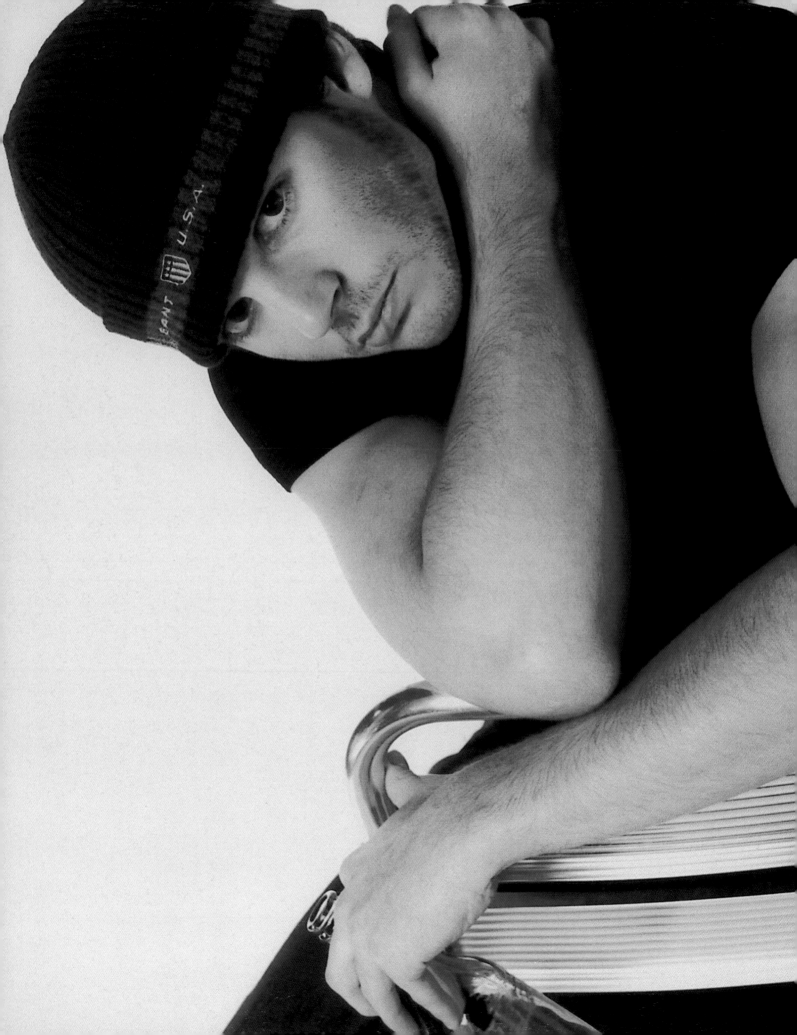

'Lighting doesn't come much simpler than this', says Trenchard, 'there's just one softbox slightly to the left of the camera, down low and pointing up, and the guy is leaning in towards it. The softbox is only 1m away from the subject, which has the advantage that you can see exactly what you're doing. I like softbox illumination, it's more directional, and you can shape the light much better.'

'The background is lit evenly by two floods at 45 degrees to each other, which makes it look fresh and crisp – this is an advertising look that clients really relate to. The picture was taken on black & white film but printed on colour paper to get the blue tone.'

- Peter Trenchard
- Personal project
- 6 x 6cm
- 80mm
- Kodak T-Max 100
- 1/250sec at f/8
- One softbox plus two background lights

plan view

guy with hat

Using a soft box close up to the subject gives a magazine-style effect.

three naked girls

Mixing different coloured gels results in a vivid wash of tones.

Iko Ouro-Preto
Pure magazine
Editorial
6 x 7cm
80mm
Kodak Ektachrome EPP
1 second at f/8
Tungsten lighting

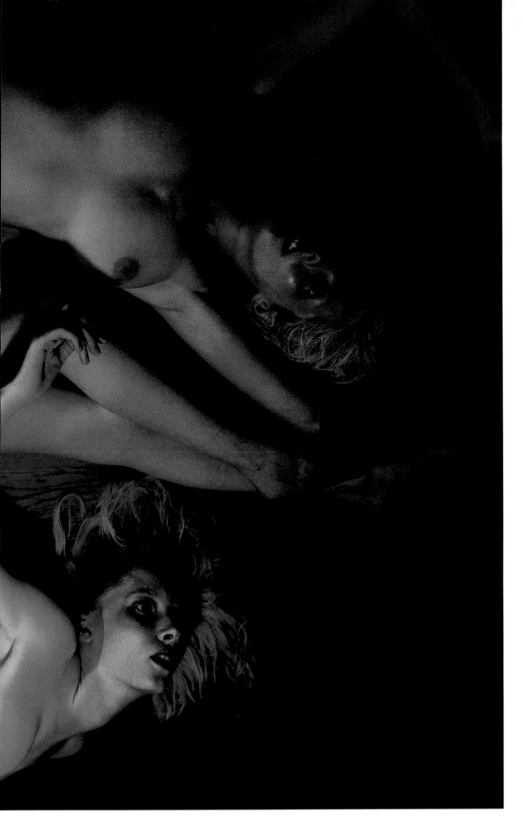

Another image from the same series, with the photographer using gels once again to mark out different parts of the subject.

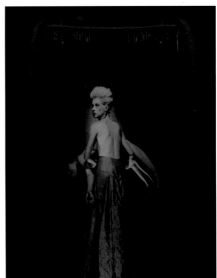

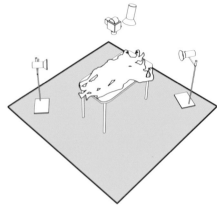

What's immediately obvious about this shot is the number of brightly coloured gels that were used. What's not so apparent are the logistical problems the photographer had in creating the image. The girls are lying on a table, and the camera is pointing directly down over them, from a height of 3m. In the studio that would be easy to set up, but this was shot on location, and the photographer had to lean over the edge of a tall cupboard – secured to the wall by means of a harness for safety.

Compared to that, the lighting was relatively straightforward. The yellow, from a tungsten light fitted with a diffusion screen but without correcting blue gels, comes from directly above, while the red comes from a gelled tungsten light at the top left and the green from a gelled tungsten light to the bottom right. Where the colours mingle, different tones such as the orange occur.

plan view

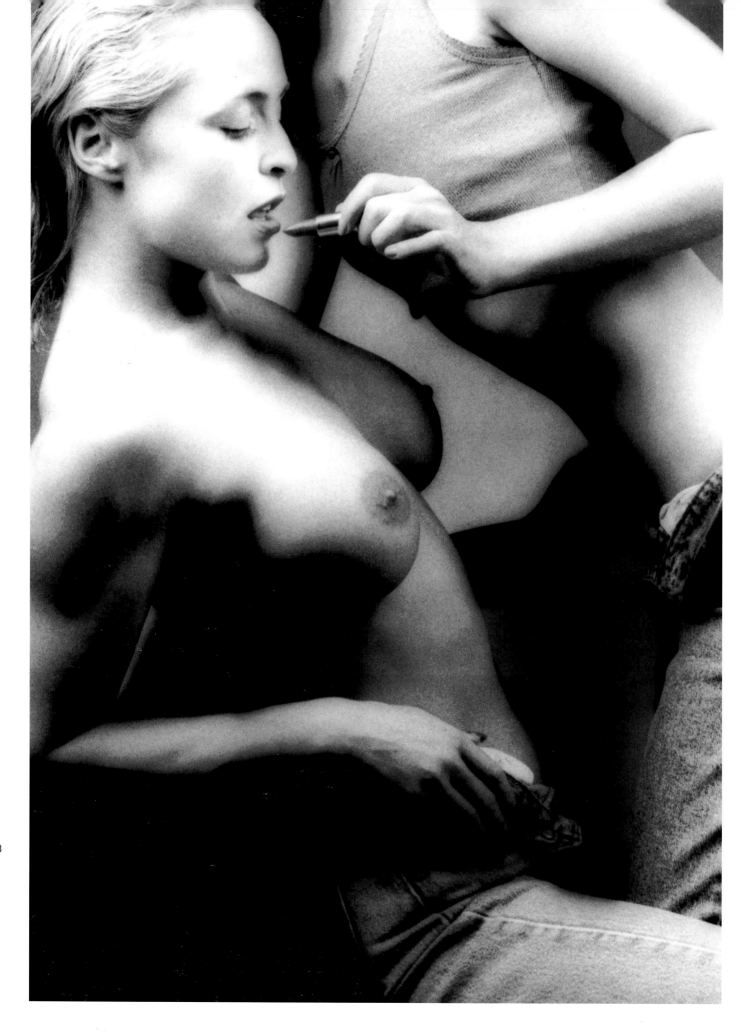

'Although the lighting here looks dramatic, in fact it's just a variation on the standard 45 degree lighting you use for portraits', says Ashford. 'However, the lights have been moved a little further round and slightly away from the subjects, giving a more defined area between the highlight and the shadow.'

'Both the main lights were large softboxes, 1 x 1.5m, and both were positioned primarily to light the faces of the two girls, although in this particular crop the face of the girl on the right is not seen. The lights are also slightly higher than usual, so the effect is rather like stage spotlights pointing down at them. There's also a light with a honeycomb on the background, to separate it out, postioned above the blonde girl's head and pointing down.'

'I never leave the lighting to chance, or just make it up as I go along. Everything is planned before the models arrive in the studio. This was part of a series for possible use on a book jacket, so it was essential the girls were in close together, and once planned, the lighting just seemed to be right.'

- Rod Ashford
- Speculative book jacket use
- 35mm
- 70–210mm
- Kodak Plus-X
- 1/60sec at f/11
- Electronic flash

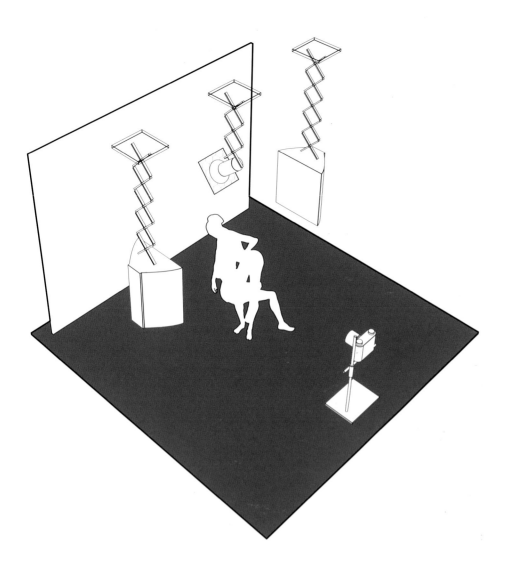

plan view

lipstick couple

Adapting standard 45 degree lighting and employing imaginative cropping results in a striking composition.

hi-glide system

119

Rod's lights are attached to the articulated arms of a hi-glide system fixed to the ceiling of the studio. This means he can position them as he likes, without worrying about wobbly stands when raising the height of the lights.

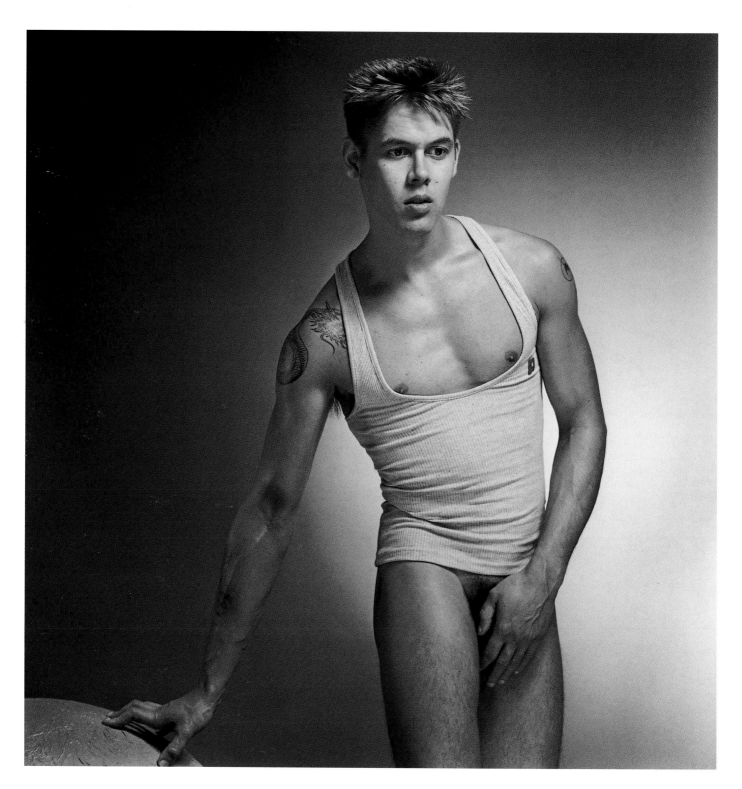

marc

One high light bounced back from a reflector creates a subtle sense of theatre in this male study.

'I have a journalistic background, in which it's common to darken the corners of the picture to concentrate attention on the subject,' Olaf explains. 'Lighting the background in this way creates a similar effect, which can then be enhanced in the darkroom.'

The clean, fresh lighting of this shot comes from two flash heads. The one illuminating the subject is fired into an umbrella, and placed high up at 45 degrees and to the right. To soften the shadows there is a large sheet of white cloth on the floor and a home-made aluminium reflector to the left-hand side. A normal household mirror is positioned close to the camera to reflect light back onto the face. Finally, there's a separate light on the background behind the subject, fitted with a honeycomb grid to focus it.'

- Erwin Olaf
- Manstore
- Editorial
- 6 x 6cm
- 150mm
- Kodak Plus-X
- Not known
- Electronic flash

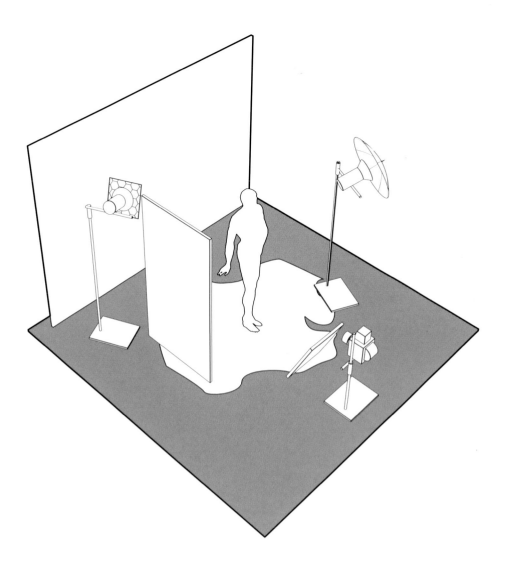

plan view

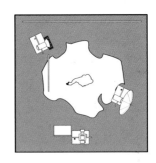

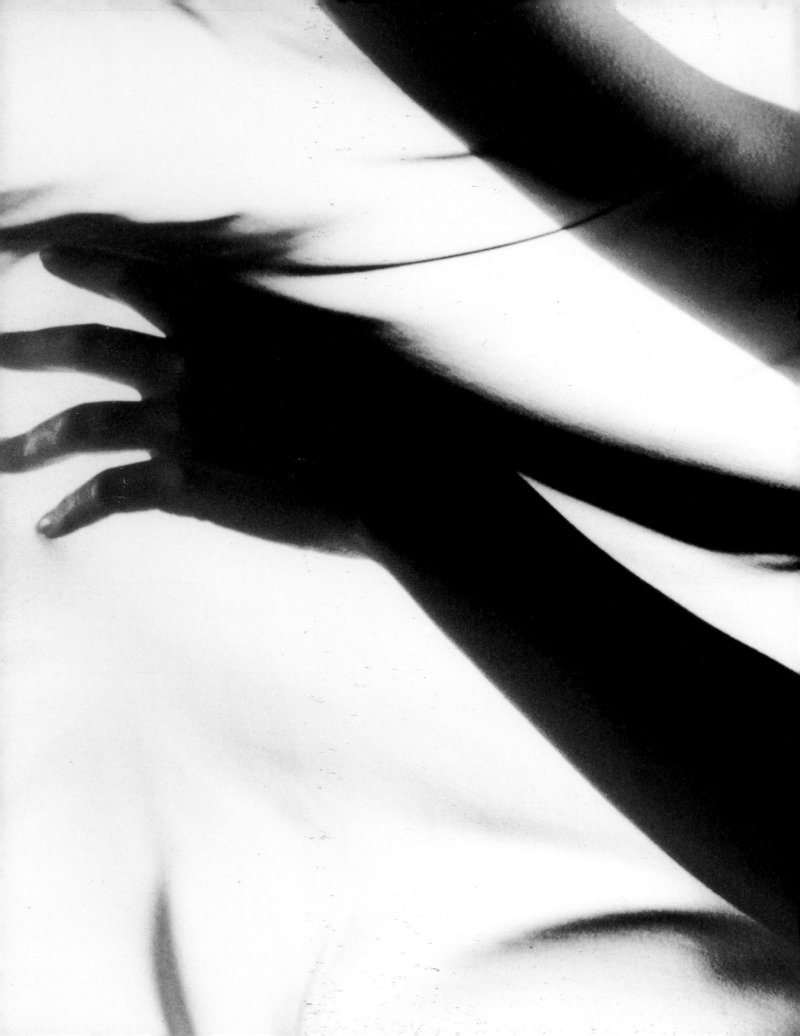

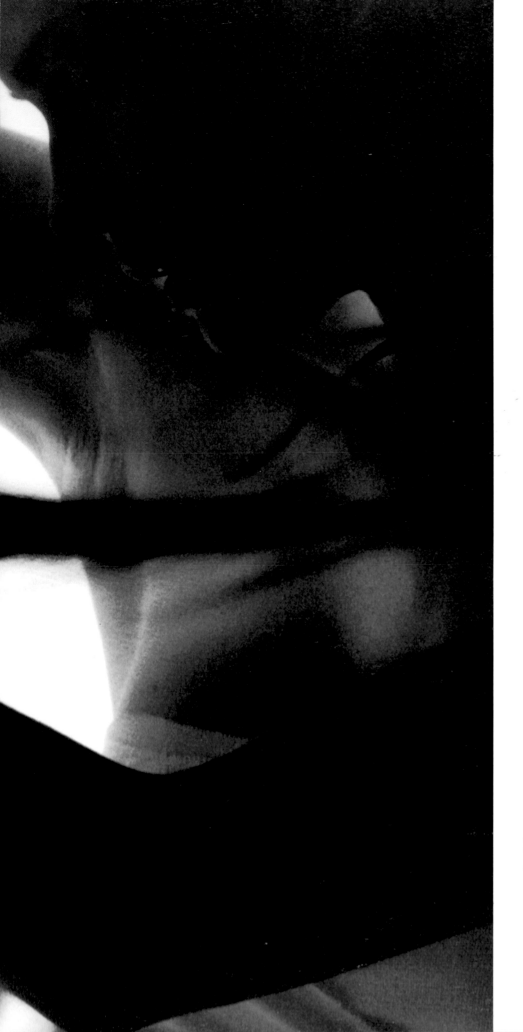

multiple lighting
techniques

The clean white background of this shot tells you immediately that it has been lit separately – in fact two flash heads were used from either side in the classic way. Two further lights were also used each side, directly alongside the model. These tall softboxes provided the highlights down the body, which have been allowed to bleed ever so slightly into the background. They also create the shadow areas which help to define and sculpt the body, showing its line and form. A final softbox was positioned over the top of the set, pointing down.

Frank Wartenberg
Stern magazine
Editorial
6 x 7cm
110mm
Kodak EPL
Not known
Five flash heads
Franziska K
Malte Bartjen and Georg Bechstädt
Renata Semba

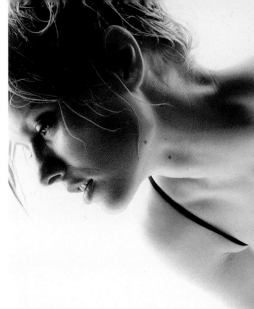

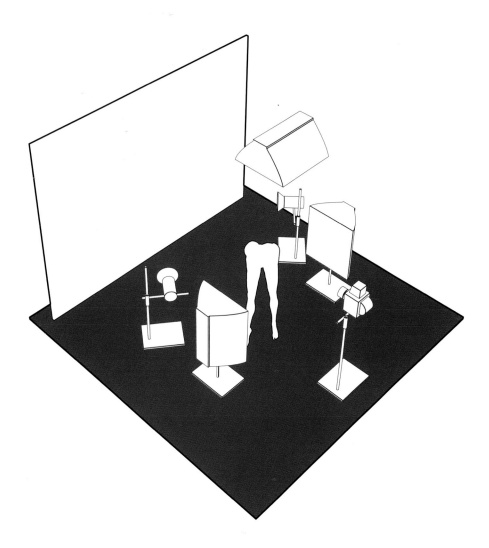

124

modern lingerie

Five lights are used to sculpt the body of a beautiful model.

plan view

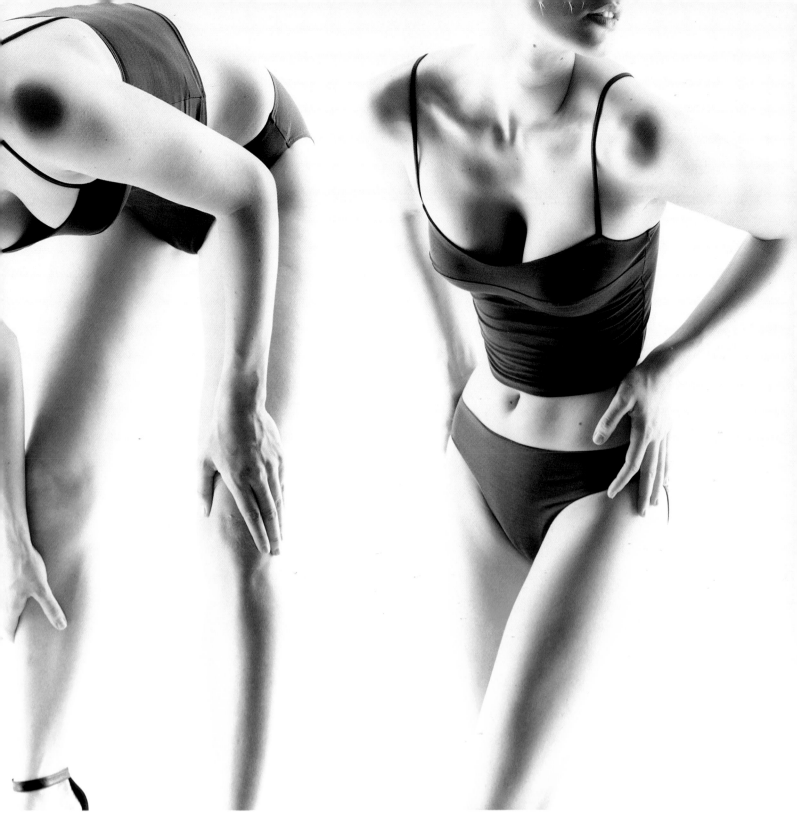

Another image from the same series
demonstrates clearly the wonderful sculpting
effect of this lighting arrangement.

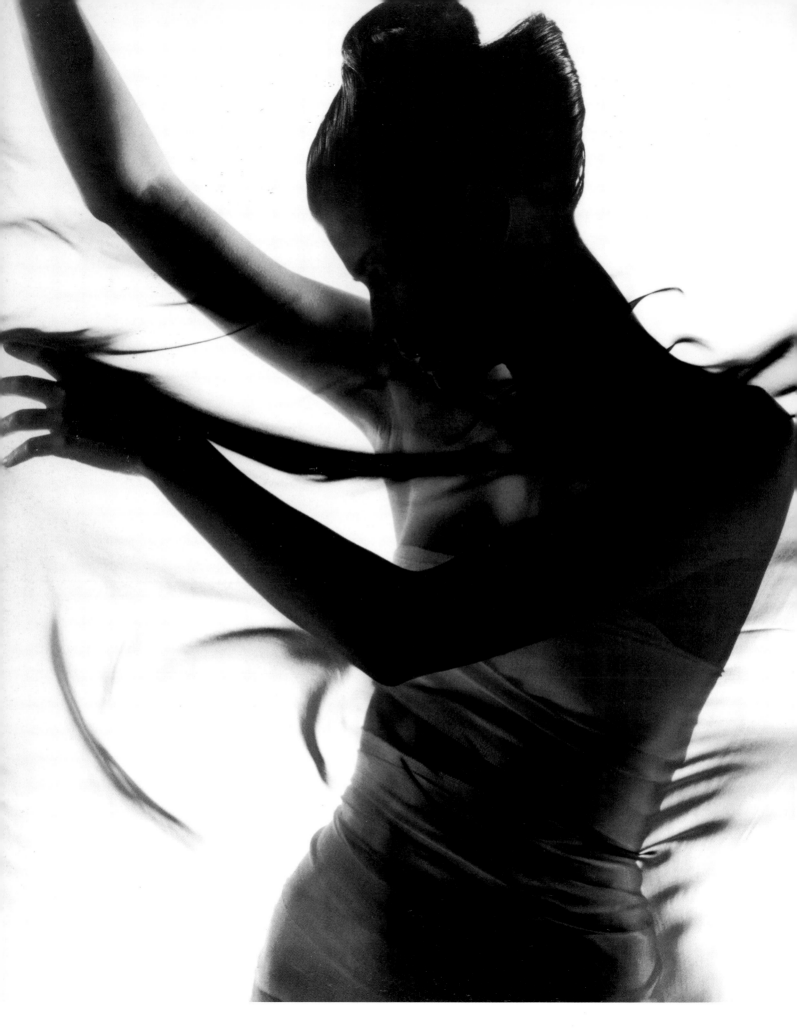

The aim of this shot was to create a sense of mystery by lighting the background and allowing the model to fall into silhouette. This was achieved by using two stacks of three umbrellas close to the background.

To make sure there were no highlights on the side of the girl, two large black boards were set up each side, as close as possible without appearing in the picture, and these produced the strong, dark edges. The girl is wrapping gauzy fabric around her, which is being blown around by a wind machine.

🚶 Morten Bjarnhof
🌀 Ecco
🔳 Brochure
📷 6 x 7cm
🔘 105mm
🎞 Kodak T400CN
🕐 1/125sec at f/16
💡 Six umbrellas
🔲 Style Counsel

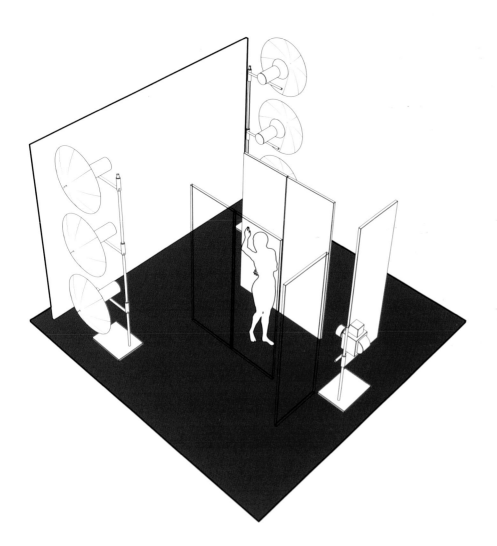

plan view

silhouette

Just by lighting the background evenly, the foreground subject falls into silhouette.

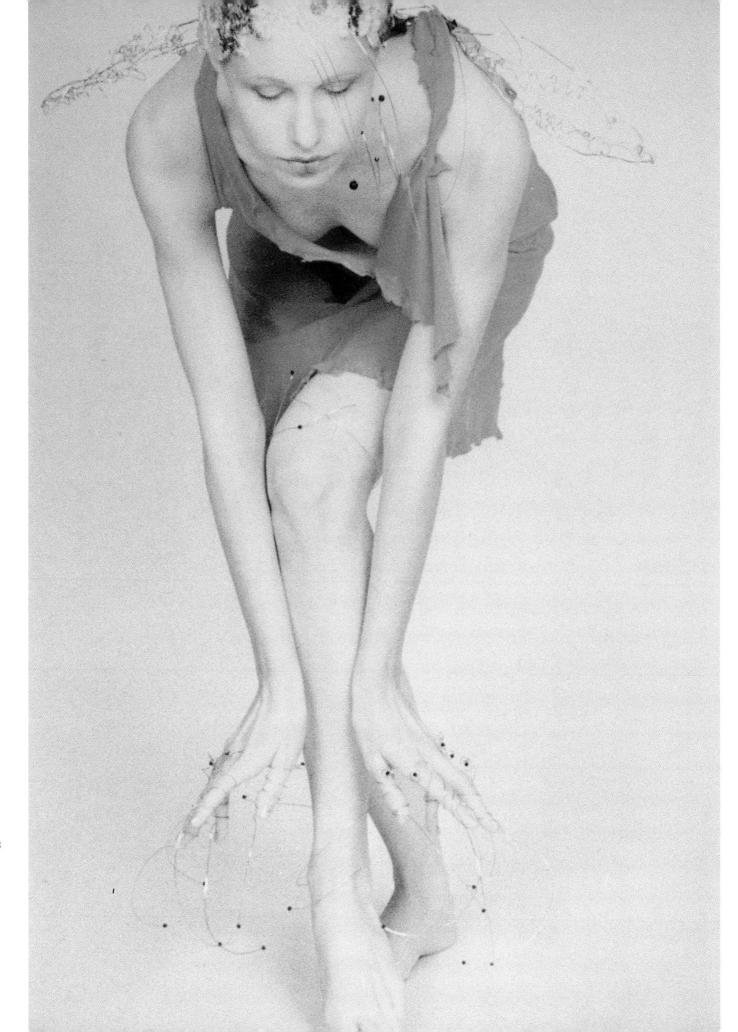

'I used four softboxes to light this picture – two at 45 degrees to the model and two at 45 degrees to the background', Trebbick comments. 'This kind of set-up produces evenly lit pictures with a light, airy feel to them, and the minimum of shadows. However, the results can look rather conventional, so for this picture I used infrared film which I cross-processed to give a more distinctive image. The skin tone has a very different quality from what you would normally get, and the model's blue dress has been rendered pink instead.'

using colour infrared film

Infrared film is sensitive to wavelengths at the extreme red end of the spectrum that are not recorded on conventional films. The only colour infrared film commercially available is Kodak Colour Ektachrome, an E-6 slide emulsion which gives 'false' colours, especially in situations where there is lots of infrared light, such as outdoors on a sunny day. It's a great choice for photographers who love to experiment, as by fitting different filters over the lens you can get a wide range of results. The most widely-used filters are yellow and sepia. Colour infrared can also be cross-processed in C-41 chemistry for even more dramatic results.

Nigel Tribbeck
London College of Fashion
Brochure
35mm
85mm + yellow filter
Kodak Infrared Ektachrome
1/60sec at f/8
Four flash heads
Kelly Schoffield
Natasha Lawes

plan view

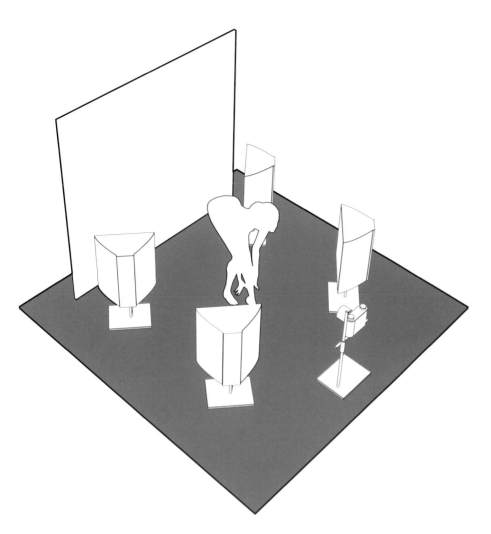

infrared girl

Flooding the subject and background with soft light gives a light, airy feel to the picture.

practical tips

* When trying out experimental techniques such as using infrared or cross-processing it's a good idea to bracket your exposures – taking a series of images at exposures above and below what you believe to be correct
* When using infrared film you either need to refocus using the infrared scale on the lens or set a small aperture with increased depth of focus

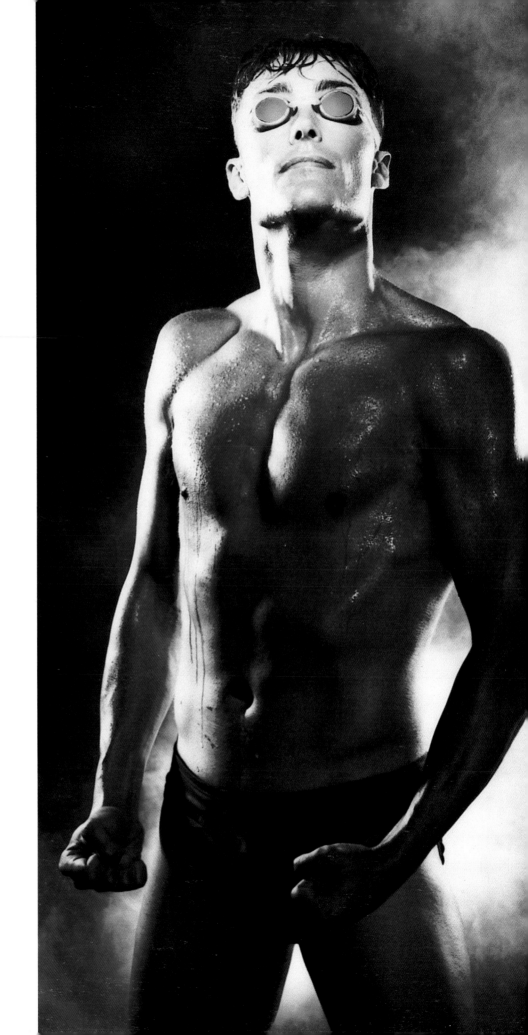

man from atlantis

Dramatic use of spotlights defines and sculpts a
muscular body.

Trenchard explained that the photograph was taken as part of a series for a triathlete, saying, 'having taken a wide range of standard shots I wanted to do something more creative – and since it was the last session of the day we were free to experiment. The picture is basically rim-lit and side-lit, to show off the muscular physique, which was sprayed with water to give the impression of sweat. There are two spotlights behind him to the left and right, raking across the body and defining the edges. The right of his body appears more brightly lit because of the way his body is turned at an angle. On each of the spotlights there's a flag to prevent light spilling onto the lens.'

'Because, as with any portrait, the face is the most important part of the picture, I felt it was important to light it separately, so I placed a small softbox directly above him, angled down, but with relatively weak output. A fourth light was used to catch the smoke from the smoke machine behind him. The picture was shot on black & white film but printed onto colour paper, where it was given the blue colouring. The goggles were then hand-tinted.'

Peter Trenchard
Portfolio for triathlete
6 x 6cm
120mm
Kodak T-Max 100
1/125 seconds at f/11
Four flash heads

plan view

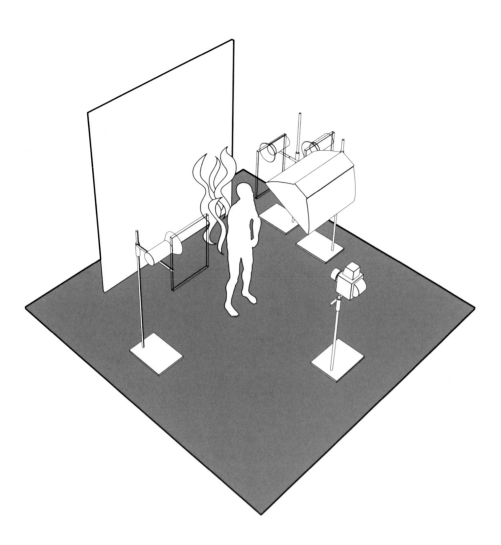

'This picture was produced when I was just playing with light,' Muscroft says, 'just seeing what happened as I moved these flash heads fitted with coloured gels around. In fact, the lighting is much more complicated than I would normally go for, but was simply a result of discovering what worked.'

'The main light is actually an unusual flash head made by Bowens for illuminating backgrounds, but it can be effective for creative treatments like this. As you can see by the shadows it's casting, it's quite high. Towards the back and facing forward are two lights without gels that are outlining the body with white light. These heads are also fairly high and fitted with barn doors to control the spread of the light. The remaining two lights are at 45 degrees to the subject, but slightly lower than normal. Both are fitted with blue gels and barn doors to limit the spread of the light.'

plan view

⚉	Dave Muscroft
⬡	Stock photography
⬚	35mm
⬖	80–200mm
⬗	Fujichrome Astia
⏱	1/250sec at f/11
⬤	Five flash heads
◉	Rebecca

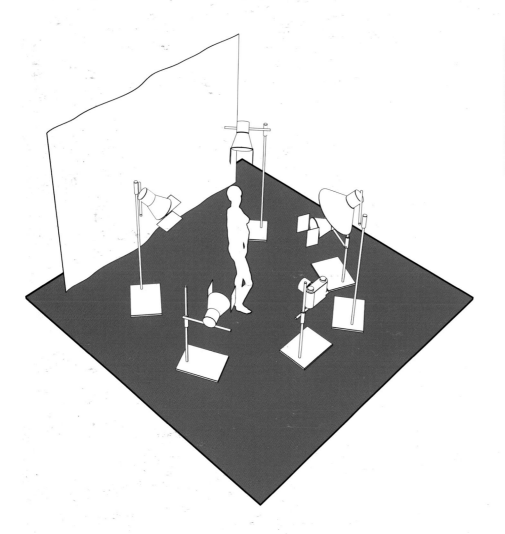

blue and red model

Heavy use of gels and five lights produce an image with a strong impact.

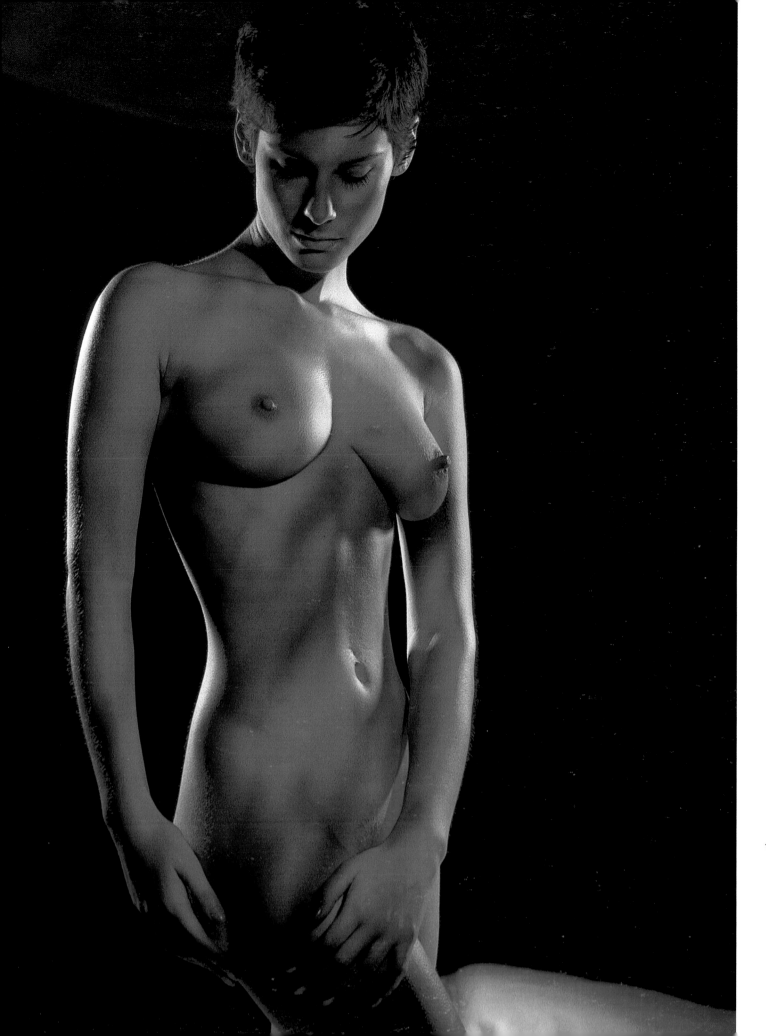

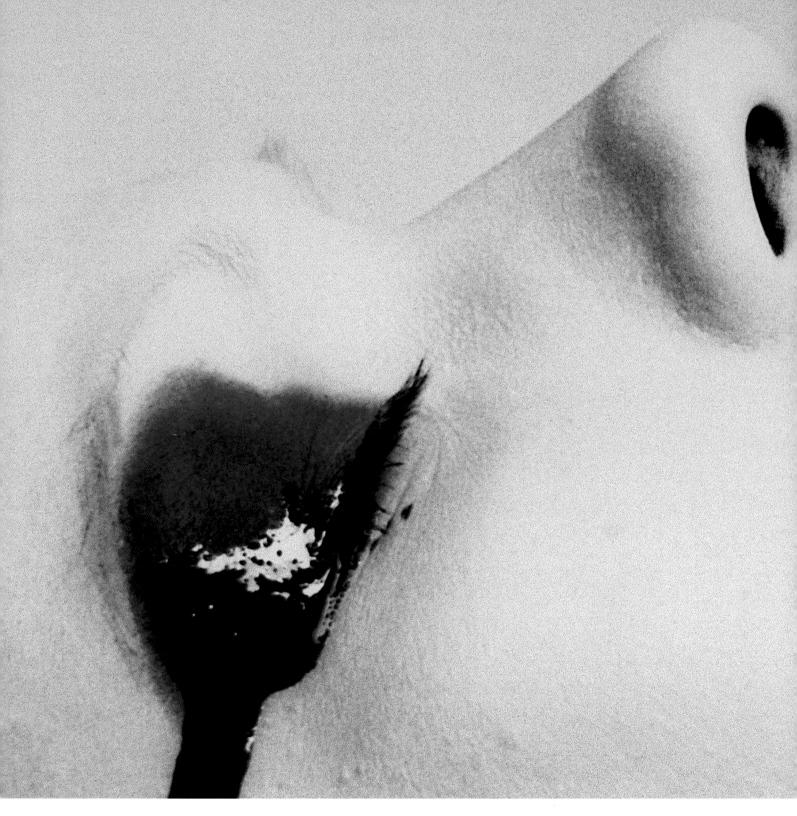

trickle of blood

Four lights combine to bring soft lighting to a gothic composition.

(⚇) Nigel Tribbeck
(⚲) Portfolio
(◑) Test shot
(⚇) 35mm
(◉) 85mm
(▶) Kodak 160 (tungsten-balanced)
(⏱) 1/60sec at f/5.6
(💡) Electronic flash

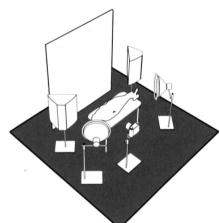

'I took this picture as part of a test series to reflect the popularity of a gothic style – with magazines featuring images of models mixed in with blood and guts.'

Trebbick elaborates: 'the make-up, combined with cross-processing a tungsten-balanced slide film, gave the cold, blue monochromatic colouring. I was looking for a soft lighting with the minimum of shadows, which often look ugly in beauty work, so I used four lights. Two softboxes were set up behind the model to evenly illuminate the backdrop, while two lights in wide reflectors with diffusion over the top were used to light the model herself.'

'Because I wanted a dense negative with burnt-out highlights I adjusted the exposure accordingly. Finally I cropped in close with an 85mm lens to maximise the impact.'

plan view

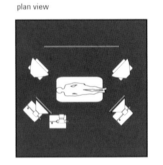

It's that shaft of light, coupled with the doves, that gives this image a mystical, almost religious feeling. One option in terms of creating it would have been to have had a spotlight pointing down, but that could easily have faded in intensity towards the bottom of the beam. Instead Wartenberg created the impression of a shaft of light by stacking three softboxes behind the model and turning them up higher than the three lights illuminating the face. Between the two sets of lights there's a 'V' shape produced by two silvered walls. This reflects fill light in from the sources in front of the model.

ⓐ Frank Wartenberg
ⓑ S. Oliver
ⓒ Advertisement
ⓓ 6 x 7cm
ⓔ 110mm
ⓕ Agfa Scala 200X
ⓖ Not known
ⓗ Six flash heads
ⓘ Greg Spaulding
ⓙ Uta Sorst
ⓚ Malte Bartjen
ⓛ Ruta Valile

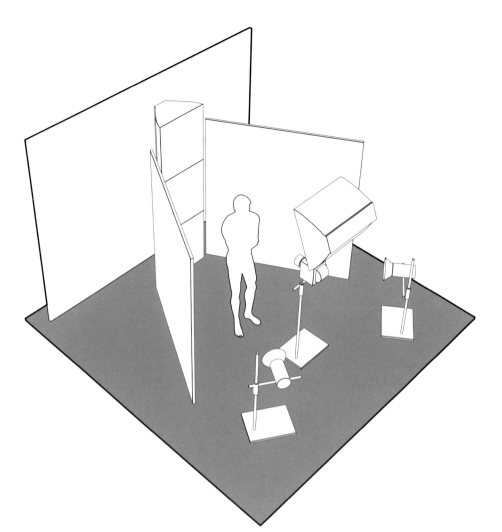

plan view

man with doves

A six-head set-up with strong backlighting creates a striking image.

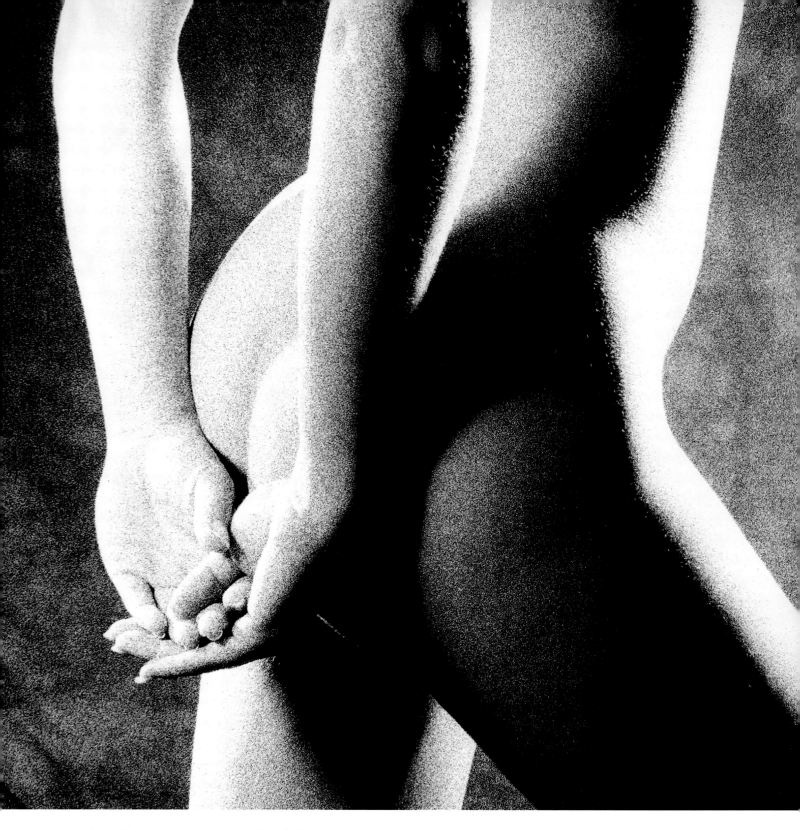

girl with hands behind back

Harsh lighting combined with processing the film in print developer creates a strong, graphic effect.

Dave Muscroft
Stock
Various
35mm
80–200mm zoom
Kodak T-Max 3200
1/250sec at f/32
Electronic flash
Sarah Heeley

'I was exploring graphic ways of photographing the body and decided to go for a more dramatic lighting set-up than I would normally,' says Muscroft.

'I started by placing a flash head 2m to the right of the model and narrowed the beam of light by fitting barn doors, which I adjusted to give the best result. To the left, also 2m from the model, I positioned another flash head in a rectangular softbox. A third light, a fresnel, was placed to my left and directed to the girl's bottom, to make sure it was fully illuminated. A final light, for the canvas background, was positioned low on a stand to the right, just out of the sight of the camera.'

creating grain

'Modern films are so fine-grained, even the fast emulsions, that it's more difficult to get pronounced grain these days. What I do is to develop the film in print developer, which gives a negative that's much more coarse and contrasty, and with a clearly visible grain structure. Contrary to what you might think, to get the best from such a negative you need a medium grade of printing paper – with hard grades the contrast is excessive.'

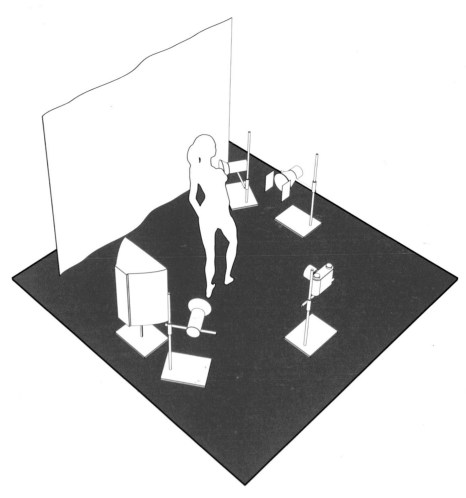

equipment focus – fresnel lights

Fresnel lights are useful because they feature an iris which can be adjusted to vary the lighting output – not the amount of light, but the quality of the light. It's a flattering light which can be directed specifically where you want it.

plan view

'The colours of this shot come from cross-processing infrared slide film in C-41 chemistry,' comments Tribbeck, 'but it's the shadows falling across the face from the fingers that add extra interest to the image.' Further information regarding infrared film can be found on p129.

'The main light was direct and just to my right, producing flat features and a catchlight in each eye. A second light off to the left creates highlights on the wire head gear. The backdrop was evenly lit by two softboxes at 45 degrees to each other.'

- Nigel Tribbeck
- London College of Fashion prospectus
- Editorial
- 35mm
- 85mm
- Kodak Infrared Ektachrome
- 1/60sec at f/8
- Electronic flash
- Kelly Schoffield
- Natasha Lawes

plan view

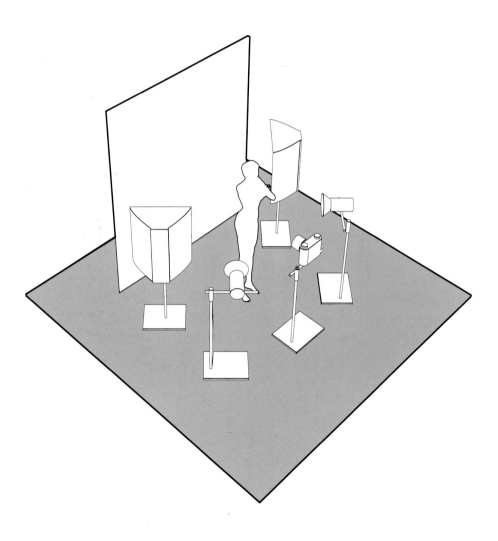

infrared portrait

Allowing shadows to fall over the face of the model gives added interest.

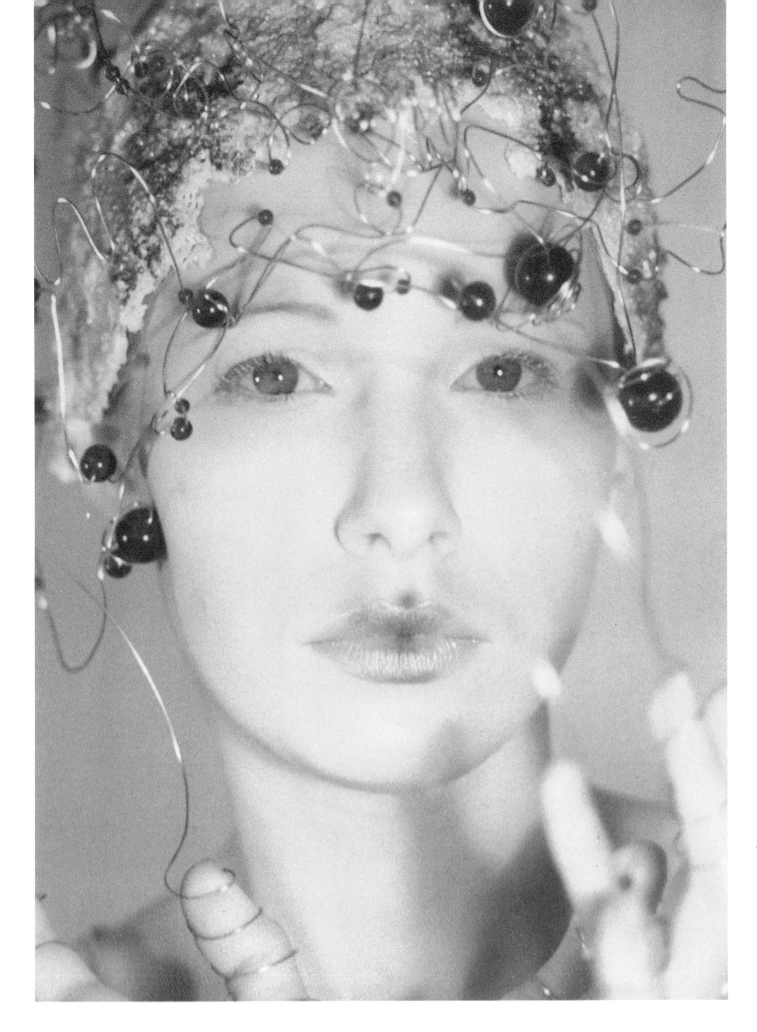

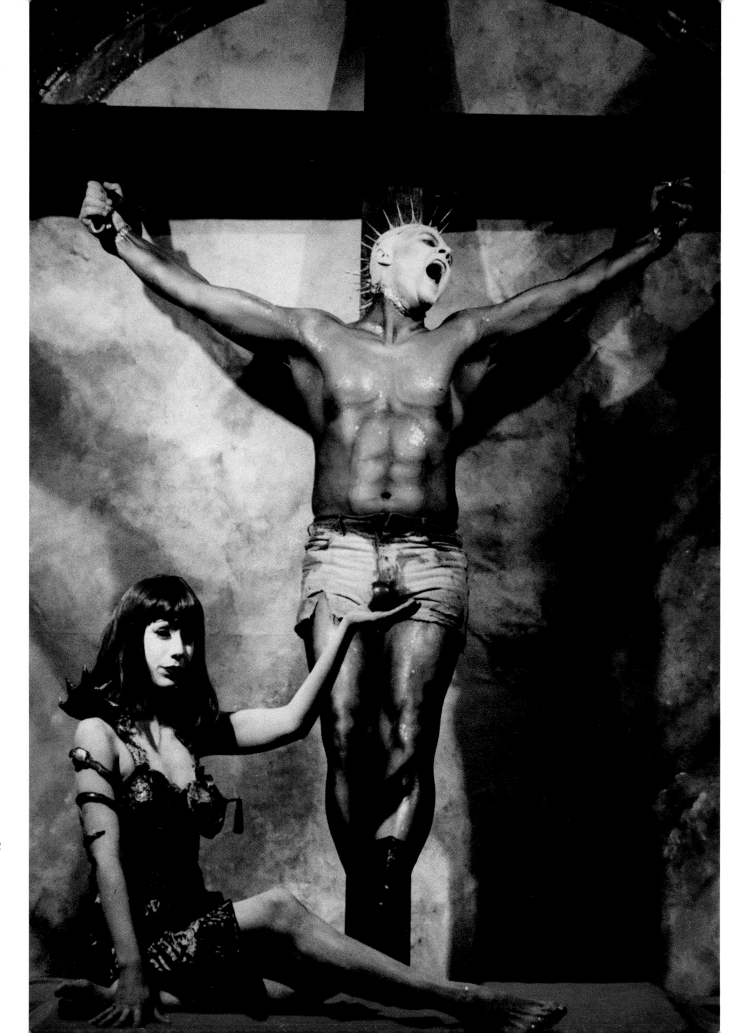

'This picture was taken for use in a magazine dedicated to body art,' comments Nigel, 'both the man's body and the background are hand-painted, and the whole set-up is deliberately theatrical.'

'To enhance this sense I lit the shot as if it were on a stage, with lights high up and pointing down. There were four snoots in a semi-circle illuminating the main subjects, I like to use snoots because of the precise control they give you over the lighting. I also like to have the light quite narrow and very directional, and almost always use snoots when anything is body-painted because they allow you to reveal the shape of the body more easily.'

Nigel Tribbeck
Body Art magazine
Editorial
6 x 6cm
150mm
Agfa RSX 100
1/60sec at f/8
Electronic flash
Unknown
David Hawkins and Caroline Scott

plan view

body-painted theatre

143

Copying stage lighting techniques allows a theatrical feeling to be produced.

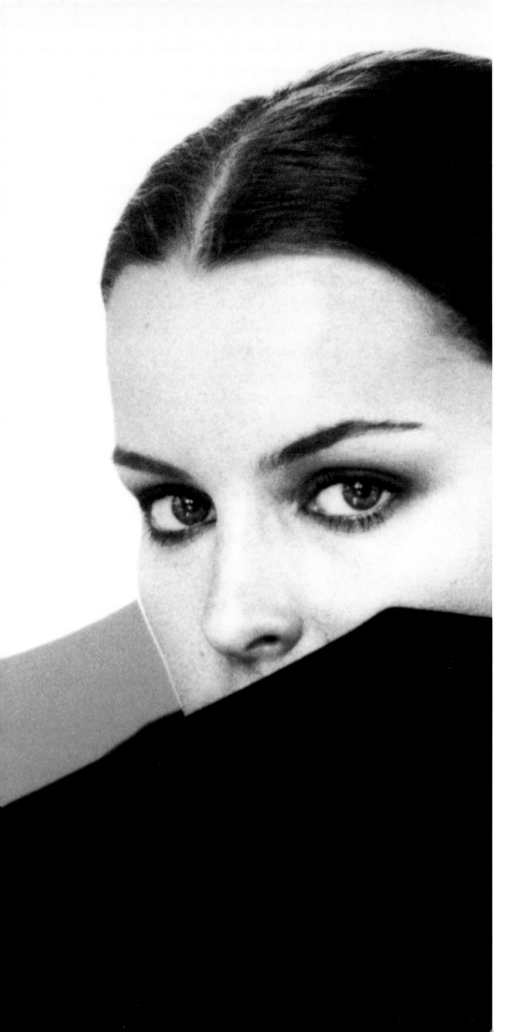

advanced lighting
options

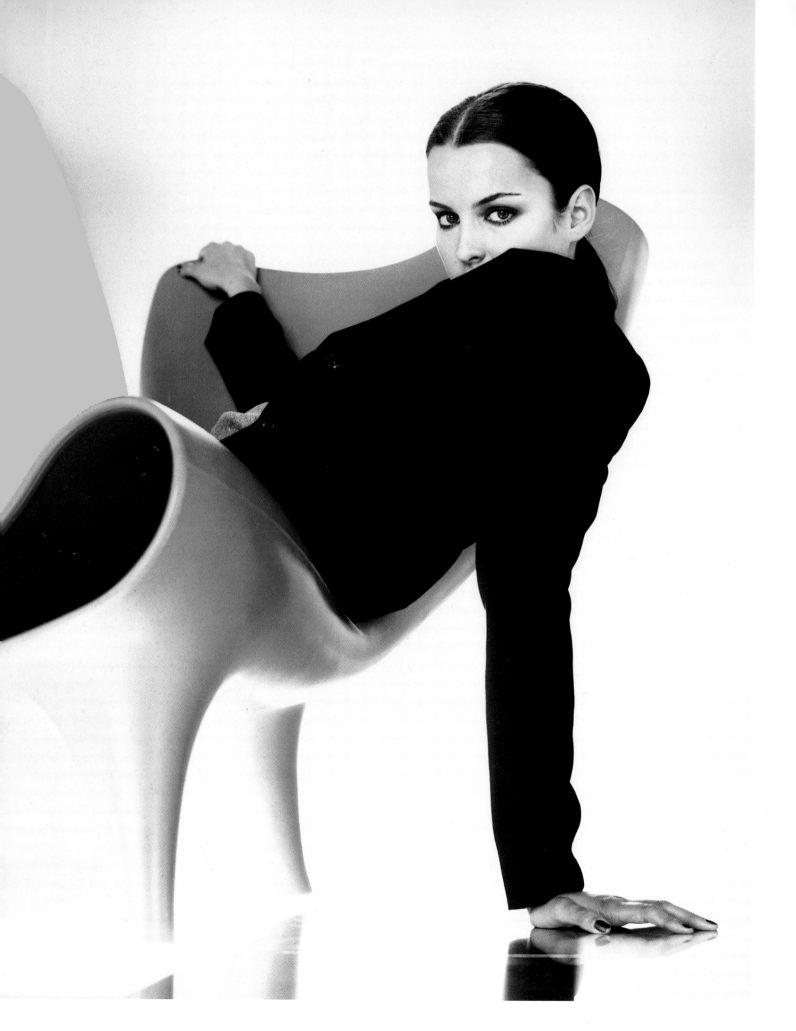

It's not unusual to employ six heads when lighting a shot, but this set-up is unconventional. The lights near the camera are arranged in a way that will be familiar to many beauty photographers – a large softbox is placed over the camera with two further lights either side. It's what is at the side of the model and behind that's more unusual. Here we have two silvered walls that converge to a slit behind the model, through which a stack of three softboxes stand. The result is a flood of light that burns out all but the top corners of the frame, and which illuminates the model softly and evenly. The model is also placed on a reflective surface; this provides up-lighting that enhances the shape of the chair, while also giving a reflective depth to the photograph.

Frank Wartenberg
S. Oliver
Advertisement
6 x 7cm
110mm
Fuji Velvia
Not known
Six flash heads
Dada Held
Uta Sorst
Malte Bartjen
Ruth Vahle

plan view

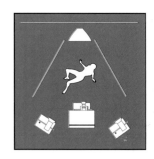

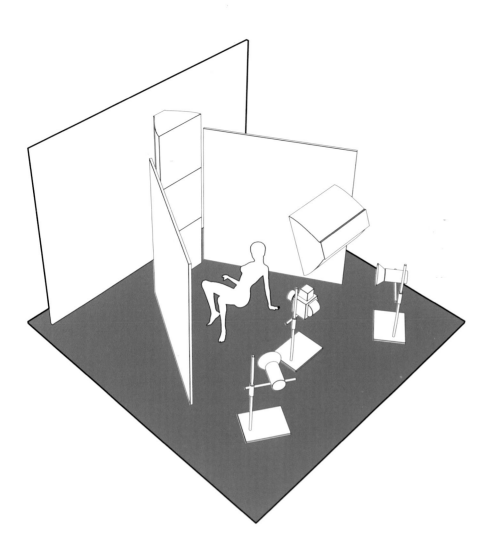

girl in chair

Sophisticated set-up using six flash heads and a reflective floor to flood the model with light.

practical tips

147

* Care must be taken to avoid flare, either by allowing the backlight to enter the lens or turning it up to high compared to the frontal lighting

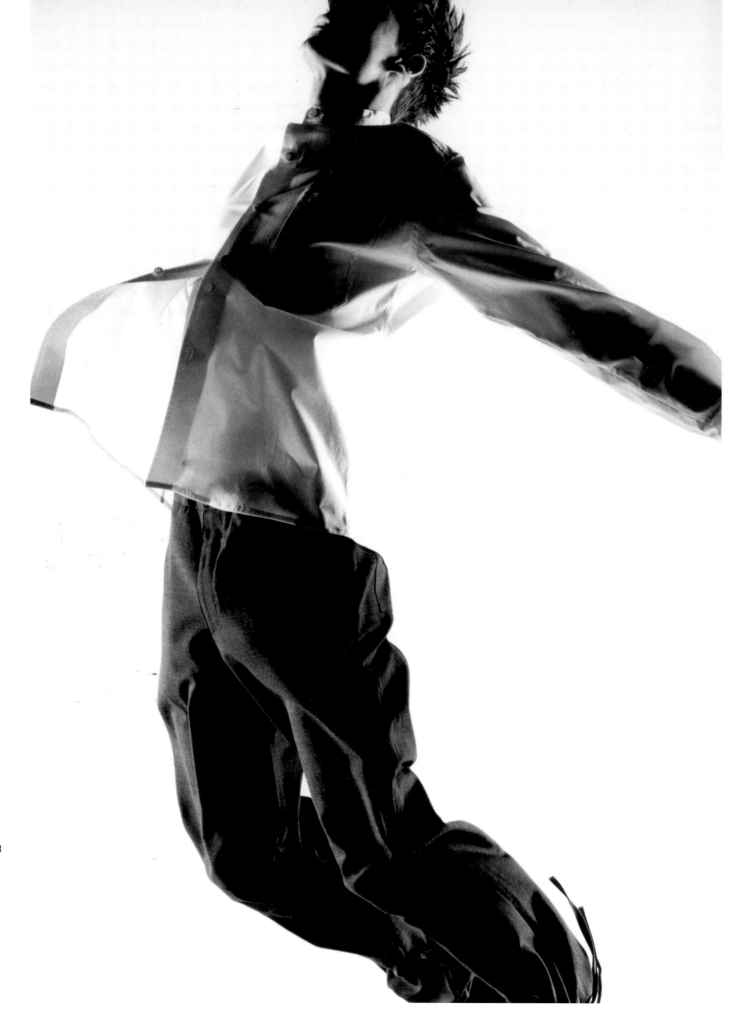

The idea for this wonderfully dynamic shot was to get a silhouette with brilliant highlights down the side. The photographer used six umbrellas, three each side, stacked on top of each other and pointed towards the background. One is close to the ground, the second at waist height and the third at head height. However, the umbrellas were sufficiently far away from the model – some 4m – that there was sufficient spill to produce the strip of highlights that edge the sides of the model.

There's no frontal lighting at all. Naturally with lighting of this kind there's a risk of light also reaching the lens, so the camera was carefully flagged off with black boards. The whole studio was kept totally black as a matter of course to make this kind of high contrast image possible. Looking to get a sense of movement, the photographer asked the model to jump, and as he did, he turned a little more to the side and the light caught his face.

🚶	Morten Bjarnhof
🕐	Ecco
●	Brochure
📷	6 x 7cm
◎	105mm
▶	Kodak T400CN
🕐	1/125sec at f/16
💡	Six umbrellas
🗄	Style Counsel

plan view

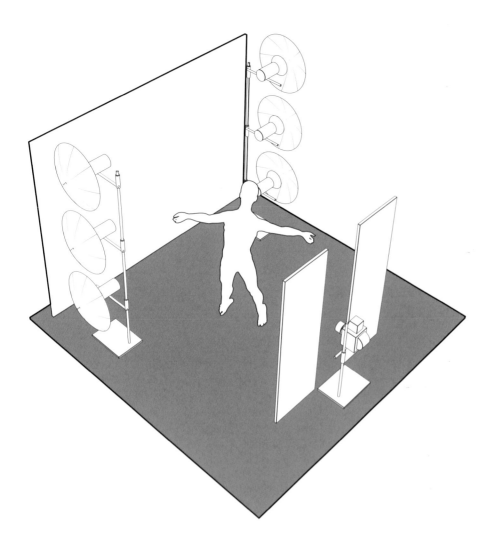

man jumping

Clever use of umbrellas combines a semi-silhouette with rim-lighting.

The Ecco brochure features a mix of moving and static shots. This picture, taken using the same lighting as the main shot, allows you to see more easily the effect of the lighting set-up.

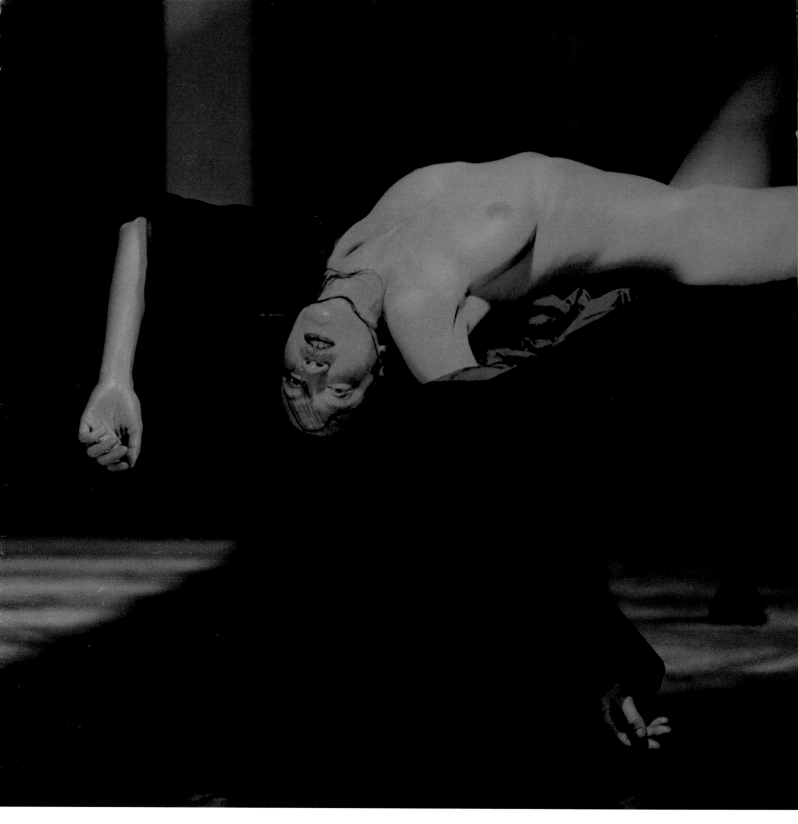

green girl

Strong use of gels produces a vivid result.

Iko Ouro-Preto
Pure magazine
Editorial
6 x 7cm
80mm
Kodak Ektachrome EPP
1 second at f/8
Tungsten

'This was a very, very complex lighting set-up which I researched and planned in great detail. It was shot at the School of Medicine in Paris, and all the lights used were redheads', Ouro-Preto explains.

'Two of the lights had green gels and were on booms, one is placed very high above and more or less in the middle, whilst another is coming down from above right. Immediately behind the girl, focused on the table there's a light with a magenta gel that is lighting the back of her leg. Other lights are used to illuminate the background and to provide the blue colouring to the cloth. The disembodied arm was taken from another picture and added in the computer.'

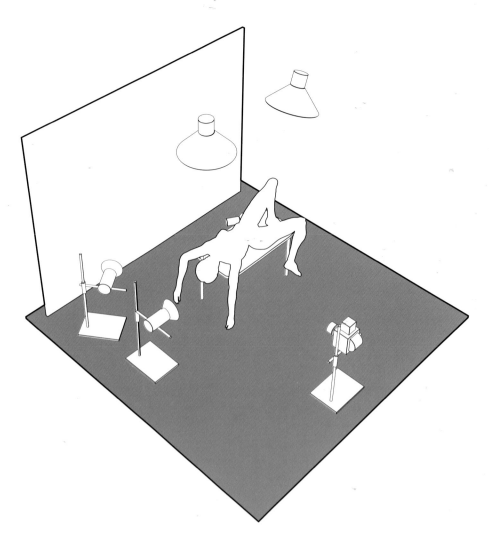

'It took more than an hour to get this shot the way we wanted – we tried dozens of different combinations of gels, mainly in the yellow and green end of the spectrum, as well as making changes to the make-up too.'

plan view

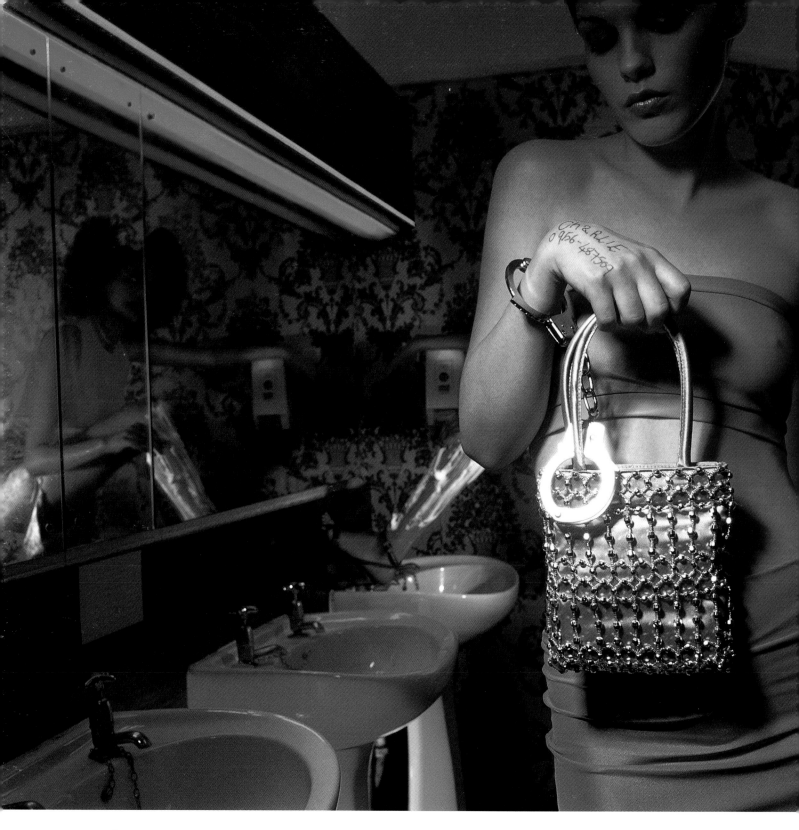

152 # powder room

Heavy use of gels produces dramatic and vibrant colours.

Simon Warren
Competition Entry
6 x 7cm
65mm
Kodak Ektachrome E100S
1 second at f/11
Studio and portable flash and fluorescent
Nana Fischer
Robin Easterby

'The girl and everything on the left of the picture was shot as you see it,' says Warren, 'and the background was copied and pasted onto the right in the computer to create a "full" room rather than a one-sided one. The location is as you see it. I just wanted to make it a lot more interesting with the lighting.'

'There's just one head on the background fired into a brolly with a purple gel over it. On the front, just above the camera, there's a direct head with a pink gel and a honeycomb grid, giving a harsh light that doesn't spill onto the background. Underneath, small enough to hide behind the pedestals of the basins, are two portable Norman lights powered by batteries. One is fitted with a red gel and the other with a green gel.'

'The fluorescent tubing was already there. The light was a horrible green colour, but without it there was a black hole at the top, so I covered it with blue gel. I used an exposure of 1 second to balance the flash and continuous fluorescent lighting, switching the modelling lamps off so they didn't contribute to the exposure.'

At first sight this picture looks like it might have been a candid shot of a girl dressed up for a night on the town leaving a garishly-lit ladies room. But when you look more closely you can see that the left- and right-hand sides are mirror images, right down to the reflection of the girl shaving her leg. It's obvious, therefore, that to some degree it was created in the computer. However, the manipulation only provided the finishing touches to the image, and it's really the complexity and imagination of the lighting that makes it work.

plan view

153

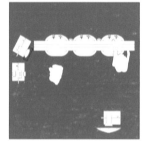

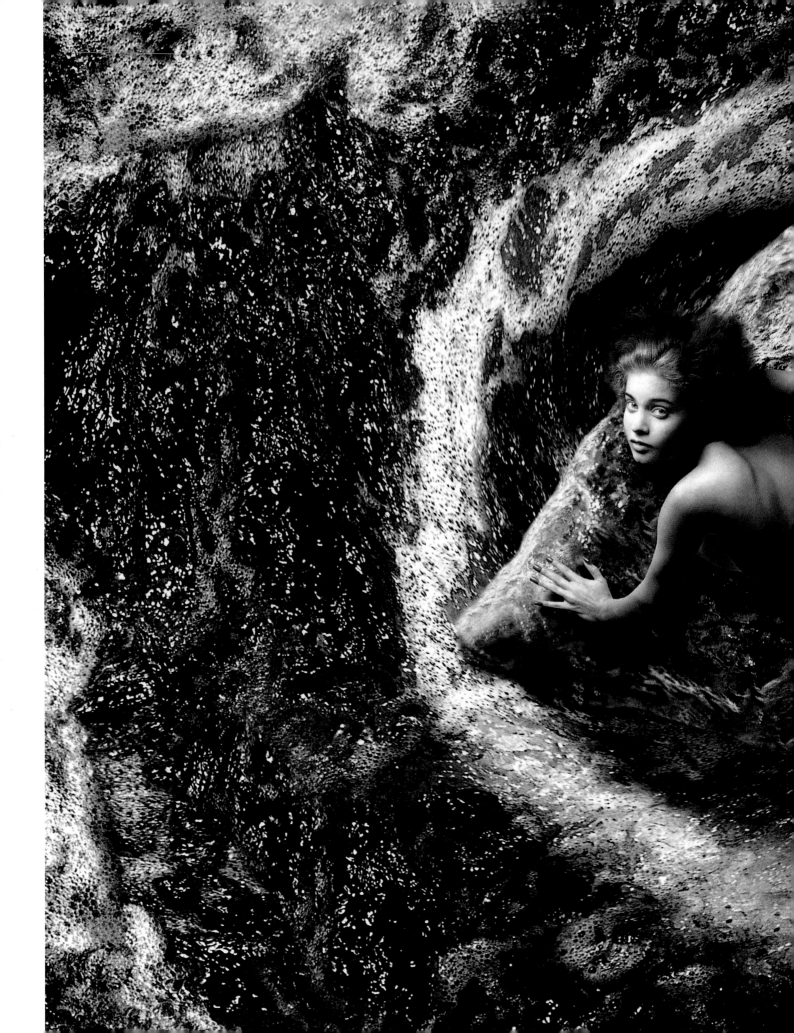

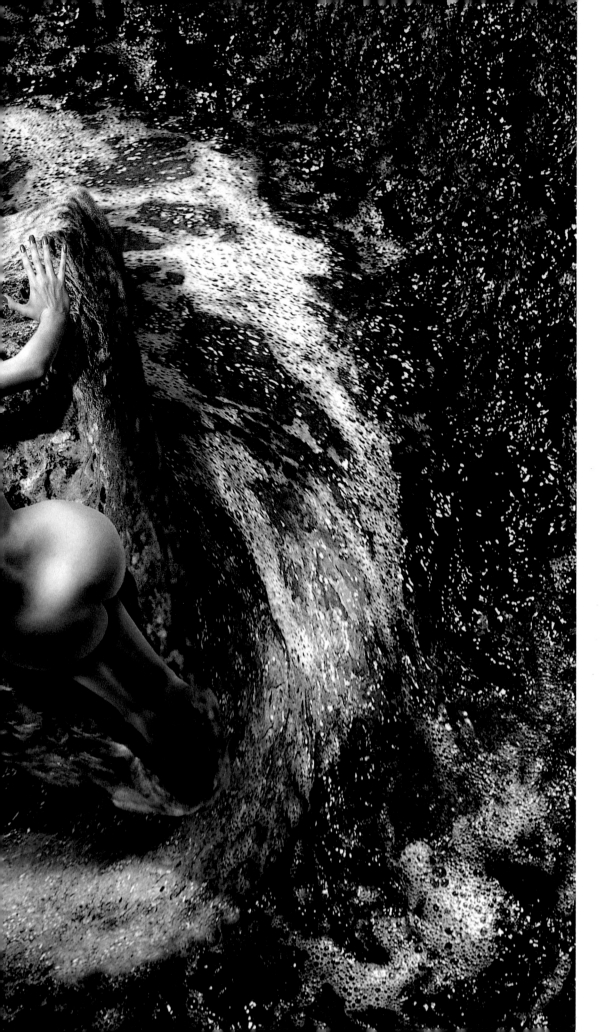

directory

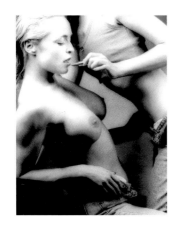

photographer	Rod Ashford
address	7B Station Approach, Stoneleigh
	Surrey KT19 0QZ, England
telephone	+44 (0)7771 593854
email	rod.ashford@virgin.net
website	www.raphotos.freeserve.co.uk

Rod Ashford is one of only a handful of high profile professional photographers who regularly write about the business of photography. His photography is always in demand and has appeared on fine art posters, postcards, greeting cards and on book jackets and magazine covers all over the world. During the last ten years Rod's articles have appeared in every major British photographic magazine including: Practical Photography, Amateur Photographer, Buying Cameras, Photo Answers, Professional Photographer, and Hotshoe International. Rod is a former Technical Editor of Camera magazine and Camcorder Monthly magazine. At present Rod writes regular columns exclusively for the British Journal of Photography on photographic technique, the law, digital imaging, website design, industry comment, and equipment tests and reviews. Rod Ashford's book 'Erotique' was published by Carlton in 1998 in hardback and has sold in excess of 40,000 copies in the UK. The book was also simultaneously published in the USA, France, and Germany. A UK paperback edition has recently been published by Carlton. In 1997 Rod Ashford was awarded a prestigious Kodak European Gold Award for his photography.

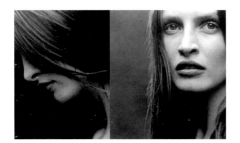

photographer	Morten Bjarnhof
address	Frederiksborgade 1A, 1360 Copenhagen DK
	Denmark
telephone	+45 33 33 01 08
fax	+45 33 33 04 08
agent	VHM Hauen Moore agent tel +44 (0)20 7629 9858
agent email	agent@vhmphoto.demon.co.uk

Morten Bjarnhof started out as an advertising photographer, moved into portraiture and made a switch into fashion in 1987 – a field in which he has been working ever since. One notable exception is his stunning product photography for Bang & Olufsen. Based in Copenhagen, Denmark, Morten does all his own black & white and colour printing. He has agents in New York, London and Denmark, and spends around half the year travelling.

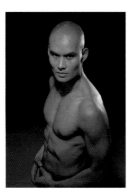

photographer	Jon Gray
address	110 Marylebone High St
	London W1M 3DB, England
telephone	+44 (0)20 7467 5681
fax	+44 (0)20 7486 0642
mobile	+44 07778 060073

Jon Gray has been in the photographic business for over 25 years. He originally trained as a still life photographer but now is best known for his fashion, advertising, lifestyle and celebrity work. He shoots stock for the Telegraph, Images and PictureBank libraries, and has worked directly for clients including Vogue magazine and Gucci. Jon uses all formats, but mostly 6 x 7cm, and has worked all over the world.

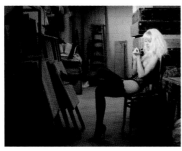

photographer	Nigel Holmes
address	7 Beach Close, Mundesley
	Norwich NR11 8BH, England
telephone	+44 (0)1263 720357
fax	+44 (0)1263 720357
email	nigel@girlfiles.co.uk
websites	www.girlfiles.co.uk

Nigel's glamour photographs have appeared in magazines including Club International, Playboy, Mayfair and Penthouse – and he also shoots fashion and beauty. Check out his website where you'll find hundreds of pictures, with information on how they were taken, often including a lighting diagram, plus articles on photography.

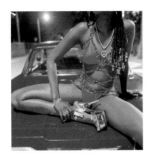

photographer	Jamil GS
address	Art Department, 48 Greene Street, 4th Floor
	New York 10013, USA
telephone	+1 (718) 387 5461
email	jamil@gs-stickups.com
website	www.gs-stickups.com

Now based in New York but originally from Denmark, Jamil GS has always been a photographer. Much of his work is for record companies such as Virgin, Sony and Warner Music or contemporary magazines such as Arena and iD.

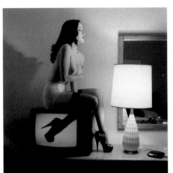

photographer	Chas Ray Krider
address	219 King Avenue, Columbus
	Ohio 4320, USA
telephone	+1 (614) 299 9709
fax	+1 (614) 299 9797
email	chasray@ee.net
website	www.motelfetish.com

Chas Ray Krider earns his living working for advertising agencies shooting a range of subjects, but started his 'motel fetish' personal project 'to try and eroticise my existence'. Motel Fetish is, he says, 'a book project in search of a publisher', and he hopes one day to see the 1000 images he's taken edited down to around 200 and published.

photographer	Dave Muscroft
address	Glamour International, Vision House, 16 Broadfield Road
	Sheffield S8 0JX, England
telephone	+44 (0)114 258 9299
fax	+44 (0)114 255 0113
email	dave@glamourintl.demon.co.uk

Having spent the last 15 of his 25 or so years in professional photography as a full time glamour specialist (including running his own stock agency) David has decided to produce much more 'beauty' and 'lifestyle' images. The three shots reproduced here still have a strong glamour flavour however! But even these have a much broader appeal than an obvious male-interest glamour picture. Market research reminded him that 'beauty' images lent themselves to the full range of photographic techniques available to any photographer, and he decided that it was time to have some fun with his work, and also to expand the markets for pictures he was exploiting.

photographer	Vinnie O'Byrne
address	Rear Regal House, Fitzwilliam St, Ringsend
	Dublin 4, Ireland
telephone	+353 1 668 5283
fax	+353 1 668 5283
email	vincent@vobphotography.iol.ie
website	www.sensual-photography.com

In 1988 Vincent O'Byrne turned professional and opened a commercial studio in Ringsend, Dublin, Ireland. Since then he has established himself as one of Ireland's foremost photographers. He has won numerous awards and has credits to his name including the sleeve to the top-selling CD Riverdance. His background is in architecture, and he enjoys photographing products, but it is the fine art figure photography published here for which he is becoming best known – much of it expertly created digitally. You can buy Vinnie's images via his website or through selected picture libraries around the world.

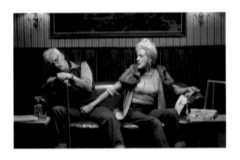

photographer	Erwin Olaf
address	Ijseltraat 26–28, 1078 CJ Amsterdam
	The Netherlands
telephone	+31 20 692 3438
fax	+31 20 694 1291
email	eolaf@euronet.nl
website	www.erwinolaf.com

Erwin Olaf is a leading Dutch photographer who started his working life in photojournalism but now shoots mainly fashion internationally. His images are hallmarked by visual humour and persistent allusions to the formal expressions of art. Clients include Heineken, Silk Cut, Hennessy and Diesel.

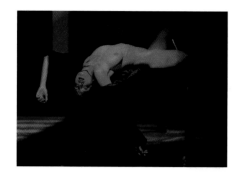

photographer	Iko Ouro-Preto
address	7 rue Git-le-Coeur
	75005 Paris, France
telephone	+33 143 547 358
fax	+33 143 547 358
email	ouropreto@cybercable.fr
website (agent)	www.olivier-rozet.com

Iko was born in Rio de Janeiro, Brazil. His parents were and still are diplomats, so he was brought up in many different countries being exposed to many diferent cultures. Today he speaks five languages and feels at ease travelling constantly. When he was 13 his mother took him to a Helmut Newton expo in Geneva – and he was hooked for life. At 14 he got his first camera, and at 16 he was fanatically going through his mother's Vogue and Harpers Bazaar magazines, and had a list of his favourite photographers: Javier Valhonrat, Max Vadukul and J-P Witkin. Nevertheless, because of family pressure, at 18 he went to Madrid to study architecture at the Complutense University. At 24 he began photography seriously. In the beginning he had a brief stint in fashion, but immediately changed to photojournalism working with clients such as the United Nations in New York, and the Rockefeller and Ford foundations, also based in New York. He has travelled all around the world many times over. 'Now I'm back in fashion', he says. 'I love it. I love the mags I work for.'

photographer	Brian Spranklen
address	Avalon Photography Ltd., 5 Pittbrook St
	Manchester M12 6LR, England
telephone	+44 (0)161 274 3313
fax	+44 (0)161 272 7277
email	brian@avalonphoto.co.uk
website	www.avalonphoto.co.uk

Brian Spranklen FBIPP QEP is Ian Cartwright's partner at Avalon Photography. He shoots fashion and people, mainly for advertising clients. A winner of many awards for his work, Brian was the Photographer of the Year for the British Institute of Professional Photography in 1999–2000 and is Fashion photographer of the Year in 2000–2001. Brian's appetite for photography is insatiable.

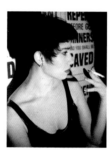

photographer	Simon Starkwell
email	the.collective@virgin.net

Simon Starkwell is based in England. His work has been featured on book covers, posters, postcards and in magazines. In his studio, Simon creates striking black & white shots that have a film-still quality, evoking a storyline that the viewer is invited to interpret. In this way, his models often come across as actresses playing a character. He works closely with make-up artist Judy Keaton to make the images graphic and crisp, and his use of colour is always vivid and exciting. To contact Simon about his work, portraiture, or commissions, please email him at the address above.

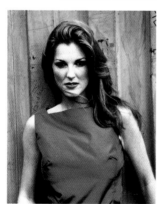

photographer	Keeley Stone
address	Stones Imaging, The Hayloft Studio, Home Farm, Wakefield Road
	Swillington, Leeds LS26 8UA, England
telephone	+44 (0)113 287 6700
fax	+44 (0)113 287 6700
email	keeley@stonesimaging.co.uk
website	www.stonesimaging.co.uk

In 1987 Keeley made a dramatic career change from professional horseracing to professional photography. After two years at college she worked briefly in many diverse professional areas from press photography to makeovers until getting the break she wanted in advertising photography. Keeley worked as an employed advertising photographer in Leeds until 1998 when she started her Leeds-based business, Stones Imaging, with her husband Alan. Advertising, corporate and fashion photography and computer-based imaging is their business, and Keeley specialises in advertising and fashion imaging. She has clients in both the UK and mainland Europe.

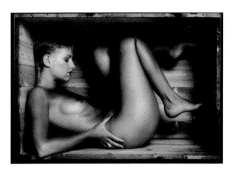

photographer	Peter Trenchard
address	Image Store Ltd., The Studio, West Hill, St Helier
	Jersey JE2 3HB, Channel Islands
telephone	+44 (0)1534 769933
fax	+44 (0)1534 789191
email	peter-trenchard@2000net.com
website	www.peter-trenchard.com

One of the foremost photographers on Jersey in the Channel Islands, Peter Trenchard specialises in taking pictures of people. His flair and creativity have won him many awards, and he is a member of the prestigious Kodak Gold Circle, as well as Fellow of the British Institute of Professional Photography.

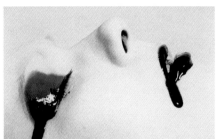

photographer	Nigel Tribbeck
address	The Garden Studio, 24A Newton Road, Notting Hill
	London W2 5LT, England
telephone	+44 (0)20 7792 0514
fax	+44 (0)20 7792 0514
email	trbbckphoto@aol.com

Nigel Tribbeck began his career as a freelance photojournalist. Since 1990 he has concentrated more and more on fashion and beauty photography. In 1996 he began to teach at the London College of Fashion, and he has been working successfully out of his own studio in West London. He has received numerous prizes and awards, including the Agfa Portrait Photographer of the year in 1998 and 2000, and BIPP National Fashion Photographer of the year in 1996, 1997 and 1999. Parallel to his work in commercial photography, Tribbeck also pursues his personal artistic interests in photography. Through the use of tight cropping and the use of lith film he often imparts an abstract effect to his images. He is very interested in experimentation during the processing and printing stages and he employs various techniques during these stages, involving the use of different chemicals on the surfaces of his photographic images.

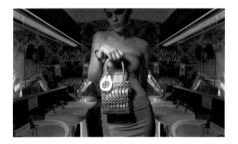

photographer	Simon Warren
address	UK
telephone	+44 07973 286120
fax	+44 (0)20 7286 2386
email	mail@simon-d-warren.co.uk
website	www.simon-d-warren.co.uk

Following college and a four year period as an assistant to leading photographers including Rankin, Snowdon and David LaChappelle, Simon is now working professionally in his own right, shooting mainly portrait and fashion. His work has appeared in the Telegraph newspaper supplement and magazines such as Mixmag, and his aim is to establish himself in the lifestyle and fashion arena. Simon works in all formats and digitally.

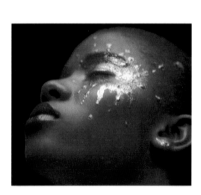

photographer	Frank Wartenberg
address	Leverkusenstrasse 25
	Hamburg, Germany
telephone	+49 (40) 850 83 31
fax	+49 (40) 850 39 91
email	wartenbg@aol.com
website	www.wartenberg-photo.com

Frank began his career in photography alongside a law degree, when he was employed as a freelance photographer to do concert photos. He was one of the first photographers to take pictures of The Police and Pink Floyd in Hamburg. He moved into fashion, and since 1990 has run his own studio. He is active in international advertising and fashion markets. He specialises in lighting effects and also produces black & white portraits and erotic prints.

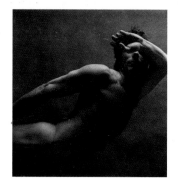

photographer Faye Yerbury
address Yerbury of Edinburgh, 71/73 East Claremont St
 Edinburgh EH7 4HU, Scotland
telephone +44 (0)131 556 5758
fax +44 (0)131 557 5248
email info@yerbury.co.uk
website www.yerbury.co.uk

During her 25-year career as a lecturer in hairdressing and cosmetic make-up, Faye was Trevor Yerbury's stylist – before becoming his wife and a frustrated would-be photographer. Choosing her camera, she has never looked back – and retired from teaching in 1996. She received her Associateship of the Master Photographers Association followed by her ARPA. She went on to win her first Kodak Gold Award in 1998 with her blue man image. She is currently working on a series of male nudes. Falling in love with Photoshop, Faye is spending time learning this new technology for use in digital, which she sees as the future of photography eventually replacing the film camera, or so they say!

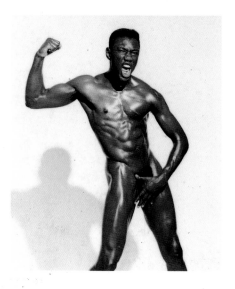

photographer Trevor Yerbury
address Yerbury of Edinburgh, 71/73 East Claremont St
 Edinburgh EH7 4HU, Scotland
telephone +44 (0)131 556 5758
fax +44 (0)131 557 5248
email info@yerbury.co.uk
website www.yerbury.co.uk

Trevor Yerbury is a photographer essentially concerned with portraiture. His portraits are inspired by the long tradition of portraiture associated with his family's photographic business which has recorded the Edinburgh scene since 1850. Trevor uses the camera not only with a photographer's eye but also with an artist's eye. He has created his own world; one populated by a cast of personalities which he chooses to focus upon with remarkable intensity, often emphasising the sensual, particularly in relation to the female face and figure. By preferring black & white photography, he makes manifest his delight in texture and the stuff and substance of surfaces inherent in forces of nature and in landscape.

would you like to see your images in future books?

If you would like your work to be considered for inclusion in future books, please write to: The Editor, Lighting For..., Rotovision SA, Sheridan House, 112–116A Western Road, Hove, East Sussex BN3 1DD, UK. Please do not send images. either with the initial inquiry or with any subsequent correspondence, unless requested. Unsolicited pictures may not always be returned. When a book is planned which corresponds with your particular area(s) of expertise we will contact you.

acknowledgements

Thanks must go, first and foremost, to all of the photographers whose work is featured in this book, and for their generosity of spirit in being willing to share their knowledge with other photographers.

Thanks also to those companies who were kind enough to make available photographs of their products to illustrate some of the technical sections.

Finally, enormous thanks must go to the talented team at RotoVision, including Editor Kate Noël-Paton; to Ed Templeton and Hamish Makgill from Red Design for the stylish layout; and to Sam Proud from Mozaic for his clear and elegant illustrations.

Woodbourne Library
Washington-Centerville Public Library
Centerville, Ohio